W9-AWZ-646

Women Artists
Multi-Cultural Visions

Betty LaDuke

Preface by Charleen Touchette

Cover: *There is a Woman in Every Color* by Elizabeth Catlett

Back cover: Betty LaDuke with painting by Mine Okubo at the Women's Caucus for Art Honors Ceremony, National Museum for Women in the Arts, 1991.

Book design by Mary Jo Heidrick

Typography by IMPAC Publications

Library of Congress Catalog Card Number: 91-68511

ISBN: 0-932415-77-6 Cloth
ISBN: 0-932415-78-4 Paper

Copyright © 1992 Betty LaDuke
First Printing 1992

All rights reserved. No part of this publication may be reproduced, stored in a retrieval system or transmitted in any form or by any means electronic, mechanical or otherwise without the prior written permission of the publisher.

 The Red Sea Press, Inc.
15 Industry Court
Trenton, New Jersey 08638

*Dedicated
to my first
art teachers
and artist friends*
Charles White
and
Elizabeth Catlett

Acknowledgment

DURING THE TEN-YEAR gestation period of *Women Artists: Multi-Cultural Visions* many people from distances both far and near contributed to the book's fruition. Foremost I acknowledge each artist for sharing with me aspects of her personal life, cultural heritage, and creative process. En route, there were numerous friends and strangers who assisted, sometimes when least expected. For example: Elinor Gadon xeroxed a much needed reference book from the Harvard University library and made it available to me; in Patna, India, V.P. Marchante accompanied me by train and rickshaw to the remote Mithila region, facilitating the interviews with the women painters; and in Sarawak, Borneo, Bonnie Bollwinkle translated the Iban dialect during longhouse interviews with the women weavers. While there have been many other generosities, the names of the people have faded, but their spirit of goodwill has not.

Through the years, three very special Ashland, Oregon friends, Chela Tapp, Florence Schneider, and Olive Streit, have vicariously made these journeys with me through the long writing process. Since it is difficult for me to shape words, rather than line, form, and color into meaningful reality-visions, their patience, and encouragement made the final results possible. Beginning with my first trip to India in 1972, Peter Westigard, my husband, has been consistently supportive and encouraging, both personally and professionally.

Once again, I want to thank my friends and typists, Lois Wright and Mary Burgess, who patiently struggled with the original handwritten pages, and the graphic designer, Mary Jo Heidrich, for her sensitive coordination of the visual and verbal components.

Many of the chapters which compose this book have previously appeared in part as articles in the following books and journals: *Women's Art Journal; Women Artists of the World; Trivia, A Journal of Ideas; KSOR Guide to the Arts; Forbidden Stitch, Art Education; City Lights Review;* and *Perspectives: National Women's Studies Association.*

The following photographs were taken by others or loaned from their collections: Figures 2-36 and 2-37, courtesy of Karuna Shaha; 2-1, courtesy of Luis Blanco; 4-2, 4-3, 4-4, and 4-6, collection of the Philbrook Art Museum; 4-5 and 4-8, courtesy of Pablita Velarde; 4-12, 4-13, 4-14, and 4-15, courtesy of Cradoc Bagshaw; 5-5, 5-7, 5-8, 5-9, 5-10, and 5-11, courtesy of Patricia Rodriguez; 6-2, 6-3, 6-4, 6-5, 6-6, 6-7, 6-8, 6-9, and 6-10, photographed by Susan R. Mogul; 7-2 and 7-17, courtesy of Mine Okubo; 8-5, courtesy of Estella Lauter; 10-1, 10-2, 10-3, 10-4, 10-6, courtesy of Milenah Lah; and 10-5, courtesy of Marija Braut.

Table of Contents

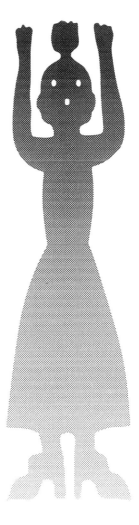

Preface
Charleen Touchette

IT WAS SOMETIME in the late 1970s, when I was a researcher for author Jamake Highwater in New York City that I first spoke with Betty LaDuke. I remember being impressed by her commitment to facilitate mainstream exposure of multicultural art and the intensity of her artistic imagery. In 1983, I met Betty's daughter, Winona LaDuke, an articulate, impassioned activist for the treaty rights of her White Earth Ojibwa tribe, who networks internationally with indigenous people. In getting to know Winona, it became evident to me that it was from her mother that she learned activism and the rare ability to see the connections between the economic, political and spiritual oppression of indigenous people. Betty clearly is an inspirational person. Winona spoke with pride of her mother's work with women artists in Asia, Borneo, Papua New Guinea, Eastern Europe, and Latin America. She told me of the continual surprise of coming home to her mother's art-making.

Here was a novel image of the 1960's mom—someone an emerging artist in the 1970s like myself could appreciate as a role-model. I was determined to meet Betty and get to know her. We corresponded often in the intervening years, but it was not until 1989 that I finally got to meet her at the Women's Caucus for Art national conference in San Francisco. By then, I felt a kinship and respect for her that has only increased with time. In 1990 at the WCA conference in Washington D.C., Betty participated on my panel, "Visionary Women Art-makers: Working For Peace & Justice." Her humility and keen intellect gave authenticity to her presentation on African women artists and imbued her subject with the dignity it merited.

LaDuke brings that same respectful attitude and extensive scholarship to *Women Artists: Multi-Cultural Visions*, making a definitive contribution to research in this area. Today, multicultural art is a timely subject. With this increased interest comes the danger that "multiculturalism" will degenerate into a trend, turning the very terms multicultural and intercultural into meaningless buzz words. In contrast, LaDuke's lifelong commitment to worldwide, multicultural inclusivity stands at the center of this field serving as an example of objectivity and sincerity. Her expansive nature combined with a trained critical eye makes LaDuke a reliable source of information about significant world artists who have not yet received consideration by the power brokers of the art world.

LaDuke is political. She sees the whole picture. Her essays articulate the importance of incisive discourse on racism, sexism and the politics of art and spirituality. What is most valuable as well as rare about her writing is her ability to make connections and to see the world with its diverse cultures as a holistic living entity. LaDuke stresses the intimate connection between women's art-making and the survival of their communities and cultures. She informs and heightens our awareness of the interconnections between social and ecological responsibility and the linkage between the survival of indigenous cultures and that of the world as a whole. LaDuke's own community is the entire world.

She acts her politics and integrates her life and art-making with her beliefs. She is a person who "walks her talk" which has taken her around the world. Since 1953, she has traveled extensively to search out, identify, document and publicize women artists of all cultures and colors. LaDuke visits their homes and studios, photographing them at work, documenting their art and sharing it through lectures, articles and books, thereby extending access to this important art.

One of the recurring obstacles faced by those who work for multicultural visibility is the assertion by those in power that they are not aware of "quality" art by people of color. LaDuke's books, amply illustrated and supported by scholarship, discredit this reactionary and exclusionary attitude. She introduces us to many great women artists of color. Because she has earned the trust and acceptance of women of color in the United States and indigenous women world-wide, she is able to make this art accessible to the mainstream.

LaDuke concludes by sharing her own powerful art. Her paintings embody a dynamic synthesis that celebrates the magic of creation, the rhythms of nature and the continuity of all life forms. She believes these elements are at the core of most traditional art and link ethnic and indigenous women artists world-wide, transcending their differences. *Women Artists: Multi-Cultural Visions* is a joy to read. By affirming their accomplishments, LaDuke weaves a multicolored tapestry that celebrates all of our world's diverse cultures.

Charleen Touchette
Santa Fe, New Mexico
September 1991

Introduction
Women Artists: Multi-cultural Visions

THIS BOOK is a gathering together of eleven journeys of exploration concerning women's art from Asia, Latin America, Eastern Europe, and the United States. The artists under consideration range from traditional longhouse weavers within Borneo's tropical rain forests, visited in 1980, to a modern sculptor and printmaker, Elizabeth Catlett, interviewed in Cuernavaca, Mexico, in 1990. Though they span vast differences in cultural heritages and aesthetic approaches, they do have a common bond, the use of the feminine form as a significant theme for their woven, sculpted, printed, painted, and mixed-media images. As a result of this shared focus, their life-affirming visions became catalysts for my discovery of links among women from diverse parts of the globe and from ancient times to the present.

My research in non-Western cultures began with a sabbatical from Southern Oregon State College in 1972, when I first traveled alone to India. Intrigued by art linked to mythology, rites of passage, and the seasonal rhythms of agriculture, I received much inspiration for my own imagery as a painter and printmaker. Fortunately, I was able to continue making journeys of exploration that later included Latin America and Africa. I also began to document women's art in relationship to the process of social change. It was gratifying to have this extension of my pen beyond sketching to writing result in the publication of *Compañeras: Women, Art and Social Change in Latin America* and *Africa through the Eyes of Women Artists.*[1]

Fortunately, early research encouragement from the Oregon Committee for the Humanities in 1980 enabled me to return to India and then to extend my travels to Borneo. These journeys resulted in the first two chapters of this book: "Borneo: Weaving the Sacred *Pua* and Rainforest Ecology" and "India: Sacred Circles, Traditional Women Painters." These chapters are followed by "Mexico: Earth Magic, the Legacy of Teodora Blanco," based on 1990 research. The three chapters comprise Part I, "Art, Ecology, and Spirituality," and focus on traditional artists. They explore Iban weavings of the sacred *pua* (Fig. 1), a ceremonial blanket that incorporates birthing images; Mithila paintings of goddesses and *kobars* (Fig. 2), or fertility images; and Mexican sculptures of earth mothers with protective *nahaules* (Fig. 3) or animal spirits. I found that these symbolic images are linked to goddesses of procreation, cultural creation, and spirituality. They

Fig. 1 *Pua* (detail), by Indai Langit, Borneo, 1980.

augment our awareness of Gaia, the earth, as a living entity whose destruction in any part of the globe affects us all.

The succeeding chapters that compose Part II, "Breaking Boundaries," focus on individual women artists of color from the United States: Pablita Velarde and Helen Hardin, Pueblo Indian painters from New Mexico; Yolanda Lopez and Patricia Rodriguez, Chicana painters and multi media artists from San Francisco; Mine Okubo, an Asian-American painter from New York; and Elizabeth Catlett, an African-American sculptor and printmaker, currently living in Mexico. Most are "grandes dames," who have broken boundaries to create art that has had a significant impact upon their communities.

On the national level, Velarde, Okubo, and Catlett have each received honorary awards from the Women's Caucus for Art of the College Art Association for their distinguished contributions to the visual arts. Catlett's sculpture is in the Smithsonian Institution's National Museum of American Art. However, most have yet to overcome barriers that prohibit their aesthetic achievements from receiving more than token acknowledgement in the art history texts and museums. In *Mixed Blessings*, Lucy Lippard laments:

> Art with spiritual depth and social meaning is homeless in this society, trapped in an art world dedicated to very different goals. The presence of more women and artists of color has changed some things about art, but it has not changed the art world much.[2]

Part III, "Art and Nationalism," includes discussions of the Yugoslav painter Nives Kavouric-Kurtovic and sculptor Milenah Lah, whose work reflects their personal and spiritual responses to survival in Eastern Europe in the aftermath of World War II. Both artists are members of government controlled artists' unions and, in addition to national visibility, have also had major exhibitions throughout Europe. Their images add another important dimension to a multi-cultural view of women and art.

Because meeting with artists of diverse cultural heritages has provided stimulus for my own art, I discuss select examples of this influence in the last chapter. In *The Reflowering of the Goddess*, Gloria Orenstein describes my work (Fig. 4) as the "*Great Chain of Being*, animal, vegetable, and human, and the cycles of life, death, and rebirth incarnated in the great bodies of humble women, seen as epiphanies of the *Great Goddess* around the globe.[3]

This introduction gathers together these artists to make some cross-cultural comparisons and to consider issues such as the role of the goddess in the past and the present; ecofeminism, indigenous self-determination, and racism experienced by women artists of color in the United States; and the effects of nationalism upon the arts in Eastern Europe. Though these topics are only briefly introduced, it is hoped they will serve as a stimulus for further interdisciplinary discussion and investigation.

Art, Ecology, and Spirituality.

What can we learn from images that transcend centuries and continue to portray women as earth mothers? What is their relevance for modern women, possessors of the microwave, the television, and the computer, compared with their relevance for

Fig. 2 *Kali*, watercolor, 22 by 30 inches, by Bua Devi, India, 1980.

women in subsistence economies who walk in the mud to plant rice, corn, or wheat? In the United States, does the goddess have particular relevance for women of color?

The role of the goddess in agriculture is universal, and, for the village artists of Borneo, India, and Mexico, there is no separation between art, life, and spiritual beliefs. The goddess, synonymous with Gaia, the earth, is considered a sacred living presence requiring individual and communal rites of respect to assure the continuity of all life forms. For endless centuries, the earth goddess has appeared woven into the Iban *pua*s of Borneo, utilized in ceremonies associated with growing paddy or hill rice, their food staple. In Mathila, India, images of Guari, the local Hindu goddess, are painted to evoke her assistance for a successful harvest. In Mexico, sculptures of earth mothers and angels appear on family and church altars beside the Virgin Mary to bless the corn, bean, and rice seedlings.

Women's activities related to these goddesses have been a continuous source of feminine empowerment, but in this century their rituals have often been dismissed by art critics and histori-

ans as "childish or superstitious." They are disturbed by the idea that "art could actually possess other levels or dimensions that include magical energies or powers contained in the imagery, in the materials used, in the site of the work or invoked by the actions and process of making art.[4]

Ignored until recent years, the extensive and irresponsible exploitation of natural resources by industrialized nations for "progress" and profit has resulted in worldwide ecological devastation and the oppression of indigenous people. "Developed nations with one-quarter of the world's five billion inhabitants consume eighty percent of the world's resources and produce seventy-five percent of the total municipal and industrial waste."[5] According to Corinne Kumar D'Souzar, this imbalance is an expression of a western scientific world view in which nature is comparable to a "passive, inert, female, and the task of the new scientists was to dominate her, to manipulate her, to transform her... in order to achieve dominion of man over the universe."[6] This world view also defines over two billion people or the civilizations of Asia, Africa, and Latin America as:

> uncivilized, undeveloped, unprogressive. Progressive is the universal measuring stick of modernity, underlying which is a substratum of intolerance and violence. It reduces the cultures of the Third World to a single monoculture, a uniformity... The industrial society is a peak of progress—the "other" civilization must catch up. The dominant mode must become the universal.[7]

Acknowledging indigenous people's land rights as well as their ability to survive in harmony with the environment is an important aspect of the ecological movement. Especially heartening is the organization of indigenous women to protest genocidal policies, to document their own histories, and to "remove 'the cloak of invisibility' that covers indigenous people, and even more so, indigenous women." A prime example is the Indigenous Women's Network founded in 1984 in the United States to "support the empowerment of native women" through "economic, social and cultural projects utilizing appropriate technology and contemporary methods, based on traditional people's philosophies and practices." In addition, the International Indigenous Women's Council, with worldwide membership, has begun to work within the United Nations in order to guarantee that "issues of indigenous women and children be voiced and our viewpoints expressed."[8]

What is the link between environmental concerns and "the reemergence of the archetype of the great goddess in art by contemporary women"? This new art, Orenstein tells us, is not about "an original creation myth connected with the fertility and birth mysteries... it is about the mysteries of women's rebirth from the womb of historical darkness... the repossession by women of the attributes of the Great Goddess is necessary in order to provide fundamental changes in vision and reality."[9] In "The Goddess Heritage of Black Women" Sabrina Sojourner states, "Now many women of my own generations are discovering that God is not only not White, She has never been considered male—until relatively recently."[10]

How do we make effective changes in our lives and in society? Ecofeminists believe that social responsibility begins with

Fig. 3 *Market Woman*, clay, 24 inches tall, by Berta Blanco, Mexico, 1990.

Fig. 4 *Iban Marriage*, acrylic, 54 by 68 inches, by Betty
LaDuke, United States, 1979.

each individual. Art can be a significant tool for achieving enlightenment and self-empowerment leading to political involvement and social change. Elinor Gadon speaks of art and the "women's spirituality movement" as having "empowered women to transform their lives and in so doing many have become politically aware activists for social and ecological justice... the melding of spirituality and politics holds promise of revolutionizing our attitude towards life on earth.[11]

Breaking Boundaries

By the turn of the century, one out of every four Americans attending school will be of Native, African, Latin, or Asian heritage. How is this reality reflected in education and the art establishment? While many educators believe "culture is a human right and not a privilege for select groups and classes" and that "cultural democracy means pluralism, diversity, variety and difference,"[12] others strongly insist that "the values, customs, conventions, and prejudices of the Judeo-Christian tradition are the bulwark of a free society. Without such ordinances, society sinks into the decay that follows moral relativism."[13] This conflict is not yet resolved within our educational institutions and programs.

Maurice Berger, a *New York Times* art critic, notes that racism in education and the professional arts is a reality. "Sad to say, with regard to race, art museums have for the most part behaved like many other businesses in this country—they have sought to preserve the narrow interests of their upper class patrons and clientele."[14] These interests are also perpetuated by the dominant philosophy of art which is based on an "art for art's sake" ideology. It promotes a view of art as an independent product that has "no social base... that art is a product of timeless talent and creative genius. The social conditions present where it originates are irrelevant."[15]

Within this narrow framework one wonders how women artists of color, creating outside a dominant male, Euro-ethnic context have managed to survive? Are there alternative channels that validate their creativity? Career highlights from Pablita Velarde, Helen Hardin, Yolanda Lopez, Patricia Rodriguez, Mine Okubo, and Elizabeth Catlett reflect how each has been inspired by her ethnic heritage and community to create images of empowerment. These artists are breaking boundaries as they portray ordinary women with pride and dignity.

It is ironic, comments Lucy Lippard, that "the last to receive commercial and institutional attention in the urban art world have been the 'first Americans,' whose land and art have both been colonized and excluded from the realm of 'high art,' despite their culture's profound contributions to it."[16] Pablita Velarde is from a Pueblo Indian community where women have maintained their traditional pottery skills. However, Velarde preferred to paint and had the opportunity to study art with Dorothy Dunn at The Studio in Santa Fe. Later, as her career evolved, she competed with male Native-Americans for professional recognition. Using subtle earth tones, her paintings illustrate events from Pueblo Indian life and ceremonies. Contradicting the stereotype of the "invisible Indian," Velarde's mural at the Albuquerque Indian Culture Center contains a self-portrait in ceremonial

Fig. 5 *Corndancer* (mural detail), by Pablita Velarde, Pueblo Indian Culture Center, Albuquerque, N.M., 1979.

Fig. 6 *Changing Woman*, etching, 18 by 24 inches, by Helen Hardin, 1982. Photo courtesy of Cradoc Bagshaw.

regalia among the male Buffalo Dancers (Fig. 5).

Generational differences are apparent between Velarde and her daughter, Helen Hardin, a painter and printmaker. Stylistically influenced by Cubism, Hardin is not concerned with illustrating reality but rather with "transforming traditional Indian iconography into an accessible universal statement."[17] Hardin created human feminine spirit presences such as *Corn Mother* and a series completed before her death titled "Changing Woman" (Fig. 6). In their different interpretations of the Tewa Creation Myth, Velarde's focus is Grandfather, the Story Teller, while Hardin's painting features a goddess giving birth, attended by spiritual helpers.

In "Art with a Historic Mission," Bruce Nixon notes that "Until the mid-seventies, Chicano art was largely dominated by men," who "depicted women as passive wives, helpmates and mothers, Indian princesses, Catholic goddesses, sex symbols and occasionally as betrayers like La Malinche..."[18] For many years the mixed media works of Chicana artists Yolanda Lopez and

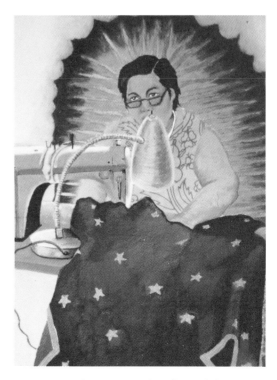

Fig. 7 *Mother: Our Lady of Guadalupe* (detail), oil pastel on paper, 28 by 32 inches, by Yolanda Lopez, 1978. Photo courtesy of Yolanda Lopez.

Fig. 8 *To the Market* (mural detail), by Mujeres Muralistas, Location Paco's Tacos, Mission District, San Francisco, California, 1974.

Patricia Rodriguez have counteracted these stereotypes. Shifra Goldman notes, "In a quest for identity and an affirmation that brown is beautiful, the Chicana has sought refuge in the image of the indigenous mother... Mother Earth." Goldman cites "the Guadalupe series of Yolanda Lopez as innovative, as she fused the Virgin with Coatlicue, 'the mother of us all.' "[19] In Lopez's painting of the Virgin of Guadalupe, she is transformed into an ordinary working woman. One image features her mother, a seamstress, seated at her sewing machine with the rays of light, ordinarily reserved for the Virgin, now radiating behind her (Fig. 7). For more than a decade, Patricia Rodriguez and the collective Mujeres Muralistas, or woman mural painters, used bright, vivid colors to paint murals on public walls such as schools, community centers, and housing projects portraying Latin American history and traditions as well as women's contributions (Fig. 8). More recently, Rodriguez and other Chicana artists have turned to altar constructions as a means of "speaking simultaneously to sexual, cultural and political issues," and to fight their way through conventional female roles as well as the even stricter sense of role within the Chicano community."[20]

Fig. 9 *Citizen 13660, pen drawing, 9 by 12 inches, by Mine Okubo, 1942. Photo courtesy of Mine Okubo.*

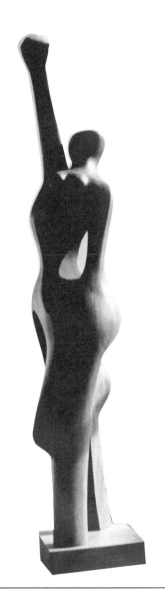

Fig. 10 Homage to My Young Black Sisters, cedar, 4 feet, by Elizabeth Catlett, 1969.

When Mine Okubo along with the 110,000 west coast residents of Japanese heritage were sent to relocation camps during World War II, she utilized her drawing skills to document this harrowing experience. They were subsequently published as a book, *Citizen 13660*,[21] (the number was her camp I.D. number), and reveal the emotional impact of the confinement, especially for mothers and children (Fig. 9). Okubo's work has evolved in a full circle: from depicting camp experiences, to a "Happy Period" of bright impressionist images of women, children, and flowers, followed by a "Primitive Period" of form simplification, emphasizing color and design. Her most recent works consist of fields of flowing color, that are her praise songs to nature and her ancestral roots. Okubo has become a significant role model for the younger generation of Asian Americans. In 1985 the Elizabeth Street Gallery, an Asian-American Cultural Center, gave Okubo her second retrospective. Dawn Aotoni points out that "Asian-Americans are composed of Japanese, Chinese, Vietnamese, Koreans, Americans and so on," but "there is a tendency for financial and critical support to be given to traditional Asian arts over contemporary Asian-American art. This tendency suggests a stereotype of a 'pure' Asian form, that one is either Asian or American, two separate identities."[22]

Elizabeth Catlett has always stood out as being "uncommonly aggressive."[23] She graduated from Howard University at a time when Afrocentric consciousness became integral to African American identity. While Catlett's prints and monumental sculptures frequently focus upon the lives and experiences of Black women, their emotional impact varies. This is exemplified by the tender embracing rhythms of *Mother and Child* and a large, semi-abstract carving *Homage to My Young Black Sisters*, described by Estella Lauter in *Feminine, Archetypal Theory* as a "militant image."[24] In *Homage* (Fig. 10), a tall, proud woman stands with her clenched fist held high, signifying Black unity and resistance

Fig. 11 *Pieta* (detail), acrylic, 48 by 62 inches, by Nives Kavuric-Kurtovic, 1986.

to oppression. Molefi Kete Asanti seems to be describing Catlett in his book, *Afrocentricity*, when he says:

> Artists in every society seek to express in their works what is natural to them. Why should the Afrocentrist using the natural concerns of his/her cultures be considered provincial? For us, the only provincial art is that which has no function for the people... A committed and functional art advances the people and enhances the culture.[25]

It is ironic that Lippard views the exclusion of artists of color from the mainstream as a "mixed blessing," because, "drawn to the illusory warmth of the melting pot, and then rejected from it, they have frequently developed or offered sanctuary to ideas, images, and values that otherwise would have been swept away in the mainstream."[26]

In *Reimaging America* Ricardo Morales asserts his belief that "artists have a tremendous power to choose what we say. This art becomes conscious dream-telling, responsible creation with the potential to affect the life of our people... by overcoming alienation... identifying the forms of internalized oppression, and... to consider the best ways to attack them."[27]

Art and Nationalism

While Yugoslavia is currently undergoing changes related to ethnic conflict and nationalism, the artists Nives Kavouric and Milenah Lah, both interviewed in 1986, offer us a view of Eastern European women's changing position in society that remains current and relevant. In defining nationalism, Josiah Cobbah simply states "We usually fall back on our birth connections. This is nationalism."[28] However, Elizabeth Minnich warns, "Those who take the provisions of any specific established culture's history, religion, political-economic system to be fundamental, necessary and necessarily right for all humans, turn our differences from interesting distinctions into divisions, boundaries into barriers."[29]

Nives Kavouric-Kurtovic courageously strips away social facades as she breaks from the conventional portrayal of women as benign madonnas, nurturing mothers, stoic peasants, or attractive socialites. Instead her large, expressionistic canvases explore the arena of interpersonal relationships, the patriarchal family, and women's sexuality. In one painting from her startling series *Blankets for Dreams without Sleepers*, an anguished woman cradles a long loaf of bread against her chest like a child. The artist explains that formerly bread was baked at home, but now it is mass produced, like children, who are ideologically inculcated by their state education rather than the family's values (Fig. 11).

Milenah Lah's stone figurative sculptures and mixed-media works soar beyond conventional concepts. This is exemplified in her life-size marble sculpture of the madonna for a Dubrovnic chapel. This seated madonna seems to rise upward, as she is propelled by multiple circular auras of enlightenment that spiral above her head. This madonna symbolizes women's spiritual rather than maternal essence and contributions to society, rather than the usual maternal (Fig. 12).

In conclusion, the following comment concerning "third world" people by Barry Gaither has relevance for women nationally and internationally. He says "the most radical act that a

Fig. 12 *The Form of Experience After the Fall of Icarus* (detail),
gypsum carving, by Milenah Lah. Photo courtesy fo Milenah Lah.

'third-world' person can commit in this country is to become
one's self?" But the challenge of our nation, says Gaither, "is to
create a model that can offer a bias-free understanding of all the
peoples who make up America."[30] This challenge needs to extend
globally to counteract the devastation of ethnic conflict, the
exploitation of indigenous people, and the oppression of women.
The success of this challenge is also dependent upon women's
ongoing efforts to organize and struggle to gain access to the
power structures that dominate their lives.

I am in accord with Douglas Davidson who believes that "The
'democratic' revolution was incomplete; it is still in process and
will not be over until **ALL** the peoples and cultures inhabiting
this soil are participants in the negotiations on the definition and
practice of democracy."[31] In a process of achieving these demo-
cratic goals, women's art contributes both to the awakening of
consciousness and the mobilizing of energy as all women strive
toward making democratic aspirations a reality.

Endnotes

1 Betty LaDuke, *Compañeras: Women, Art and
 Social Change in Latin America* (San Francisco,
 Calif.: City Lights, 1985), and *Africa Through the
 Eyes of Women Artists* (Trenton, N.J.: Africa
 World Press, 1990).
2 Lucy Lippard, *Mixed Blessings* (New York:
 Pantheon Books, 1990), 11.
3 Gloria Orenstein, *The Reflowering of the Goddess*
 (New York: Pergamon Press, 1990), 86.
4 Orenstein, x.
5 J. T. Nguyen, "Rich, Poor Nations Destroy
 Earth's Resources," *Daily Tidings*, (Ashland,
 Oregon), 26 June 1989.
6 Corinne Kumar D'Souzar, "A New Movement, A
 New Hope: East Wind, West Wind, and the Wind
 From the South," in *Healing the Wounds: The
 Promise of Ecofeminism*, ed. Judith Plant
 (Philadelphia, Pa.: New Society Publishers,
 1989), 32.
7 Ibid., 32.
8 *Indigenous Women's Network* (Lake Elmo, Minn.:
 Indigenous Women's Network, 1990).

9 Orenstein, 74.

10 Sabrina Sojourner, "The Goddess Heritage of Black Women," in *The Politics of Women's Spirituality*, ed. Charlene Spresnak (New York: Doubleday, 1982), 57.

11 Elinor Gadon, *The Once and Future Goddess* (New York: Harper and Row, 1989), 257.

12 Robert Bersson, "For Cultural Democracy in Art Education," *Art Education* 37 (November 1984): 42.

13 *The Battle of Ideas*, (Bryn Mawr, Pa.: Intercollegiate Studies Institute, 1990).

14 Maurice Berger, "Are Art Museums Racist?" *Art in America* 78, (September 1990): 70.

15 Herbert I. Schiller, "The Corporate Art: Pitchers at an Exhibition," *Nation* 249 (10 July 1989): 597.

16 Lippard, 6.

17 Lucy Lippard, "Double Vision," in *Women of Sweetgrass, Cedar and Sage: Contemporary Art by Native American women,* ed. Harmony Hammond, Lucy Lippard, Jaune Quick-to-See Smith, Erin Younger (New York: Gallery of the American Indian Community House, 1985).

18 Bruce Nixon, "Art with an Historic Mission," *Artweek* 25 (27 September 1990): 1, 20.

19 Shifra Goldman, *Arriba* (Austin, Texas, October 1983).

20 Nixon, 20.

21 Mine Okubo, *Citizen 13660* (1946; reprint, Seattle: University of Washington Press, 1973, 1985).

22 Dawn Aotoni, "Bone by Bone: How and Why to Research the Work of Asian-American Women Artists, *Heresies* 7, no. 1 (1990): 52.

23 Samela Lewis, *The Art of Elizabeth Catlett* (Los Angeles, Calif.: Museum of African American Art and Hancraft Studios, 1984).

24 Estella Lauter and Carol Schreier Rupprecht, *Feminine, Archetypal Theory* (Knoxville: University of Tennessee Press, 1985), 77.

25 Molefi Kete Asanti, *Afrocentricity* (Trenton, N.J.: Africa World Press, 1989), 83.

26 Lippard, 5.

27 Ricardo Levins Morales, "The Importance of Being an Artist," in *Reimaging America*, 23.

28 Cobbah, 25.

29 Elizabeth Minnich, "On Some Meanings of Community and Culture for Women," *Network* 10, no. 1 (1990): 22.

30 E. Barry Gaither, *Inheriting the Theory: New Voices and Multiple Perspectives on DBAE* (Los Angeles, Calif.: Getty Center for Education in the Arts, 1989), 27.

31 Douglas Davidson, "Black Culture," *Network* 10, no. 1 (1990): 19.

Art,
Ecology,
and
Spirituality

Borneo

Weaving Sacred *Pua* and Rain Forest Ecology

SACRED *pua*, intricately designed ceremonial blankets woven by the Iban women of Borneo, are intimately related to their community's survival in the tropical rain forests. After centuries of adaptation to this environment—living in longhouse communities, cultivating paddy or hill rice, and *pua* weaving—the Iban future is now threatened. This was evident during my 1980 visit to Sarawak, located in eastern Borneo, and Kalimantan, in western Borneo, as lumber companies from Japan, Europe, and the United States were rapidly destroying thousands of acres of forest by harvesting the hardwood trees for commercial export.

There is growing international awareness of the importance of the rain forests as they "produce 40% of the world's oxygen and hold over half the world's wild animals, plants and insects. One out of four pharmaceuticals comes from a plant grown in the rainforest."[1] However, the forest inhabitants are often overlooked, as the Prince of Wales noted:

The main focus of concern must be on the remaining tribal people for whom the tropical forest has been their home for many generations. Their story... is one of which we must all be profoundly ashamed. The people of the so-called "developed world" have always treated tribal people as total savages, be it to enslave them, subdue, "civilize" them, or convert them to our way of religious thinking... even now, that dreadful pattern of collective genocide continues...[2]

In 1971 Leigh Wright predicted in *Vanishing World, The Ibans of Borneo*, that within "the next two decades the old life will probably have gone for good. The Borneo world that has endured in all its strangeness and charm, its illogicality and its curious order, in its glorious island setting will disappear..."[3] However, I was glad to discover that the past and present remained intertwined: Dyaks with extended earlobes and traditional body tattoos wore Harley Davidson tee shirts; *pahuas* or paddle boats with painted tiger's eyes to ward off evil rode upriver beside outboard motorboats; and skulls from former head-hunting ventures adorned the longhouses alongside John Travolta posters. I not only saw aspects of Dyak culture intact, exemplified by the women's weaving, beadwork, and embroidery, but, even more encouraging, I learned of indigenous organization and resistance to cultural assimilation and exploitation.

Fig. 1 *Borneo Landscape*, pen drawing, 11 by 14 inches, 1980. Betty LaDuke.

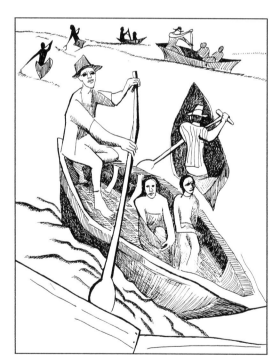

Fig. 2 *Rejong River*, pen drawing, 11 by 14 inches, 1980. Betty LaDuke.

Borneo: A Brief Overview

During the colonial period, Borneo, the third largest island in the world, was divided into four nations, Sarawak, Sabah, Brunei, and Kalimantan. In the 1600s the Dutch monopolized trade relations in Kalimantan, while the English controlled Sarawak, Sabah, and Brunei. The colonial presence dominated until 1945, when strong nationalist movements culminated in wars for independence. By 1963 Kalimantan was incorporated into Indonesia; while Sarawak and Sabah became independent, Brunei remained a British Protected Sultanate until the mid-1980s. However, the position of Borneo's two million indigenous peoples did not improve within the new nation states, as their land, with its vast resources of timber and oil, was appropriated for national and international economic expansion.

Borneo is crossed by the equator and receives an average annual rainfall of 125 inches. In this hot and humid climate, most inhabitants live along the coast, with rivers serving as high-

ways. Rivers provide the only means to penetrate the jungle interior to reach the Land Dyaks in Kalimantan and the Iban or Sea Dyaks in Sarawak (Figs. 1, 2, 3). Dyak is a general term for the Iban, Penan, Ot, Danum, Ngadju, Kenyaj, Kayan, Bahau, etc. Among the other dominant groups which compose Borneo's six million population are the Malays, who are Moslems. They comprise forty percent of the total and have political power.

The Chinese, the second dominant group, first came to Borneo in the early centuries as traders, seeking exotic items such as rhinoceros horns and bezoar stones for aphrodisiac and medicinal purposes, the ivory beaks of the hornbill birds for carving, and nests of the swiftbird for making a gourmet soup. They traded bronze gongs, coins, silk, thread, beads, and porcelain jars for food and water storage. Later, their immigration was encouraged by the English as a cheap labor resource for cultivating the pepper, rice, and rubber plantations in Sarawak and the Dutch gold mines in Kalimantan. Through the centuries, the Chinese succeeded as business entrepreneurs and now control Borneo's economy.

To the Dyaks the land is "life and blood," as they consider it "a living entity with a sacredness of its own." Not only does the land provide for their material needs but "they also share a spiritual relationship with it... as it is... the school-house of their children and the resting place of their ancestors"; "the land gives life and meaning to their whole being."[4] In addition to fishing, hunting, and the collecting of fruits, ferns, and mushrooms, the Dyaks practice slash-and-burn rice cultivation based upon periodic clearing of the hilly jungle terrain. After one or two years of planting, the soil nutrients are depleted, requiring the land to remain fallow for at least ten years before replanting. Therefore, Dyaks continually seek new land to clear and farm cooperatively, which has created patterns of migration or "wandering."

In *Natives of Sarawak*, Evelyne Hong asserts that very little timber "goes up in smoke" when the land is cleared because many trees are needed for longhouse construction, boats, and farm implements; "the total amount of virgin jungle cleared in any one year is almost infinitesimal." In many sections of the Asian tropics there is "no other system of greater efficiency... swidden is not as destructive of primary forest and as wasteful as it is made out to be."[5]

The Dyaks live in longhouses containing as many as five hundred people (Fig. 4). Composed of individual family rooms or *biliks*, each approximately twenty by thirty feet in size, the longhouse is built fifteen feet above the ground. Two notched logs serve as stairways along either end of the outer deck or *tanju* and can be quickly lifted up in case of danger. The *tanju* is like a village main street where communal activities occur. These include the daily pounding and winnowing of rice prior to cooking it over a raised clay-covered hearth in the family *bilik*. Outside each *bilik* is an enclosed verandah, considered the men's space, where they smoke, plan communal work, arrange ceremonies, or rest. After the rice harvest, the women also weave their *pua* on the *tanju*.

Fig. 3 *Dyak Market*, pen drawing, 11 by 14 inches, 1980. Betty LaDuke.

Fig. 4 *Rumah Rawing Longhouse, Sarawak, Borneo*, 1980.

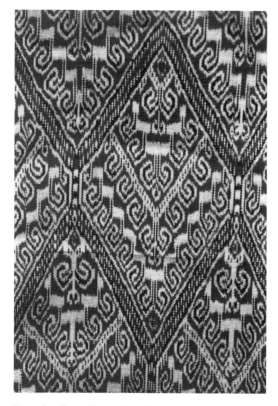

Fig. 5 *Iban Pua*, detail.

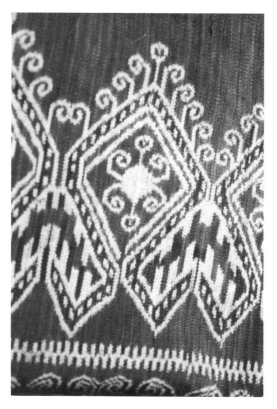

Fig. 6 *Iban Pua*, detail.

Sarawak: Weaving the Sacred Pua

Dyak weaving is mythical, magical, and technically complex. While Dyak weaving incorporates ancient spiral and rhombus patterns from China and North Vietnam, they have also developed their own motifs. In addition to insects, animals, and plant forms (Figs. 5, 6), there are humans and spirits. These figures frequently incorporate the birth motif.

Max Allen describes the "birth symbol in traditional women's art" as an ancient representation of the Great Goddess, that "in its simplest form consists of a diamond with pairs of lines projecting like arms and legs from its top and bottom vertices." Allen also raises some disturbing questions concerning the historical documentation of this symbol, which is a consistent Dyak motif.

The earliest religious practices involved the veneration of the female principle; in the beginning, God was a woman. Traditionally, the art of women—almost universally rendered in textiles—has been concerned with the preservation and communication of spiritual and cultural values... Art history has ignored the special aesthetic productions of women, labelling them crafts. Similarly psychoanalytic studies of art have missed women's work almost entirely. Phallic symbolism has been widely analyzed, but women's conceptions of the reproductive force have remained mostly invisible to scholars. In spite of the fact that the birth symbol is still the single most frequently occurring iconic motif in Eurasia and Indonesia, it has never before been systematically described.[6]

According to a Dyak creation myth "the unborn child is offered a spear or a weaving implement. The choice between the spear of manhood or the weaver's tool of womanhood pre-determines sex."[7] By age thirteen, girls are taught to weave baskets, and, soon after and prior to their marriage, they are taught by their mothers and grandmothers to weave cloth. Experimentation and the development of new designs are encouraged, and "some of the women say that the patterns originally were interpretations of dreams."[8]

Pua designs are related to their intended use. For example, *pua* are not only worn over the shoulders as a protective cover by the priests during healing ceremonies and dream chants, but become curtains to protect the sick, to shelter the body of a relative during the funeral ceremony, to create privacy for newlyweds, or to veil structures containing charms and offerings at agricultural festivals. "The function of the textile is twofold. It at once becomes the means for transcendent experience and provides the protection needed at dangerous times."[9]

In another myth, "a raja's wife covers a *bankit* tree with a large cloth, from underneath which men and women are born."[10] Birthing practices require that the newborn infant is laid upon a cloth and a *pua* is also used during the child's first ceremonial bath. John Wilson who lived with the Iban as a teacher and community worker from 1948 to 1968, observed that after a woman gives birth,

> The infant has a hand woven blanket draped over it like a tent, preventing the evil spirit from seeing it (or much air getting in), and over mother and child is suspended a fishing net to trap that spirit in the shape of a bird which

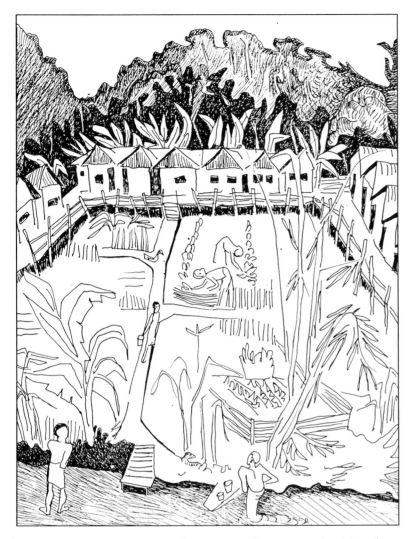

Fig. 7 *Rumah Rawing Longhouse*, pen drawing, 11 by 14 inches, 1980. Betty LaDuke.

swoops down to carry off the baby's soul unless the mother stays awake to guard it for the whole of the first two nights.[11]

Pua are part of the elaborate gift exchanges during the wedding ceremony and are placed over the shoulders of the newlyweds to join them. In the past, young Iban warriors were required to prove their virility by presenting their future brides with an enemy's head, and a *pua* was used to receive the head and weapons, "thus honoring the brave who died. The predominant use of skulls, faces, heads and whole human figures in the motifs of the Iban ikat cloths attests to this connection."[12] The missionary William Howell noted in the *Sarawak Gazette* in 1912 that

a Sea Dyak or Iban bachelor, in order to win the affections of a maiden, must needs get a head first; similarly the Sea-Dyak maiden, to win the affection of a bachelor, must needs be accomplished in the arts of weaving and dyeing.[13]

The skulls were suspended from wood carved poles on long-

Fig. 8 *River Bath*, Sarawak, Borneo, 1980.

Fig. 9 *Rumah Rawing Hospitality*, pen drawing, 11 by 14 inches, 1980. Betty LaDuke.

Fig. 10 *Indai Langit*, pen drawing, 11 by 14 inches, 1980. Betty LaDuke.

house verandahs. Since "spiritual power was thought to reside in the head of the victim,"[14] the skulls were ritually fed rice during celebrations honoring the God of War. In Sarawak head hunting was repressed in 1841, at the beginning of the long reign of James Brooke, the White Raja, as it interfered with trade, commerce, and agricultural development.

Since most accounts of head-hunting usually come from colonists, missionaries or anthropologists it was refreshing to find an indigenous perspective. The 1988 Report of the Indigenous Peoples Forum states that head-hunting is "the result of lapses on the part of indigenous peoples when they allowed opportunistic elements among themselves to re-define indigenous social relations to serve their own needs, be it gender or class needs."[15] The report also notes that in weaving "the very laying out of the yarns was compared with head-hunting and called 'the warpath of the women.'"[16] In discussing the form and content of Iban textiles, Gittinger states:

> The key to the significance of the *pua* for the Iban may be in the sanctification conferred by myth, which assigns distinctive powers to particular textiles and enhances all Iban cloth with a special aura. Myth thus defines the major Iban textiles: the jacket, the woman's skirt (*bidang*), and the *pua*. It also gives a sacred source to the major cultural practices.[17]

To create a ceremonial *pua* in the *ikat* technique (approximately four feet wide by eight to ten feet long) the warp threads are first processed on a tying frame. They are tied with strips from the lemba plant coated with bee's wax before being submerged in a series of deep red, brown, blue, and black dye baths, which establish the design before it is woven on a back strap loom. Few women possess the knowledge to make certain vegetable dyes, which constitutes a highly specialized skill.

Some affirm that they learned the Iban art from a fairy goddess whose name means "She who knows the secret of measuring out the dyes in order to obtain the rich color." A festival with religious overtones accompanies the dyeing processes and is attended by a great number of women. The dyer is paid well with pottery, beads, jewelry and fetishes.[18]

The vegetable dyes come from local sources: browns come from the jackfruit tree, mangrove tree, and enkerebai leaves; reds are from mengkudu root bark and ratan resin; blue is obtained from tumeric roots and indigo leaves; and black comes from the large leaves of the mlastomacer plant. Formerly synthetic dyes were used only for the outer decorative *pua* stripes, but in recent years commercial dyes are utilized by some weavers for the entire *pua*.

The large ceremonial *pua* are composed of two equal sections that are stitched together. "There are no short-cuts to producing a fine textile," as they are a result of the weavers' "intuitive and psychic realms, reflected, for example, in the importance of trance, dreams, concepts of maintaining social and spiritual harmony by propitiations to the spirits." Gittinger notes the power of some of Indonesian textile imagery "to reach out across time and culture to touch and affect us visually and emotionally derives at least partially from this deep-rooted focus on inner feeling and the ability to manifest and express this feeling in ritual and art."[19]

Pua are integral to the ten ceremonies held for each stage of rice cultivation which is "at the heart of Iban religion and Iban life."

Fig. 11 *Apai Langit, Rumah Rawing Longhouse Chief,* pen drawing, 11 by 14 inches, 1980. Betty LaDuke.

Wright notes that "for the Ibans, everything connected with the rice cycle is ascribed to the well-being or unhappiness of the indwelling rice spirits. Attention is given to ritual rather than agronomy."[20]

Men are responsible for clearing the jungle with knives and small axes and burning the piled-up branches and underbrush. For planting, men poke holes in the earth with pointed sticks and are followed by women who drop the rice seeds in. However, the arduous task of weeding during the five-month growing season is primarily women's responsibility, as is harvesting. In addition, vegetables with shorter growing seasons like maize, cucumbers, peppers, squash, and pumpkins are planted between the rice plants, at the edge of the field or on plots close to the longhouse. Prior to harvest, men help protect the crops from large predators and then help carry the heavy baskets filled with harvested rice to the longhouse.

Fig. 12 *Indai Richards Bilik,* pen drawing, 11 by 14 inches, 1980. Betty LaDuke.

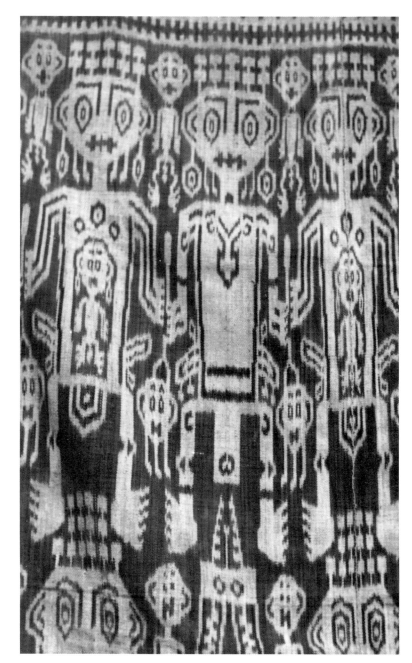

Fig. 13 *Pua with a Birthing Image* by Indai Richards, Rumah Rawing Longhouse, Borneo, 1980.

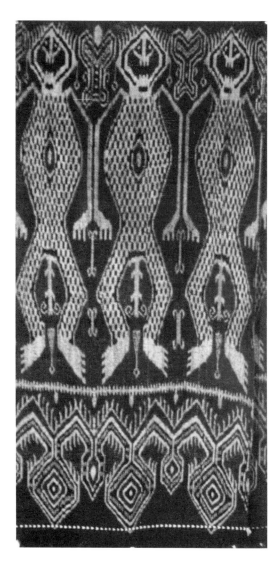

Fig. 14 *Pua* by Indai Richards, Rumah Rawing Longhouse, Borneo, 1980.

Throughout the growing season when ceremonies are held to placate the soul of the rice (Festival of the Whetstones, First Augury Confirming the Site, Wishing the Burned Site, Planting Sacred Rice, Tabooing the Fields, Harvesting and Storing Rice), *pua* are draped around the tools, altars, or whetstones. Tabooing the Fields consists of a ritual offering to the insect, rat, bird, and animal spirits, supplicating them to eat the offerings of rice cakes and eggs instead of the growing rice plants and then to leave for the sea.

The Rumah Rawing longhouse in Sarawak is one of the few communities where the sacred *pua* are still woven. *Pua* are now

collectors' items, as noted by Joseph Fischer in *Threads of Tradition*:

> Largely ignored by the outside world until after 1920, Iban textiles are today eagerly sought by museums and collectors. The heirloom cloths are being traded or sold. The status, beliefs and head-hunting traditions which were underpinning have died out or changed. Many of the skills still remain and the textiles are still being made, but their future under the impact of "modernization" is uncertain and precarious.[21]

The Rumah Rawing Longhouse Weavers

Leaving Kuching, the bustling port city and capital of Sarawak, one takes a small covered passenger express boat for the five-hour, 150-mile journey along the Rejong River to Sibu and then on to the small town of Kapit, our destination. Six kilometers from Kapit, the Rumah Rawing longhouse, with approximately 350 residents, is located along a stream. Constructed in a horseshoe shape with garden patches in the center, this is one of the very few longhouses with piped-in water. However, everyone still washes clothes and bathes in the warm river water (Figs 7, 8).

I was warmly greeted by the Iban women as Bonnie Bollwinkle, a well known missionary, accompanied me. She was also a weaver and spoke the Iban dialect. During our visits we were always offered coffee sweetened with Nestlé canned and sugared milk or spicy rice with meat sauces. According to longhouse tradition, the food offered a visitor should at least be tasted or touched in acknowledgement of its soul, so as not to offend the spirits. Although some families had couches and chairs, we sat with the women on the bamboo floor that was covered with linoleum. Upon the walls, family photographs, magazine cutouts, and posters were displayed (Figs. 9, 10, 11).

In each longhouse an elected chief and the council of elders resolve disputes and make decisions concerning alliances with other tribes, the selection of land for cultivation, and the leading of rituals and ceremonies utilizing *adat* law "a value system placing the community above all else."[22]

Among the men, skills formerly receiving social status were the working of iron at the forge, boat making, the finding of camphor, and the observation of and determination of seasons. These skills have been replaced with wage labor employment: joining the Army or police force; taking government jobs such as teachers, hospital assistants, or clerks; or working for a multinational timber or oil corporation. This has allowed the Iban to buy rice as well as participate in twentieth-century consumerism, as exemplified by Indai Richard's family (Fig. 12).

Her husband works upriver for an international corporation and operates machinery. Once a month he returns home for a brief visit. Their three children are in school, leaving Richards ample time to weave. But her daughter isn't interested; she aspires to be a secretary. In the local government elementary school, students learn Malay, the national language, English as a second language, and other academic skills. Government educators and Christian missionaries, who claim a high percentage of converts, are not promoting the Iban dialect, traditional story telling, songs, dance, or the broad range of Iban art expression

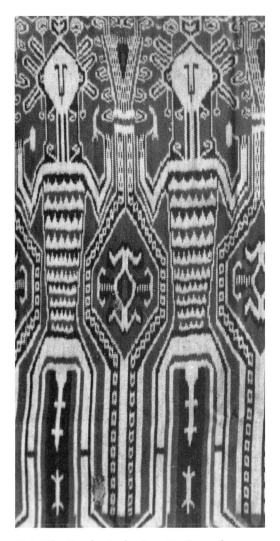

Fig. 15 *Pua* by Indai Langit, Rumah Rawing Longhouse, Borneo, 1980.

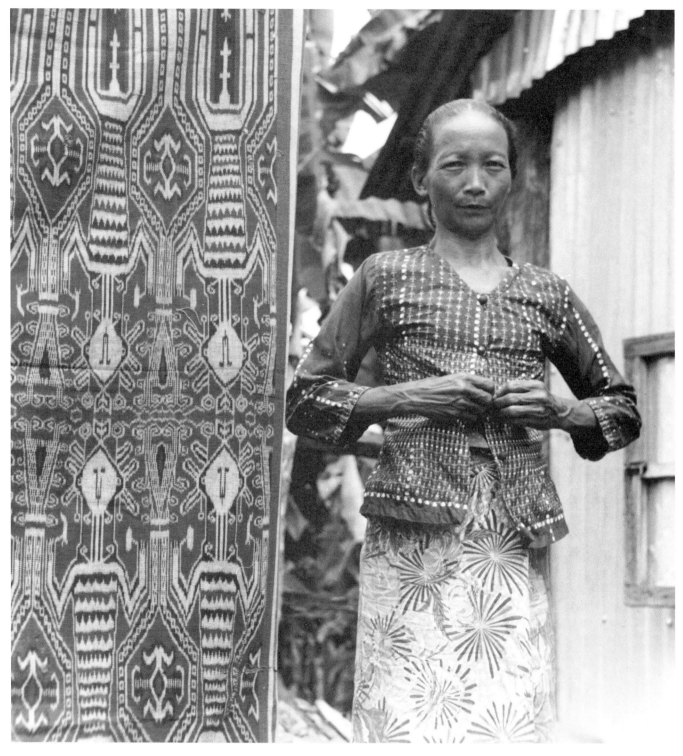

Fig. 16 Indai Langit's *Pua*, Rumah Rawing Longhouse, Borneo, 1980.

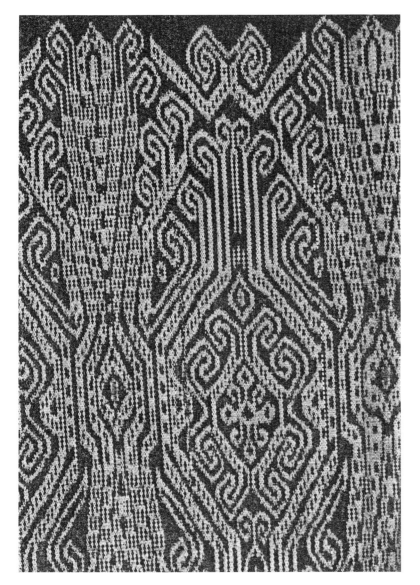

Fig. 17 *Bidang* detail by Indai Langit, 1980.

that includes beadwork, jewelry, and clothes; Ibans are encouraged to participate in the mainstream culture.

It was exciting to see Richard's large collection of *pua* from several generations. In one *pua*, themes of life and death are juxtaposed, as a child is contained within the female body while a skull is suspended from the hand of the male. According to Allen, this *pua* may have been used to "invoke spiritual assistance in regenerating the dwindling population"[23] (Fig. 13). *Orang* and *antu* or people, ghosts, or spirits were the *pua* motif of a family heirloom made by the grandmother of Indai Richards. These male figures were filled with a vibrant red-and-black checkered pattern with lizards suspended between their legs. Below the three large figures that compose one half of the width of the *pua* is a row of vibrant diamond shapes suggestive of symbolic wombs (Fig. 14).

Birthing images dominated Indai Laongit's *pua* collection along with fertility symbols: stylized crocodiles and snakes (mani-

Fig. 18 *Washing Clothes*, pen drawing, 11 by 14 inches, Kalimantan, Borneo, 1980. Betty LaDuke.

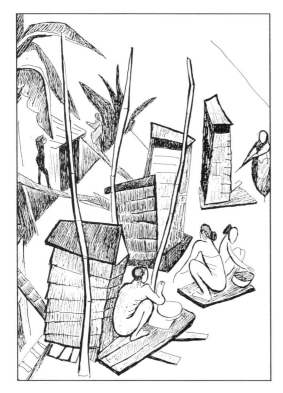

Fig. 19 *Washing Clothes*, pen drawing, 11 by 14 inches, Kalimantan, Borneo, 1980. Betty LaDuke.

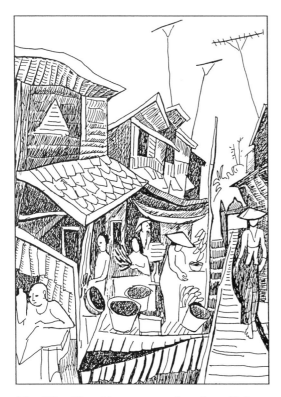

Fig. 20 *River Towns*, pen drawing, 11 by 14 inches, Kalimantan, Borneo, 1980. Betty LaDuke.

festations of demon spirits); birds (mediums between people and the spirit world); and frogs, insects, and plants. One *pua* featured an elongated series of male forms with upraised arms and lizards between their legs. Integrated between each figure was the ubiquitous diamond shape or womb symbol (Fig. 15).

The prevalence of the birthing motif, Adams notes, can be traced back at least eight thousand years in textiles from Eastern Europe, Asia, Indonesia, and the Philippines, and "even in the 20th century we can see *The Birth Symbol* woven and embroidered as a memory of the ancient status of women. *The Birth Symbol* is the female counterpart of phallic symbolism, a symbol not of male power but of life itself."[24]

In contrast to the large, bold forms of the *pua*, the women's *bidang* or skirt, is a cloth approximately eighteen inches wide and over a yard long. The stylized design of the *bidang* are vividly described by Allen as a "vegetable and animal world of growing, twirling, twisting shapes—a tangled world of shadow and motion, of the unexpected. Most designs represent spirited things, whose depiction by the weaver may imply her control, respect, knowledge or identification, and perhaps even communication"[25] (Figs. 16, 17).

At present the Rumah Rawing weavers regard their work as family heirlooms and are no longer selling *pua*s to Chinese traders or tourists. However, as cultural incentives for ceremonial weaving are declining, some weavers are producing for tourists, Borneo's most recent invaders. These simplistic suitcase *pua*s, sold in Kuching, were twenty-four by thirty-six inches and made with commercial dyes. A typical tourist theme was an isolated skull, perpetuating the Borneo head-hunting stereotype.

Nelson Graburn's *Ethnic and Tourist Arts* raises questions concerning the arts "as portable and visible" and the "increasing tendency among the artists to speak *only* to the consumer and to remove those elements of style or content that might prove contradictory, puzzling or offensive to the unknown buyer." Graburn believes that "the obvious danger here is that what is offered up today as a spurious artifact or souvenir might someday re-emerge— in the culture of origin—as an authentic representation of one's forgotten ancestors."[26] Perhaps as indigenous women continue to organize, they will realize the validity of considering the changing form and content of their diverse aesthetic expressions, its relevance for tourism, and its significance for their own cultural preservation and transformation.

Kalimantan: Dayak Beadwork and Embroidery

In Kalimantan, our 150-mile journey up the Mayakam River on an old cargo boat from Tenggerong gave us the opportunity to visit many river towns including Rukon Damai and Tanjung Isuy. These towns are built above steep, muddy banks and can be reached with notched logs or bamboo ladders. Along the river, narrow wood sheds constructed on raft platforms served as communal outhouses; nearby women wash dishes and clothes. River activity begins with the first light of dawn, as by 10:00 A.M. the intense heat and humidity slows activity until late afternoon. Only the children continue to splash and play in the warm river water (Figs 18-22).

In contrast to other relocated Dyak villages, Rukon Damai

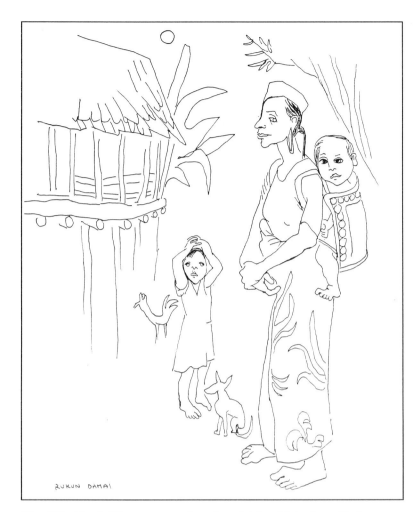

Fig. 22 *Dyak Woman*, pen drawing, 11 by 14 inches, Rukon Damai, 1980. Betty LaDuke.

had three small longhouses, each with decorated rice storage barns beside them. Mothers still carried babies on their backs in traditional bead-decorated baby carriers. Older men and women had long, extended ear lobes, body tattoos, and wore traditional garments; the younger generation preferred store-bought clothes (Figs. 23-25).

Rukon Damai village was formed in 1975. It is the result of the Indonesian government transmigration scheme, which forced thousands of families from the densely populated island of Java into the less populated areas of Kalimantan, East Timor, and Irian Jaya. From the indigenous perspective, "the Indonesian government considers 'non-material, animistic' cultures a 'threat to national integrity and diminutive of the country's progressive image.'" In their attempts "to create 'one kind of man' in Indonesia,"[27] the one million Dyaks who lived in the jungle interior had to be controlled, and they were systematically forced from ancestral lands to single family homes along more accessible rivers.

At Rukon Damai, the Dyaks reconstructed their village in traditional longhouse style, and, although they had learned to cultivate irrigated rice, they consciously tried to maintain cultural traditions. They had initiated the position of a second village chief whose role was to preserve Dyak traditions by establishing

Fig. 21 *Children*, pen drawing, 11 by 14 inches, Rukon Damai, 1980. Betty LaDuke.

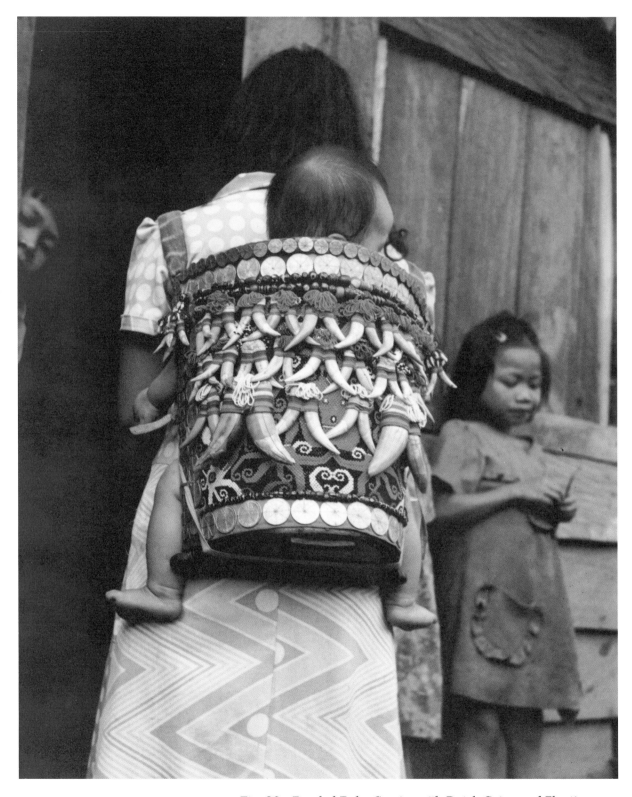

Fig. 23 *Beaded Baby Carrier with Dutch Coins and Plastic Teeth*, Rukon Damai, Borneo, 1980.

Fig. 24 *Beaded Baby Carrier* (detail), photo by Kirk Wall.

ceremonial dates, teaching the dances to the younger genera-
tion, coordinating food preparation, and overseeing the storage
of the elaborate ceremonial garments and musical instruments
in a "culture house."

Electricity and televisions, prevalent in many river towns,
had not yet reached Rukon Damai. There was a government ele-
mentary school and two small shops where packaged foods,
flashlights, and clothes were sold. As Rukon Damai had experi-
enced only twelve foreign visitors that year, the five women on
our tour were warmly welcomed and invited to sleep in a small
guest house.

Throughout our visit the bright-patterned beadwork on the
back of the women's baby carriers captivated my attention, and I
gradually began to understand why beads were viewed as
"miniature bundles of secrets waiting to be revealed,"[28] and "the
earliest evidence of abstract thinking... as they could render in
material form concepts of prestige, prowess, protection and
beauty."[29] Baby carriers, considered the resting place for the
child's soul during the first few months of life, were composed of
a wood seat with sides and back constructed from woven rattan,
and shoulder straps for the mother. The beadwork panel, ap-
proximately fourteen by eighteen inches in size, is stitched to a
cotton cloth cover that fits over the rattan (Fig. 26).

It takes approximately three months for an experienced

Fig. 25 *Rice Storage Barn*, pen drawing, 11 by 14 inches, Rukon Damai, Borneo, 1980. Betty LaDuke.

woman to complete the symbolic bead decoration, which in former years signified the parents' social class as well as the child's sex. A stylized human figure, tiger, or hornbill bird was used by upperclass women, while the dog, deer, lizard, shrimp, or scorpion were designated for the lower class, but these distinctions are no longer enforced. "Shells, beads and the teeth of bears, crocodiles, and pigs—animals with protective spirits—are often suspended from the wooden carrier to make a rattling sound, which frightens away evil spirits. An uneven number of teeth indicates the infant is male."[30] However, in recent years Dutch coins and plastic tiger teeth frequently replace shells and animal teeth.

Beads, which formerly came to Borneo from Arab, Indian, and Chinese traders as early as the first century, are now imported from Hong Kong, Malaysia and Yugoslavia. Bead colors have symbolic designations: green represents jungle vegetation; pink signifies bravery; blue is the color of life; and yellow stands for royalty. White is prevalent in the swirls of the *aso* motif, "a stylized open-jawed dragon that frightens away evil spirits."[31] The continued creation and use of the traditional beaded baby carrier in Rukon Damai remains a source of pride for the Dyak women of the Kenyah tribe. The baby carriers are not produced commercially, and most of the old ones are kept as family heirlooms.

Fig. 26 *Beaded Baby Carrier*, Rukon Damai, Borneo, 1980.

In the village of Tanjung Isuy, the Bahau Dyaks live in individual homes but have constructed a longhouse for traditional ceremonial occasions and tourist accommodations. Another longhouse was maintained as a craft center for the production and sale of embroidered cloth, wood carvings, and bark fiber vests which provided an additional source of income (Fig. 27). The needle has been in use since pre-historic times, but Bahau embroidery depends upon the use of manufactured cloth and thread introduced through contact with Chinese traders. In the past, these traders were the Dyaks' only connection with the outside world.

For everyday use, many Bahau women wear dresses, but we saw traditional garments during a ceremonial performance. I was particularly impressed by the wrap-around skirts designed from commercial cloth composed of a wide black waistband, bright red side panels, and a white central panel intricately embroidered with floral forms. Variations of this colorful floral motif produced as separate panels, approximately twelve by eighteen inches, were available for purchase (Figs. 28-31).

The growing number of foreign oil and lumber technicians as well as the increasing number of tourists have spawned interest in Dyak art forms, primarily as souvenirs, which has stimulated their production. The Bahau women have pride in their creativity and appreciate the money it now generates.

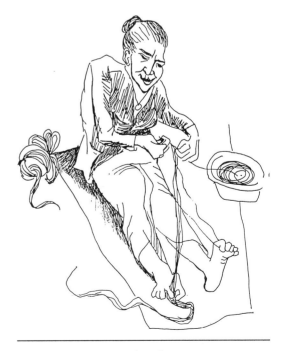

Fig. 27 *Spinning Fiber for Weaving*, pen drawing, 11 by 14 inches, Tanjung Isuy, Borneo, 1980. Betty LaDuke.

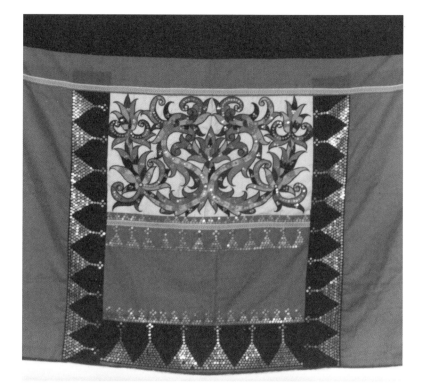

Fig. 28 *Embroidered Skirt*, Tanjung Isuy, Borneo, 1980.

Borneo: Cultural and Environmental Survival

Most people from industrialized nations view others as poor or deprived if they are satisfying basic needs through self-provisioning mechanisms. But our world environmental crisis necessitates reconsideration of our relationship to the earth and its finite resources and learning from those who have lived for centuries in harmony with nature. In the international arena, organizations such as Survival International and Cultural Survival have taken action to educate the public "with activities such as representations at the United Nations, letter writing campaigns aimed at the Malaysian Government and logging companies, fact-finding missions in the area and petitions."[32] They have also reported that unsuccessful Dyak resistance to logging operations by legal means, led to the construction of log barricades as a means of protest often followed by arrest and imprisonment. But this has not deterred the Dyaks from their resolve "to unite and press on with the defense of their forests and land rights."[33]

The Dyaks and indigenous peoples throughout Asia are continuing to organize and act on their own behalf. One example is by the United Nations Working Group on Indigenous Populations, or The Working Group (WG), created in 1982.

Its sessions each year represent the most significant international gathering of representatives of indigenous people all over the world, to exchange their experiences and views. The mandate of the WG is to "monitor the developments pertaining to human rights and to give special attention to the evolution of international standards concerning the rights of indigenous people."[34]

The recognition that the position of indigenous women

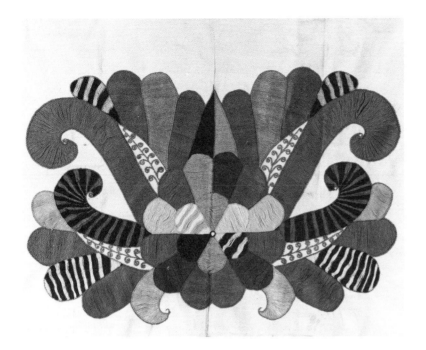

Fig. 29 *Embroidery*, detail, Tanjung Isuy, Borneo, 1980.

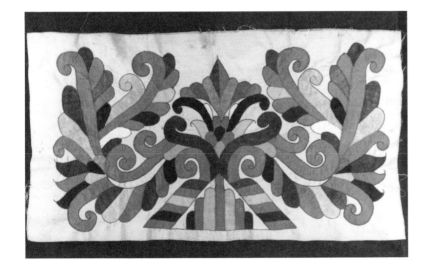

Fig. 30 *Embroidery*, detail, Tanjung Isuy, Borneo, 1980.

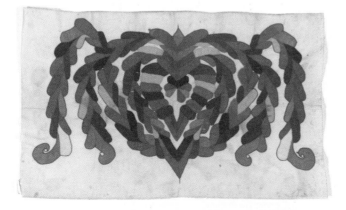

Fig. 31 *Embroidery*, detail, Tanjung Isuy, Borneo, 1980.

Endnotes

1 *Clear Actions* (Ashland, Oregon: Peace House, November 1990), 5.

2 Charles, Prince of Wales, *The Rainforest Lecture* (London: Survival International, 1990).

3 Leigh Wright, Hedda Morrison, and K. F. Wong, *Vanishing World: The Ibans of Borneo* (Tokyo, Japan: John Weatherhill and Serasia Ltd., 1971), 22.

4 Colin Nicholas, ed., *Indigenous Peoples in Asia, Towards Self Determination*, Report of the Indigenous Peoples Forum, Chiengmai, Thailand, August 1988 (Bombay, India: Asia Indigenous Peoples Pact, "Prakash Nivas," Dr. Charat Singh Colony, Andheri East), 11.

5 Evelyne Hong, *Natives of Sarawak, Survival in Borneo's Vanishing Forests* (Penang, Malaysia: Institut Masyarakat, 1989), 24, 25.

6 Max Allen, *The Birth Symbol in Traditional Women's Art from Eurasia and the Western Pacific* (Toronto: Museum for Textiles, 1981), 3.

7 Michael Palmieri and Fatima Ferentinos, "The Iban Textiles of Sarawak," in *Threads of Tradition: Textiles of Indonesia and Sarawak*, ed. Joseph Fischer (Berkeley: University of California Press, 1979), 73.

8 Ibid., 73.

9 Mattiebelle Gittinger, *Splendid Symbols, Textiles and Tradition in Indonesia* (Washington, D.C.: The Textile Museum, 1979), 218.

10 Palmieri and Ferentinos, 73.

11 John Wilson, *Budu, or Twenty Years in Sarawak* (London, England: Tantallon Press, Ltd., 1969), 218.

12 Ibid., p. 73.

13 Gittinger, 219.

14 Wright, Morrison, and Wong, 58.

15 Nicholas, 21.

16 Ibid., 21.

17 Gittinger, 218.

18 Ibid., 214.

19 Fischer, 13.

20 Wright, Morrison, and Wong, 116.

21 Fischer, 78.

22 *PACT, An Occasional Newsletter of the Indigenous Peoples Pact*, no. 1 (1990): 17.

23 Allen, 75.

24 Ibid., back cover.

25 Ibid., 74.

26 Nelson Graburn, ed., *Ethnic and Tourist Arts* (Berkeley, Calif.: University of California Press, 1976), 32.

27 *PACT*, 11.

28 Ibid., 9.

29 Ibid., 26.

30 Lois Sherr Dubin, *The History of Beads* (New York: Harry N. Abrahms, 1987), 229.

31 Ibid., 230.

32 *PACT*, 12.

33 Ibid.

34 Ibid., 13. For details of the UN Working Group, contact Voluntary Fund for Indigenous Populations, Centre for Human Rights, Palais des Nations, CH 1211, Geneve 10.

35 Nichols, 20.

36 Ibid., 13.

37 Judith Plant, ed., *Healing the Wounds: The Promise of Ecofeminism*, (Philadelphia, Pa.: New Society Publishers, 1989), 49.

throughout Asia "is less than satisfactory, to say the least," proves that indigenous societies are not static. The report of a forum held in 1988 asserted; "Indigenous women, though they are equal, if not greater contributors to the production and reproduction of indigenous society, are not accorded equal status in many spheres of living, particularly in politics."[35]

Indigenous women also continue to organize; the second International Indigenous Women's Conference was held in 1990, hosted by the Sami Women's Association in Norway. Hailing from thirty-five countries and five continents, the women considered the founding of an International Indigenous Women's Council discussed indigenous women's perspectives on such issues as "energy projects, global warming, depletion of the ozone layer, exploitation of natural resources, indigenous women and racism, impact of development and neo-colonialism and co-option of indigenous socio-political structures.[36]

From an ecofeminist perspective, Judith Plant points out: When we resist the rape of the earth, we are fighting the same mentality that allows the rape of women... In our desire to save the earth... it is folly to overlook the inter-connectedness of the war on nature and the daily, often hidden war on "others"—whole cultures, women and children.[37]

In creating *puas*, beadwork, and embroidery even in modified form, Dyak women assure cultural continuity and self-pride while contributing to their families' survival. Future global survival will necessitate a renewed respect for the earth, its dwindling resources, and the indigenous peoples who can guide us toward maintaining a harmonious balance.

India

Sacred Circles, Traditional Women Painters of India

FOR MORE THAN 3,000 years, sacred circles and other magical images have been painted by the women upon the earth and the mud walls of their homes in the Mithila region of India. However, their art only gained widespread recognition when they began painting on paper in the 1960s and was recorded by the French anthropologist Yves Vequaud in *The Women Painters of Mithila*, published in 1979.[1] After seeing examples of the women's brightly patterned representations of Hindu gods and goddesses and learning of their use of the *Kohbar*, a fertility symbol related to marriage, a rite of passage uniquely celebrated in the Mithila region, I was determined to follow Vequaud's path, to gain a firsthand view of their art and culture. I also extended my research to include interviews with two modern women painters from Calcutta.

To the uninitiated, the *Kohbar* is a mere floral design, but Vequaud enthusiastically considers it "unequal in the history of the world's art—a glorious crucifixion seen on the walls of every bedroom."[2] The *Kohbar* motif consists of a vertical *lingum*, or phallic shape, which penetrates a sacred circle, frequently portrayed as a lotus. This circle is the *Yoni*, a symbol of female genitalia (Fig. 1). Vequaud states that in Mithila, a matriarchal society, "there are regular gatherings of young men to which girls who want to marry come." A small painting with the *Kohbar* design is then "used to indicate a girl's proposal of marriage to a young man she is interested in."[3] I soon learned that there were various scholarly perspectives concerning the lingum-kohbar metaphor.

My 1980 journey to the village of Jitwapur, where most of the painters reside in the Mithila region, proved to be a challenging venture. In contrast to previous travel in India when I focused on temple sites, I now experienced the village life of eighty percent of the population, or over one hundred million people. I then became more aware of the arduous rhythm of daily survival and how the creative process serves as a means of personal empowerment.

While delving into the historical aspects of Mithila painting and its persistence with minor modifications for over 3,000 years before attaining commercial popularity, I found divergent views expressed by American anthropologist, Dr. Carol Henning Brown, Pupul Jayakar, an Indian scholar and former director of

Fig. 1 *Kohbar* (detail), by Bhuma Devi, ink on paper, 12 by 13 inches, 1980.

Fig. 2 *Landscape from Train Window*, pen drawing, 11 by 14 inches, 1980. Betty LaDuke.

India's National Handicraft Board, and Vequaud. Their viewpoints are considered before concluding with personal observations of village life and the interviews with select Jitwapur traditional painters and two modern urban artists.

Historical Overview

Concern for the rhythms of nature, the magic of creation, and the continuity of all life forms are at the core of most traditional arts. In Mithila, memories of ancient events, such as migrations, wars, epidemics, and hunger have been preserved in myths and legends. These are enacted at festivals that include song, dance, and epic performances. In each household continuity with the past is maintained through the daily ritual of *Vratas* or prayers that invoke the goodwill and protection of deities. Transcending the centuries, these prayers represent a living storehouse of Mithila's history and traditions. Jayakar notes:

For the woman, as the main participant and actor of the

ritual, the Vratas were the umbilical cord which connected her to the furthermost limits of human memories—when woman as priestess and seer guarded the mysteries, the ways of the numinous female.[4]

In 1750 B.C. when the agricultural settlements of the Maitils were invaded by the nomadic, cattle-rearing Arayans, their culture was suppressed. However, this surface disappearance of "an archaic people's culture based on the primacy of the female principle secretly survived in woman's rites and fertility rituals."[5] Visual representations of Maitil culture are perpetuated through women's ritual painting upon mud walls and in *aripanas* or magical diagrams upon the earth. The act of painting was as significant as the end result. It was a means to preserve history, celebrate the immense magic of creation, and to provide psychological empowerment over the forces of good and evil.

Since the paintings are temporary, their significance is derived from the concentrated energy exerted during the process of creativity, which is also accompanied by incantations and Vratas. For the women of Mithila, Gauri, their supreme goddess, is linked to ancient tantric beliefs and

"rites centered around the physical worship of woman and the organs of sex in which the woman's body became the *Ksetra*, the enclosed field of power, the instrument of magic and transformation."[6]

The supreme visualization of the tantric doctrine of sexual unity occurs on the walls of the *Kohbarghara*, the special hut within each Mithila family compound where the bride and groom chastely spend the first four nights of their marriage chaperoned by four older women who oversee the performance of rituals. The consummation of their marriage usually occurs when the couple leave the bride's compound to live with the groom's family. The *Kohbarghara* is also the chamber reserved for childbirth.

Illuminating the *Kohbarghara* are the *lingum* and *yoni*, or bamboo shoot and lotus, symbolizing sexual encounter, love, and fertility. These are all proper themes for the bride and groom to contemplate upon their marriage, which usually occurs when the girl is between thirteen and fifteen years. Gauri's radiant face frequently appears at the tip of the *lingum* or in the interior of the six lotus blossoms that rotate around the *lingum* axis. Surrounding this central image are the earth, sun, water, trees, plants, animals, and birds, all symbols of sex, fertility, wealth, and power. Also surrounding the central image is the pond or cosmic waters with the fish, tortoise, frog, and crocodile, further symbols of fertility.

Jayakar discusses the function of the *Kohbar* which serves psychological needs during a rite of passage. She considers the *Mohaka Kohbar*, or falling in love diagram, "one of the most charming," whose purpose is "to break down barriers and to awaken desire between the bride and bridegroom who may be totally unknown to one another."

The bride and bridegroom sit before the diagram facing each other and feed each other rice and curds. The spell that accompanies the rites... is used on the fourth day of marriage when the husband and wife anoint each other's eyes and the bridegroom says, "Put thou me within thy heart, may our minds verily be together," and the bride covering the groom with her garments says, "I bridle thee with my manuborn garment that thou mayest

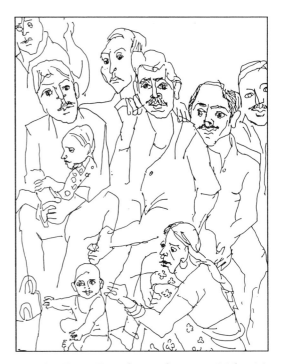

Fig. 3 *Train Travel*, pen drawing, 11 by 14 inches, 1980. Betty LaDuke.

Fig. 4 *Train, Second Class Sleeper*, pen drawing, 11 by 14 inches, 1980. Betty LaDuke.

Fig. 5 *Rickshaw*, pen drawing, 11 by 14 inches, 1980. Betty LaDuke.

be wholly mine, mayest not make mention of other women."[7]

Disturbed by Vequaud's narrow interpretation of the *Kohbar-lingum* metaphor, Brown consulted with the Mithila women and was told that this elongated form is a stem which roots the lotus leaf to the bottom of the pond. Brown links the Maithili word *narpuren* to placenta or afterbirth and laments that "Men never see this." For the Maithili women,

"the long stem which attaches to the bottom of the pond is a metaphoric umbilical cord... a metaphor of fertility, but it is fertility in the idiom of women—their own psychological processes—not in the idiom of men."[8]

Brown emphatically disagrees with Vequaud's classification of contemporary Mithila society as matriarchal and cites genealogical evidence for patriarchy. She considers "ridiculous" Vequaud's description of the gathering of men attended by women for the purpose of selecting a husband and explains:

"There is a gathering of boys for the purpose of arranging

marriages. Each year in June or July at Saurath in Madhubani District as many as 50,000 Maithil Brahmins per day from all over North Bihar turn out to negotiate a good marriage for their son or daughter. The boy is usually there, seated in pink embarrassment on a mat, while gatherings of the uncles of girls of marriageable age look him over, ask him questions to check out his intelligence, ambition, and piety, and dicker with his father over the dowry. This event is indeed unique for India, probably for the world, but it is not the girls who come to choose a boy."[9]

Jayakar comments on a tradition of painting on small scraps of paper as "aides-de-memoire, to teach the growing daughter the basic vocabulary of *alankara*, the ornamental forms and symbols unique to each family group and caste." There are also diagrams of fertility. "These drawings are placed in baskets along with the tumeric and kum kum that form part of the bridal dowry."[10] While Vequaud considers them as marriage proposal *Kohbars*, Brown, in accord with Jayakar, states that they are sent to the girl's house by the groom's family "as part of the extensive nuptial exchanges."[11]

The *aripanas* or magical diagrams are another form of ritual art created by women throughout India, with distinct local interpretations. Made with colored rice powders sprinkled between the fingers to form symbolic geometric designs, their function is to establish a sacred space on the earthen floor of the courtyard, the house verandah, or within the bedroom or altar room. In Mithila, the geometric patterns of the *aripanas* focus around passion, sex, and fertility. A new bride is expected to make an *aripana* every morning for several months after marriage so that her marriage will be happy. It is insignificant that the *aripana* may soon be stepped on and destroyed.

In addition to the *kobars*, Mithila wall paintings also focus on the adventures of the gods and goddesses, particularly Rama and Sita, Krishna and Radha. Their escapades are based upon the ancient epic texts of the *Ramayana* and the *Mahabhrata*. Paintings are also created for seasonal events related to agricultural practices.

Since the Mithila region is isolated, women's paintings remained undiscovered by outsiders until W. G. Archer, an English colonial officer and scholar, wrote about them in 1947 in the journal *Marg*. Brown reports:

He was the first to recognize the quality of the ceremonial wall art of *Maithil* Brahmans and Kayasthas when the 1934 earthquake broke open the rural mud houses and exposed their interior beauty to outsiders.[12]

Jayakar mentions that she first visited Mithila "in the midfifties, but the bleak dust of poverty had sapped away the will and the energy needed to ornament the home." This situation was augmented by years of drought which "accentuated the problem of finding light labor schemes for the women of the area and encouraged me to start a project to provide these women with hand-made paper on which they could paint."[13]

Sri Kulkarni assisted Jayakar with this government project and resided in Jitwapur in order to encourage the women's painting of their traditional themes upon large sheets of paper. This handmade rag paper varied in size from 24 by 30 inches to

Fig. 6 Sita Devi's House with Oxen, pen drawing, 11 by 14 inches, 1980. Betty LaDuke.

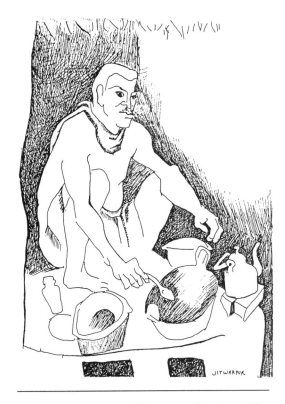

Fig. 7 *Chai or Tea Shop*, pen drawing, 11 by 14 inches, 1980. Betty LaDuke.

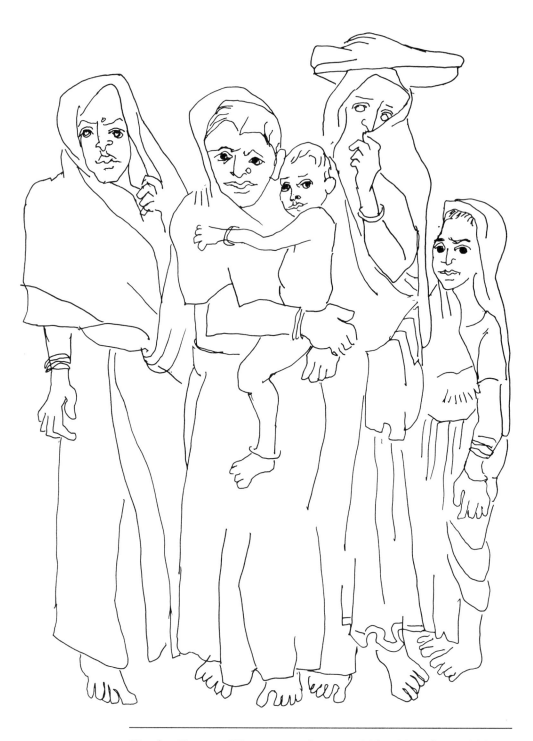

Fig. 8 *Jitwapur Women*, pen drawing, 11 by 14 inches, 1980.
Betty LaDuke.

long scrolls. Several months later when Jayakar returned from her Mithila visit, she noted:

> Old women, young women, girls, were bent over paper, painting with bamboo twigs and rags. The colours, deep earth red, pink, yellow, black, were laid out in little bowls in trays of sikki grass... A sense of pride and joy had already permeated and transformed the women of Mithila—there was visible and simple dignity, a poise and a supreme self assurance.[14]

Surprisingly, "in the midst of the grim tragedy of drought," Jayakar realized these paintings lacked "a total absence of the tragic and of the anguish, and the anxieties that are the central category of the contemporary situation."[15]

In Mithila the brewing of magical colors from plants remained a consistent activity until the 1960s when commercially powdered dyes were introduced. Gum arabic was then substituted for goat's milk or cow urine as a binder. Formerly, black was prepared from burnt wood or ashes, yellow from tumeric or the carnation flower, red from the kusum flower or local clay, and green from the bilua leaf. Cotton-wrapped twigs served as brushes. Now commercial brushes and pen and ink for outlining forms are also in use.

There are two dominant styles of paintings. The Brahmin women first outline everything with a thin black line and then fill in each form with bright color. The Kayasthas women only use red and black ink lines to create all their intricate and elaborately textured images. For both the Brahmins and Kayasthas the intense white background color of the paper functions as a significant compositional element. In contrast, Yamuna Devi, the only painter from the Harajan or untouchable caste in Jitwapur, completely eliminates the white background as her entire surface is covered with soft fluid forms and colors that are arranged within compartments. Among most painters their abhorrence of empty space is evident, as everything is filled with symbolic textures and patterns.

Commenting on the significance of the eyes, drawn in frontal position even when the face is shown in profile, Jayakar says:

> Like all rural art forms the eyes are the source of Sakti (female energy), they are the central point of power. The pupil within the eye is placed therein after the painting is complete. It is the placing of this Bindu within the eye that generates communication with the beholder.[16]

An ironic reason for the perpetuation of the women's art has been its impermanence due to the humid climate, which necessitated the constant repainting of their walls. Vequaud notes: "Creation is important; holding on to things is foolishness."[17] Jayakar disturbingly adds the following thought:

> "Tradition has sought through constant repetition to strengthen its moral and ethical codes as they relate to the duties and obligations of women. They deny a woman initiation but leave her with peripheral rituals."[18]

Mithila art and artists are no longer anonymous. As a result of outside contact, commissions and travel, their world view is gradually expanding and may eventually affect their art. These dramatic changes occurred, for some, after they began to paint on paper, making their art a transportable and saleable product. Their paintings have since been exhibited nationally and interna-

Fig. 9 *Pumping Water*, pen drawing, 11 by 14 inches, 1980. Betty LaDuke.

Fig. 10 *Preparing Chappatis*, pen drawing, 11 by 14 inches, 1980. Betty LaDuke.

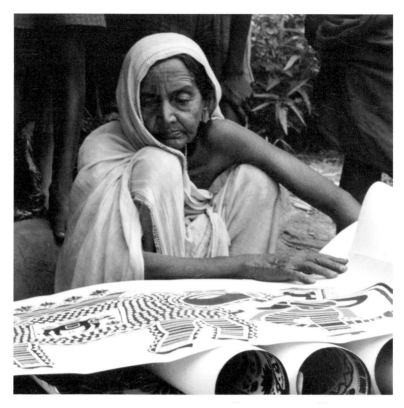

Fig. 11 Jagadamba Devi with Her Paintings, Jitwapur, India, 1980.

JAGADAMBA DEVI

Fig. 12 *Jagadamba Devi*, pen drawing, 11 by 14 inches, 1980. Betty LaDuke.

tionally, making significant impact on some Mithila villages and the women's lives.

In Jitwapur, to facilitate marketing procedures a local Handicrafts Board was formed. Paintings are left there on consignment, and the prices fixed according to categories established by the Board (men and women), in conjunction with each artist. The categories are determined by the painting's size, the artist's technical skills in rendering detail, and the artist's reputation. In recent years, tourists, entrepreneurs, and collectors from Japan, Europe, and the United States have gradually begun to visit Patna, the state capital, in order to buy at various shops, Mithila paintings. This has increased the artists' expectations of a sustained income, and, as a result, some men are beginning to paint or to assist their wives or mothers. However, increased production has resulted in an over-supply, as the market for Mithila paintings expands very slowly.

Significant attention to the Mithila region occurred when the former Prime Minister, Indira Gandhi, commissioned painters to decorate the walls of her home. Others received commissions to create murals for railroad stations and urban hotels. Elated by the commercial value and success of their work, some Mithila painters have begun to sign their work. Several Mithila artists have also been recipients of important government awards. Internationally, the mythical-magical symbolism inherent in Mithila painting is a significant topic of discourse among anthropologists.

Tantric Roots of Mithila Painting

The ancient, sexual roots of Mithila art. or "Tantrism," says Vequaud, "is like any other ethical system: everyone gets out of it what he looks for. At its lowest level there is superstition; at its highest, the self-mastery of yoga and the insistence on the supremacy of intuition." He defines Tantra as a "mystical act that claims to be able to unite people with the cosmos; Tantrism might be explained as a manner of acting and living according to esoteric principles," and "in Mithila, the tantric leaders insist that their ancestors were the first tantrikas," and that "ceremonial intercourse makes it possible for each person to approach, and perhaps understand, the primordial unity symbolized by the union of the two sexes..."[19]

> Jayakar's emphasis is upon Tantrism as earth magic: the involvement with earth, fertility and food and the primitive wonder at the transformation of seed into the living, life-giving plant had triggered the search for the explosive energy resource that generates life and change... fertility could be ensured by enacting the functions of reproduction.[20]

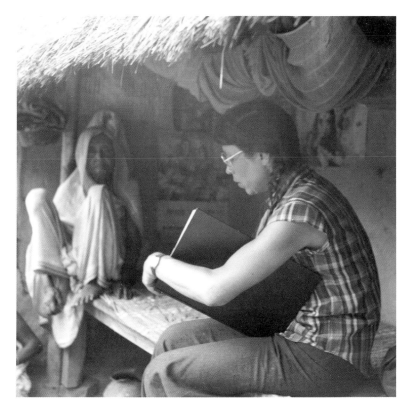

Fig. 13 Betty LaDuke Drawing Jagadamba Devi.

Jayakar describes how the Bhils, a tribal people of western India, paint their sacred Pthoras (altars) and include in an obscure corner copulating men and women. "When asked to explain, they say, 'Without this where would be the world?'"[21]

In contrast to Vequaud and Jayakar, Brown does not want

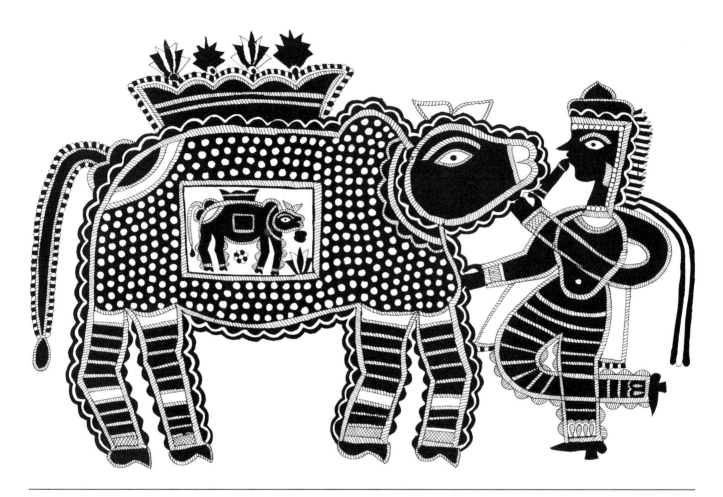

Fig. 14 *Krishna and the Cow*, Jagadamba Devi, watercolor, 22 by 30 inches, 1980.

to be considered "mean-spirited, far less expose oneself as repressed."[22] But reasons for disassociating *Kohbar* iconography from the *lingum* and Tantra are based upon her informants, the village priests and the women painters themselves. From her research she notes, "A serious problem is the fact that the women are not used to having their opinions asked... but any interpretations must start with what they can be induced to say about it." Therefore, she emphasizes the primacy of women's biology related to the pond, the womb, and the lotus leaf to emphasize fertility. "Just as the seed of the lotus falls into the pond and produces many offspring, so must the bride and groom produce many children."[23]

In considering the future of Mithila art, Vequaud recognizes a "danger that mass production will stifle the gentle breath of this art that has never been practiced for profit." His vision is that

some Mithila women will make their creative spirit known with such freedom and strength that one may hope that the "living art" so many critics speak of exists in Mithila too, and that we may even one day see a school of "modern art" develop there.[24]

Jayakar is concerned with "losing the sense of mysterious sacredness" and knowing of the Earth as the "living giving, tranquil, fragrant, auspicious Mother!" She warns us:

> The danger to rural India lies in its accepting the values and norms of a technological culture and of consumer-oriented societies and so losing communion with nature and its inexhaustible resources of energy.[25]

Brown's quarrel is with "ethnographic fabrication, unjustifiable error and phony analysis... since more and more we share the field with other experts—art collectors and film-makers—interpreters of cultures for a western clientele." Therefore, her scholarly integrity requires that "It is at least our responsibility to set the record straight when we can."[26]

Vequaud's publication perpetuates the anonymity of women artists, so that "the beauty and meaning of the paintings and the fame of the artists shall not be confused."[27] Would this rationalization have been applied to male painters? During my Jitwapur visit not only were distinct stylistic tendencies revealed in each woman's paintings but also their desire to be recognized as individuals as well.

Jitwapur Life and Art

I arrived at the village of Jitwapur in the summer of 1980 after a long, arduous journey of several days. Traveling by train from Calcutta to Patna, the capital of the state of Bihar, I had ample opportunity to sketch the broad, quilt-like landscape filled with men and oxen, contained in small patches, as they plowed (Fig. 2). The gently curved thatched roofs of mud wall homes bordered the vast, flat horizon. In the crowded train, people sat upon the floor, wherever and however they could. At the frequent station stops, numerous vendors sold locally made snacks and tea or chai. This steaming liquid was poured into small clay disposable cups and seemed almost as hot as the air (Fig. 3). At night, in the second-class sleeper, wood benches unfolded from the walls above forming six beds. A dim light then illuminated the sleeping forms of men and women while overhead a tiny fan stirred the hot air (Fig. 4).

From Patna for the next two days I took a combination of train, bus, boat, and ultimately a bicycle rickshaw, for the last four kilometers, before finally arriving at Jitwapur. As I traveled north, local dialects dominated. Therefore, I felt fortunate to find, in Jitwapur, Ram Deo Jha, a teacher who spoke some English. He agreed to be my guide and translator. He also provided me with lodging in a guest room of his mother's compound.

Ram Deo Jha's mother, Sita Devi, age seventy-two, was then in New Delhi, fulfilling a mural commission for a new hotel. I was told that Vequaud had also been a guest in this same one-room structure, which was entirely open in the front to the rhythms of community life. Solitude or privacy was non-existent. I slept on a wood cot covered with a thin cotton pad, while Ram Deo Jha's three young sons, all crowded together on a similar bed, slept near me. Meals consisted of chapatties, rice, mangoes, and yogurt served by the teacher's wife, who did not eat with us.

Jitwapur is located in a densely populated, hot, humid region south of the Nepal border. As in most villages, the Hindu temple pond and two wells were the only source of water for

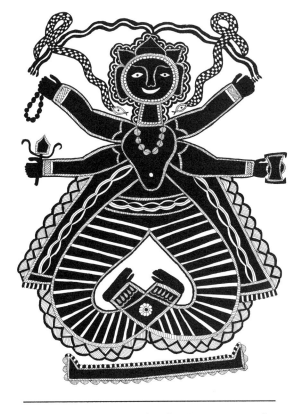

Fig. 15 *Shiva*, Jagadamba Devi, watercolor, 22 by 30 inches, 1980.

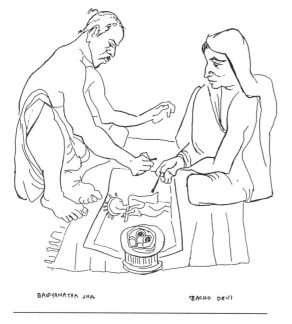

BAIDYANATHA JHA BACHO DEVI

Fig. 16 *Bacho Devi and Her Husband Painting*, pen drawing, 11 by 14 inches, 1980. Betty LaDuke.

1,500 people. The inhabitants were divided among the upper Hindu castes of Brahmins and Kshatriya and the Harajans, formerly known as "untouchables." The Brahmins and the Kshatriya are designated as priests, teachers, or merchants, while the Harajans are designated to perform the arduous labor of tilling the small parcels of land owned by the upper caste and doing other menial chores. Though they live segregated in distinct parts of the village, they all mingle at the Hindu temple and pond.

The local tea and betel nut shop are social centers as there are benches outside, and men gather there to talk. The tea or chai was prepared by a man who sat upon his adobe stove while mixing the tea with boiled milk and sugar (Fig. 7). The men chewed the betel nut which has a mildly narcotic effect. It also dulls hunger and is integral to their social life. They did not mind my joining them to drink tea and sketch, and occasionally women en route from the temple came by to observe (Fig. 8).

Each morning in Jitwapur when I awoke at 4:30 A.M. with

Fig. 17 Bacho Devi Painting, Jitwapur, India, 1980.

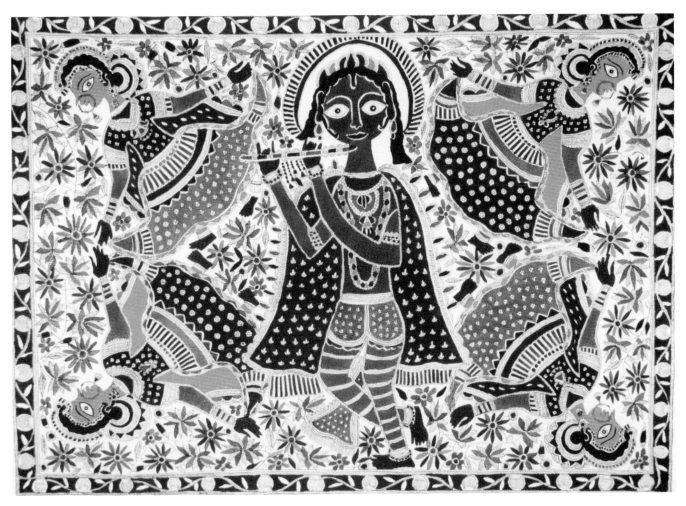

Fig. 18 *Krishna and the Gopi Girls*, Bacho Devi, watercolor, 22
by 30 inches, 1980.

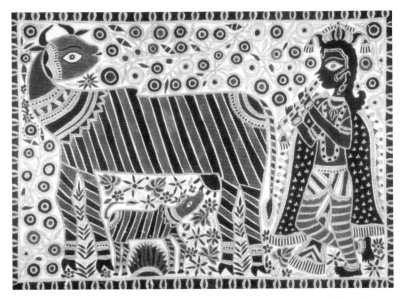

Fig. 19 *Cow and Calf*, Bacho Devi, watercolor, 22 by 30 inches,
1980.

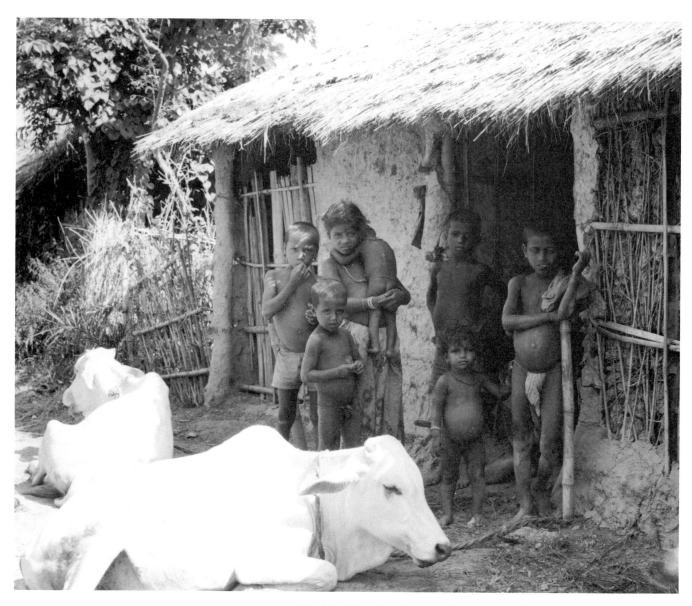

Fig. 21 Harajan Homes, Jitwapur, India, 1980.

Fig. 20 *Yamuna Devi*, pen drawing, 11 by 14 inches, 1980. Betty LaDuke.

the first rays of dawn, a procession of women was already beginning to gather at the well in front of Sita Devi's compound, waiting their turn to pump the water, an arduous activity. Then they walked slowly back to their compounds, carrying a heavy pail in each hand and a clay pot filled with water upon their heads. Morning chores began with scrubbing the courtyard of the family compound, preparing the whole wheat flour for chapatties or flat bread for the morning meal, and bathing the children (Fig. 10). Men were responsible for feeding the oxen.

When national attention began to focus on the women painters of Jitwapur, a significant improvement occurred in their community. Fifteen more water pumps were installed by the government. In recent years with the increased sale of paintings, some visible signs of affluence have made their appearance in the form of transistor radios and bicycles. While select male children are given the opportunity to receive advanced education,

Fig. 22 *Goddess and Parrots*, Yamuna Devi, watercolor, 22 by 30 inches, 1980.

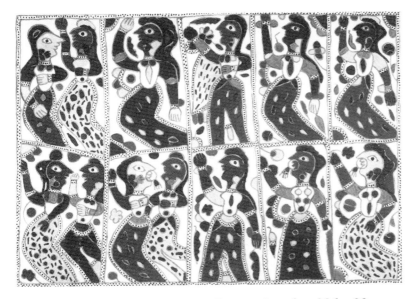

Fig. 23 *Rama and Sita*, Yamuna Devi, watercolor, 22 by 30 inches, 1980.

Fig. 24 Giraj Devi, Jitwapur, India, 1980.

the literacy rate for women has remained at fifteen percent.

Painting is not an isolated event but has always taken place in the midst of the family activities. When possible, the women paint between two and four hours each day and it may take several days or more to complete a painting, based on the amount of detail. They work on the raised mud porches of their homes, seated on mats which extend underneath their paper. The women work with intense concentration, sometimes with sleeping babies on their laps or while nursing. In interviewing the following artists, I also began to appreciate their stylistic differences within this traditional form of expression.

Jagdamba Devi

Jagdamba Devi's frail health and failing eyesight at age 80 do not keep her from painting (Fig. 11). Jagdamba was married at thirteen but within the year was a childless widow and did not remarry. Painting became an important part of her life, and ten years ago she was the recipient of the National Award for Artists

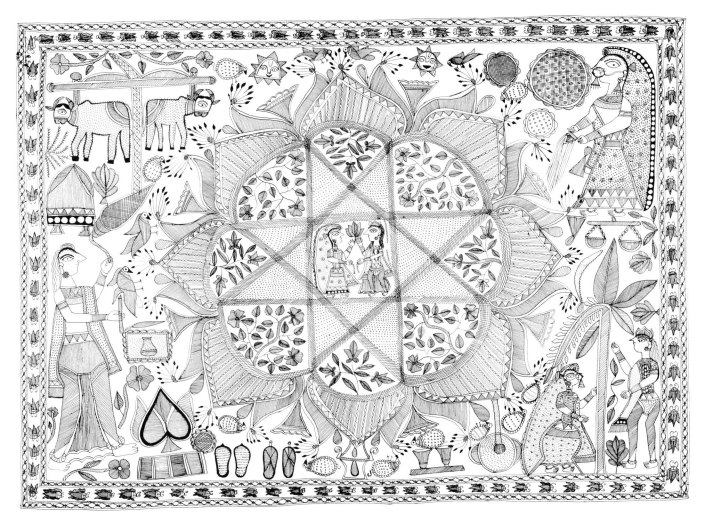

Fig. 25 *Bride and Groom*, Giraj Devi, watercolor, 22 by 30 inches, 1980.

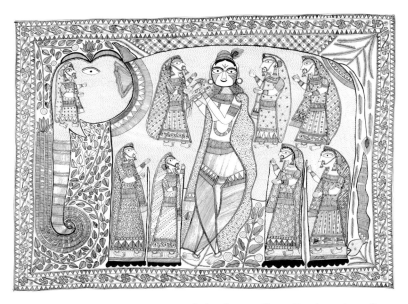

Fig. 26 *Elephant, Krishna and the Gopis*, Giraj Devi, watercolor, 22 by 30 inches, 1980.

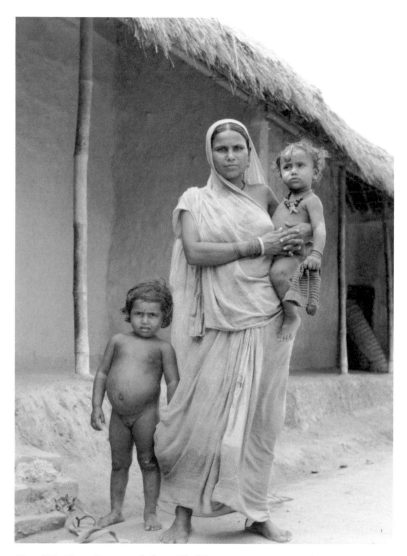

Fig. 27 Bua Devi with her Children, Jitwapur, India, 1980.

of the Highest Order. This has been a source of personal pride, elevating her to prestigious position within her family and the community. Jagadamba's nieces and nephews enthusiastically showed me her bronze plaque while I drew her (Figs. 12, 13).

Jagdamba seemed just as eager to show me her work as I was to see it, as she unrolled a thick group of recent paintings. I was surprised by her bold images. In contrast to most other painters, she avoids excessive detail, leaving her dominant forms clearly silhouetted against the white paper background. In *Krishna and the Cow* (Fig. 14), a tiny calf appears within the belly of the mother cow whose body is painted with a large red and white spotted pattern. Both appear entranced by Krishna's flute. To the Hindus, the pregnant cow is an archaic sacred symbol, as, according to the ancient Vedic texts, the earth took the form of a cow as mother of gods and men. "Whoever kills a cow or allows another to kill it, shall rot in hell as many years as there are hairs upon its body." In Jagdamba's painting of *Shiva* (Fig. 15), a curved rhythmic pattern permeates the red and black form of the four-armed Shiva who holds a trident and other

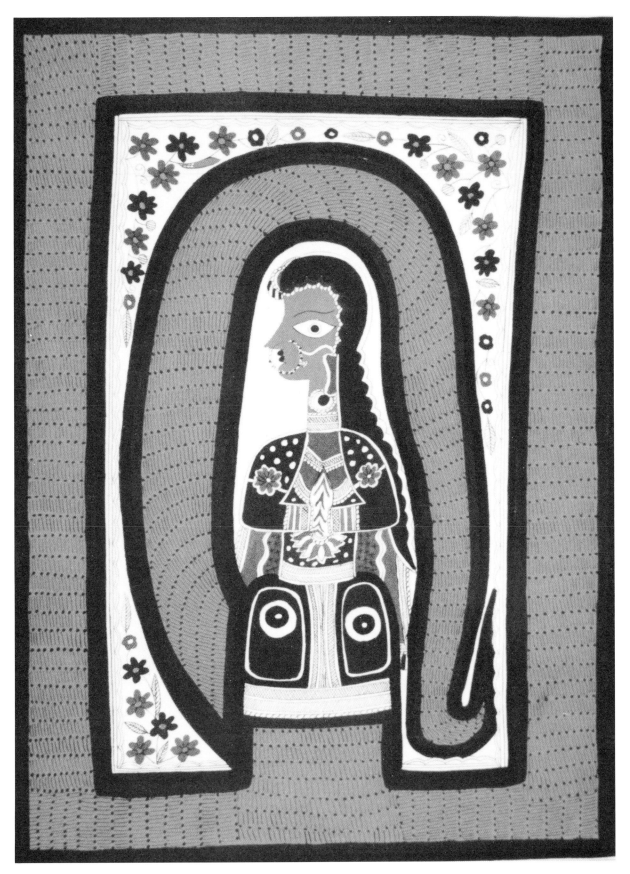

Fig. 28 *Snake Goddess*, Bua Devi, watercolor, 22 by 30 inches, 1980.

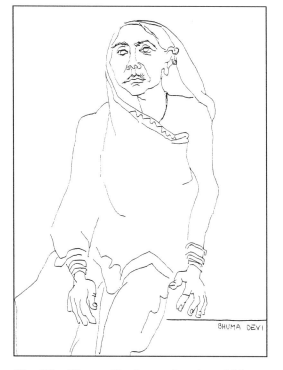

Fig. 29 *Bhuma Devi,* pen drawing, 11 by 14 inches, 1980. Betty LaDuke.

Fig. 30 *Kohbar,* by Bhuma Devi, ink on paper, 12 by 13 inches, 1980.

power symbols. Two ribbon-like snakes, painted with a checker-pattern, rise from Shiva's head while his legs are curved into an inverted heart shape, reinforcing the painting's rhythmic vitality and joyous mood.

I was sorry to learn from Carol Henning Brown that Jagdamba Devi had died in 1984. Vequaud omits reference to Jagdamba, while using examples of her work in his book. Jayakar consistently refers to Jagdamba's work with great respect.

Bacho Devi

When I arrived at Bacho Devi's compound she was painting, but I was surprised to see her husband, Baidyantha Jha, the village judge, seated opposite her, also working on the same painting (Figs. 16, 17). I was told that only after Bacho Devi outlined with black ink her intricate composition of *Krishna and the Gopi Girls* (Fig. 18) her husband then assisted by filling in the detailed patterns with bright primary colors. The couple worked harmoniously, and, due to their combined effort, the painting was completed by the following day, available for me to purchase. In Bacho Devi's interpretation of the *Cow and Calf* (Fig. 19), Krishna plays his flute as a calf stands contentedly underneath its mother. The complex pattern of flowers and stripes that permeates the cow's body, Krishna's garments, and the background are intricately balanced through size and shape variation, creating an overall dazzling effect.

There are seventeen family members crowded into this small compound, all depending on four acres of land to grow their food. With the added income from the sale of her paintings, Bacho Devi's younger son is now able to continue his education. He is majoring in business administration and has a bicycle for the four kilometer journey to his school in Madhubani.

Yamuna Devi

As Ram Deo Jha led me through the narrow lanes of Jitwapur to visit Yamuna Devi (Fig. 20) in the Harajan sector, the lanes grew even narrower and the houses more congested and less carefully constructed (Fig. 21). A distinguishing characteristic of many Harajan homes was their bas relief murals on the outer verandah walls, created with a mixture of mud and cow dung and featuring an elephant, a god, or a goddess. When children stopped their play to stare at us with curiosity, Ram Deo Jha lamented that most of them did not attend school.

Since Yamuna Devi and her husband are employed by Sita Devi's family to perform agricultural work and household chores, Yamuna had the opportunity to observe Sita paint. When the government provided paper to all the village women in 1968, she too began to paint, but I was told Yamuna is the only Harajan to do so.

The subtle coloring of Yamuna's painting is based on her use of cow dung mixed with water and gum arabic to form a natural brown pigment that she also blends with her commercial pigments. In her painting *Goddesses and Parrots* (Fig. 22), Yamuna Devi juxtaposes multiple goddesses and parrots placed within little rectangular compartments arranged in horizontal rows. In her depiction of *Rama and Sita* (Fig. 23), the figures are also repeated

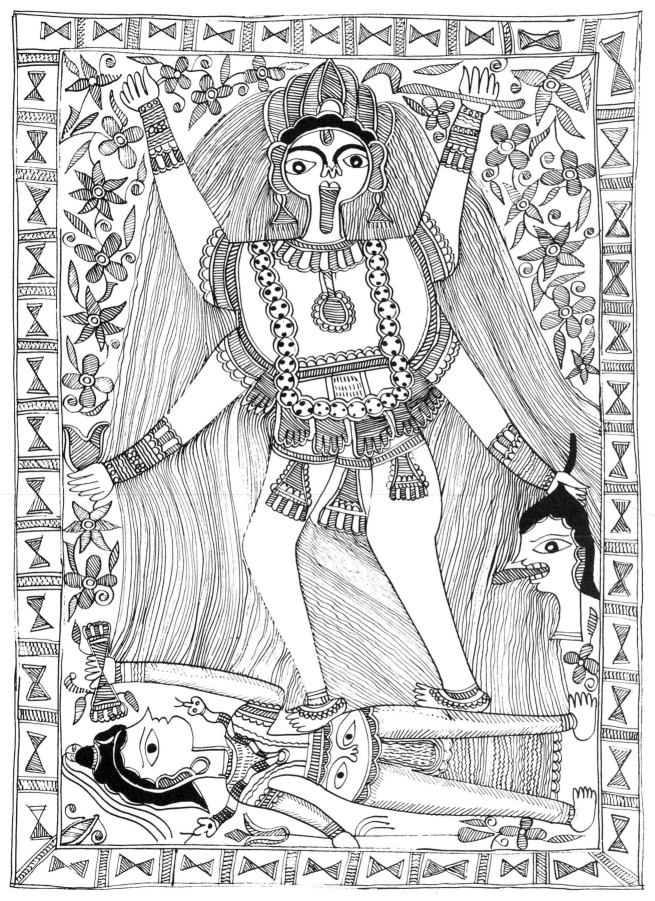

Fig. 31 *Kali*, Bhuma Devi, ink on paper, 9 by 12 inches, 1980.

Fig. 32 Zoofin Moochala, Calcutta, India, 1980.

in a series of vertical compartments reminiscent of the closely grouped Harajan homes.

Giraj Devi

Giraj Devi (Fig. 24), a tall, lean woman of the Kshatriya caste from the nearby village of Ranthi, brought several of her paintings to Jitwapur for me to see. The effect of her linear style, limited to a fine red and black ink lines, is dazzling, as each composition vibrates with intense textural detail.

In *Bride and Groom* (Fig. 25), the couple are placed in the center of a geometrically designed lotus, the eight-petalled cosmic lotus of energy. In the bottom right-hand corner of the painting, two women offer ritual prayers for the blessing of the bride, as they stand beside a sacred tree. In the left-hand corner are two yoked oxen, and directly below them is a palanquin or enclosed sedan chair for carrying the bridegroom to the bride's

house. Interspersed throughout the composition are parrots, the symbol of Kama, the god of love, and a scattering of rats, a symbol of the self which enjoys all pleasure without concern about vice or virtue. There are also numerous household items, like mats, cups, sandals, and even a small scale, which are brought into the courtyard annually for cleaning and blessing. In *Elephant, Krishna and the Gopis* (Fig. 26), Giraj Devi has filled the elephant's legs and body with the forms of the Gopi Girls and Krishna playing his flute. The elephant is considered a symbol of the macrocosm, the beginning and end of time.

Bua Devi

When I met Bua Devi, she was holding one small daughter, while the other, slightly older, hid behind her sari (Fig. 27). Bua Devi soon managed to unroll a series of her current paintings. Each one contained a bold singular image that dominated the space, and distinguished her work from that of the other painters. In *Snake Goddess* (Fig. 28), the form of a bright, lemon yellow snake, thickly outlined in red and black, curls around the painting forming an inner frame or border, while in the center a goddess calmly emerges from the serpent's jaw. The snake symbolizes power and regeneration, and the Snake Goddess is worshipped during the festival of Nag Panchami, held every year during the monsoon season when snakes are prevalent. The coiled serpent with a body of a maiden is also considered a symbol of awakening passion.

Bhuma Devi

Sadly, Bhuma Devi, only 55, can no longer paint as her eyesight is failing (Fig. 29). She has three sons, and she told me that one is employed as the village social worker. He has political aspirations, but, since the family lacks money, his ambitions will be limited to the local level.

Bhuma Devi still had several small paintings available for me to see, on the themes of the *Kohbar* and the goddess *Kali*, each thickly outlined in red and black. Bhuma Devi's *Kohbar* (Fig. 30) contains three lotuses on either side of a larger, central lotus, which is pierced by a vertical *lingum* with the goddess Gauri's face painted at the tip. A parrot appears in all four corners. The goddess *Kali* (Fig. 31), the creator, preserver and destroyer of life, is shown in her bloodthirsty aspect, wearing a necklace of small skulls and dangling hands, while she stands upon the prostrate form of Shiva. The background is filled with a delicate flower pattern as Kali is associated with the divine promise, the endless renewal of life.

In conclusion it is important to note that in many parts of India, artists and artisans have not fared as well as the Mithila painters. Mulk Raj Anand, an Indian art educator, notes:

> Crafts, which are very popular in the villages, are dying due to want of money. The government pays little attention to remote areas. People throughout the world would be stunned by the way they live and work. There is an artistic touch in these crafts, but since they are not encouraged they are also dying. There is nothing to maintain or protect them.[28]

Fig. 33 *She #1*, Zoofin Moochala, ink drawing, 9 by 12 inches, 1980.

Fig. 34 *She #2*, Zoofin Moochala, pen drawing, 9 by 12 inches, 1980.

Fig. 35 *Untitled*, Zoofin Moochala, ink drawing, 12 by 18 inches, 1972.

The celebration of ancient myths, human passions and people's harmony with nature as expressed in the Mithila paintings seem just as relevant and visually refreshing now as it did in the past. As these artists have had the good fortune to receive support and become more internationally known, their aesthetic appeal will be mingled with a recognition of the historic roots of their art and its significance for cultural continuity.

Modern Indian Art

While traditional art serves an historical and communal purpose by perpetuating ancient myths and legends and fulfilling ritual needs related to agriculture and rites of passage, India's modern artists are free to express themselves in any of the contemporary international styles. In describing the roots of contemporary Indian painting, Richard Bartholomew states, "Whatever its defects may be, it is no longer the effeminate, quasi-patriotic art that it was for the four decades of this century..."; in recent years, "it has echoed the rhythm of the age,"[29] dominated by Expressionism, with regional variations.

However, the art educator Anand is disturbed by India's current split between fine art and crafts and believes that India's "building of consciousness for the future" should include all the arts. He notes;

> The crisis of consciousness in regard to the creative arts began with the impact of art for art's sake, which came into India with Western infiltrations. The word Art with a capital **A** began to occupy the minds and hearts of the middle sections... and in the later days of British rule, the theories of significant form, abstract art and individualistic self-expression became dominant... and contemporary experimentalism possessed the bourgeois and petty bourgeois of the big cities of our country.[30]

These comments offer a brief perspective for viewing the work of Zofin Moochala and Karuna Shaha, who are both urban, educated, modern artists. Though they have been exposed to international contemporary art trends, each has maintained a link to Indian culture in her figurative drawings, paintings, and prints. Visiting them briefly in 1980 in their Calcutta homes and studios provided insights concerning each one's personal development.

Zofin Moochala

After climbing five flights of stairs to reach Moochala's apartment in the midst of a bustling Calcutta neighborhood filled with the intense activities of street-vendors, rickshaws, cars, and people, I felt a sense of calm and order when Moochala opened her door. Shoes are left outside as one steps in, first to a small room containing a stove (no refrigerator), sink, and a washroom and then to the one main room where the family (her husband and two teenage sons) eat, sleep, and entertain and Moochala paints.

Several of Moochala's small abstract oil paintings, featuring waves of horizontally layered green and blue colors, are displayed on the walls (Fig. 32), but most of her work is stored above an extensive wardrobe which borders two walls of the main room and holds all of the family's possessions.

Moochala grew up in a small town near Bombay. At the local

Fig. 36 *Woman*, Karuna Shaha, woodblock, 9 by 12 inches, 1980.

Fig. 37 *Untitled*, Karuna Shaha, oil painting, approximately 24 by 34 inches. Photo courtesy of the artist.

school, a teacher noted her drawing skills and encouraged her parents to send her to Bombay's J. J. School of Fine Art. Fortunately, when her father's company job was relocated to Bombay, she was able to continue her art studies at the Fine Art school for four years where she was exposed to diverse modern art styles. Her early figurative painting was Cubist influenced. Later her images became more abstract and personal. It was during this period that she began to exhibit professional work.

At age twenty-three, Zoofin married. Her marriage was arranged for her by her parents. For the next eight years, she devoted her energy to raising their children in this small apartment, while her husband and his two brothers worked together in the family's hardware business. Fortunately, Moochala's husband encouraged her to continue painting. Since they are Moslem, Moochala feels her spiritual growth evolved after their six-week sojourn to the Islamic religious centers in Iraq and Iran. Moochala would love to travel more widely, and, in her way, she does, as the symbolic forms in both her figurative drawings and canvases seem to fly free from confined space. For the past four years Moochala has been teaching art at the Birla Modern High School for Girls. Her students are only ten to twelve years of age, and she teaches six classes each day with forty to fifty students in a class. To sustain this routine, she has household help, a vil-

lage woman, who shops, cooks, and cleans for the family. Moochala manages to do her own creative work evenings, weekends, and holidays.

I was impressed by Moochala's recent series of introspective feminist pen drawings titled *She* (Figs. 33 and 34). The singular forms of women float on the page, as if emerging from a dream. The upraised arms and loose flying hair seem to guide the figures in a fantasy flight. However, reality is evident: contained within the womb area of one figure is a series of small, organic forms suggestive of hearts and the *lingum-yoni* motif. In another drawing, the woman's torso has evolved into a giant wheel whose many spokes are reminiscent of the Hindu and Buddhist cyclical wheel of Karma and endless rebirth.

More complex in form is a larger twelve-by-eighteen-inch drawing, *Untitled* (Fig. 35) in which multiple vertical compartments are filled with undefined organic shapes. The pen lines are richly textured, creating a mood of light, shadow, and mystery, perhaps a reflection of Moochala's dreams. In speaking of her work, Moochala says, "Sometimes I get the form, sometimes the form gets into me." Her paintings are described in a 1970 review in *The Calcutta*:

> In spite of their finesse and obvious affiliation with the traditions of modern Western painting, her canvases reveal an implicit kind of Indianness. The landscapes represent areas "seen" during a journey into the inner self...[31]

Fig. 38 *Untitled*, Karuna Shaha, oil painting, approximately 24 by 34 inches. Photo courtesy of the artist.

1 Yves Vequaud, *The Women Painters of Mithila* (London: Thames and Hudson Ltd., 1977), 122.

2 Ibid., 17.

3 Ibid.

4 Pupul Jayakar, *The Earthen Drum: An Introduction to the Ritual Arts of Rural India* (New Delhi, India: National Museum, 1981), 10.

5 Ibid.

6 Ibid., 16.

7 Ibid., 139.

8 Carol Henning Brown, "Misconceived Fertility Symbols in Mithila Art," (Unpublished paper, Department of Anthropology, Whiteman College, Walla Walla, Washington, 1986), 9.

9 Carol Henning Brown, "Folk Art and the Art Books: Who Speaks for the Traditional Artists?" *Modern Asian Studies* (Cambridge: Cambridge University Press, 1982), 519-22.

10 Jayakar, 110.

11 Brown, "Misconceived Fertility Symbols," 4.

12 See W. G. Archer, "Maithil Painting," *Marg* III, no. 3 (1949): 24-33.

13 Jayakar, 94.

14 Ibid.

15 Ibid., 95.

16 Ibid., 96.

17 Yves Vequaud, 28.

18 Jayakar, 136.

19 Vequaud, 15.

20 Jayakar, 9.

21 Ibid.

22 Brown, "Misconceived Fertility Symbols," 2.

23 Ibid., 8, 9.

24 Vequaud, 3.

25 Jayakar, xii.

26 Brown, "Folk Art and the Art Books," 522.

27 Vequaud, 31.

28 Mulk Raj Anand, *Fifth Asian Regional Conference Sponsored by INSEA* (Calcutta: INSEA and F.K.M. Institute of Culture, 1980), 23.

29 Richard Bartholomew, "Contemporary Indian Painting," *Modern Art of Asia* (Tokyo, Japan: Toto Shuppan Co., 1961), 32.

30 Anand, 24.

31 *The Calcutta* (Calcutta, India), 1970 (newspaper clipping in possession of artist).

32 Gaultero Viviana, *Pegaso* (Florence, Italy) (December 1978) (magazine clipping in possession of artist).

Karuna Shaha

Karuna Shaha's prints and paintings are inspired by direct observations from reality. Born in Calcutta, she graduated with honors from the government School of Arts and Crafts in 1949. In the following years she received further recognition and prizes for her posters, postage stamps, and book cover designs. She has regularly exhibited paintings and prints in Calcutta and New Delhi while teaching full-time at the Birla Modern High School for Girls.

From 1959 to 1962 Shaha was the recipient of an Italian government scholarship to Florence, Italy, where she studied at the Academia di Belle Arti and obtained a diploma in fresco and mural painting. She also had the opportunity to visit museums and galleries in Europe. Her only regret was that during those years of study she had to leave her young daughter in Calcutta with her husband. He is an important national photographer known for his portraits of Gandhi, the Nehru family, and other government dignitaries. The walls of their spacious home, located in a Calcutta suburb, are filled with examples from both their diverse creative careers.

In 1978 Shaha was invited to return to Florence, Italy, for an exhibit, which was reviewed in *Pegaso*, an Italian journal:

> Her paintings... represent an extraordinary range of occidental and oriental culture. Far from the spurious hybridization which work of this genre risks falling into, these paintings are jewels of balance and style. Karuna Shaha's work, the result of a perfect oriental sensibility allowed to blossom in the Occident, belongs neither to the East or West, but to the world.[32]

Shaha's 1979 black-and-white woodblock, *Woman* (Fig. 36), exemplifies her merging of East-West aesthetics. It is composed of a woman seated on a white rug, with a flower-filled vase nearby. On the right, a rectangular floor pattern shown in perspective leads to an open door and an undefined space. The white rhythmic contour lines of the woman's body are fragmented and varied in width, and the upper part of her body and the flowers (both black) are framed by bold white rectangular shapes.

Since fine art is usually the privilege of the select few who can afford to create for self-expression, it will be interesting to see the synthesis that continues to emerge between modern and traditional painters (Fig. 37–38). Each group has much to learn from the other's strength and sensitivity in the formation of a national aesthetic consciousness and heritage.

Mexico

Earth Magic: The Legacy of Teodora Blanco

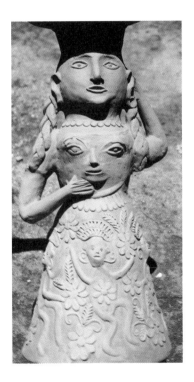

FOR MORE THAN thirty years, mythical, magical life-affirming forms of women have been emerging from the kilns of Santa Maria Atzompa and receiving international acclaim. Almost exclusively created by women, these unglazed red clay forms vary from palm size to commanding heights of four and five feet. Entirely hand-built, these sculptures are elaborately embellished with flowers and animal spirits and represent a joyful glorification of women's physical and spiritual link with nature. Their symbolism integrates ancient indigenous myths with contemporary reality.

I first encountered flower-decorated Virgins and Market Women during a *Semana Santa,* Holy Week, visit to the Oaxaca region in 1976. The church altars were then lavishly adorned with candles, palm branches, flowers, clay figures, and pots with corn, bean, or rice seedlings, placed at the feet of the Virgin. Here, Easter represented not only Christ's resurrection, but also the annual regeneration of the soil and the fertility of all life forms. Through the years I wondered who made the clay figures, but it was not until 1990 that I had the opportunity to trace their evolution.

In the city of Oaxaca, market vendors informed me that clay products are produced in the village of Atzompa, primarily by the family of Teodora Blanco. To my dismay I was told that Teodora died ten years ago (Fig. 1). However, I decided to visit Atzompa, in order to learn how her aesthetic expression had evolved, from those who knew her best.[1] I soon became aware that Blanco's legacy had continued, especially through the work of Berta, her sister, Luis and Irma, her son and daughter, as well as by some in-laws and friends.

For the 4,000 residents of Atzompa, routines have changed little since 1926, when Teodora was born. Located five miles from the city of Oaxaca, this village is nestled in the foothills of Monte Alban, an indigenous Zapotecan archeological site. The road was paved ten years ago, electricity installed twenty years ago, but men and oxen continue to plow the surrounding fields of corn and beans as they have for centuries.

A Catholic church and marketplace dominate the homes made of adobe and thatch. Most unusual were the green-glazed ceramic heads of domestic animals gazing down from the top of the sixteenth-century church wall, perhaps a reminder of the residents' pre-Columbian ancestors' beliefs in protector spirits.

Fig. 1 Teodora Blanco with *Market Woman*, approximately 1970, Atzompa, Mexico, photo courtesy of Berta Blanco.

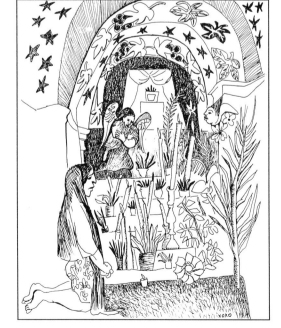

Fig. 2 *Church Altar*, pen drawing, 11 by 14 inches, Betty LaDuke.

On Sunday, the church is filled with fresh flowers to honor the priest's arrival, and the mass includes guitar music and songs (Figs. 2, 3).

There is much excitement on Tuesdays and Fridays, the local market days, when people bring produce, animals, and pottery to trade or sell (Figs. 4, 5). These two centers of activity, the church and the market place, inspired the monumental sculptural forms *Market Women* and *Virgins* initiated by Blanco in 1978. The sculptures also incorporate ancestral beliefs in *nahuales* or animal spirits. When *nahuales* are imaginatively integrated into the bodies of the *Market Women*, these forms are transformed into mythical earth goddesses.

Leonore Hoag Mulryan explains the legends associated with *nahaules*:

Each person has a *nahual*. At night the mother and father put the newborn baby on the ground. Then they sift a circle of ashes around the baby. The first animal to cross the ashes is the *nahual* of the baby and will protect the child for the rest of its life. One can tell what kind of

animal it is from the paw prints. At night the *nahual* leaves the human body in search of the person's rival, to attack him. If the rival wounds or kills the *nahual*, the person at home is injured or dies.[2]

Angélica Vásquez of Atzompa, whose sculpture is also inspired by *nahuales*, told me:

According to Zapotec legend, when a child is born, the parents must search for an animal spirit to become the child's protector. The placenta is laid along a straight line made from fire-ashes outside the house. Whichever animal first crosses that line is the protector spirit. If something terrible happens to our protector animal, we suffer too![3]

Though Teodora's descendants did not speak of their current belief in *nahuales*, I was told that, in nearby villages where traditional dialects instead of Spanish are still spoken, the beliefs persist, because *Nahuales* "represent local spirits that are active in daily life"; these spirits are believed to explain sudden illness, or death, and the high infant mortality rate.[4]

The people's personal connection with the earth was explained by Dora Martínez-Virgil, a friend of the Blanco family. She related that after the birth of her children, the umbilical cord was ritually buried in a small clay pot in the courtyard of her Oaxaca home.

Therefore, when people say, "I have a great love for my pueblo," it also refers to their personal link with the earth. Now many traditional indigenous people feel that with babies born in hospitals and the placenta discarded, people are like lost souls. They don't have a sense of belonging to the earth, and that's why the world is so crazy.[5]

Why did Atzompa evolve as a significant pottery center? What were the personal factors that led Teodora Blanco to create monumental, mythical clay figures in contrast to most Atzompa women, who still produce utilitarian wares for home use, trading, or selling? I will consider these questions before reviewing the work of Teodora's descendants.

In addition to farming with unpredictable results because of inconsistent rainfall, the major occupation of most residents is pottery making. This is easily observed in each family compound, a series of mud-brick rooms surrounding a central courtyard. In the center is a circular stone-and-adobe kiln, approximately four feet in height. Other common courtyard inhabitants are turkeys, goats, dogs, and donkeys. There is no indoor plumbing, and big, sturdy clay jugs hold water obtained from the central unpaved street or courtyard spigot.

Other significant courtyard features are two mounds of soil, the first, mined by men in the nearby hills of Atzompa, and the second, purchased from San Lorenzo, a nearby village. As long as residents can remember, these two soils, when pounded, sifted, and mixed together with water and then kneaded into a clay mass, have provided the basis for the development and flourishing of this local pottery industry.

Production wares vary from ashtrays and candlestick holders to tall flower vases, decorated bowls, plates, cups, saucers, casseroles, or thick, flat *comales* for cooking tortillas (Fig. 6). Most of the utilitarian pottery is covered with a green glaze made from a local vegetable dye into which the pieces are dipped and fired for a second time.

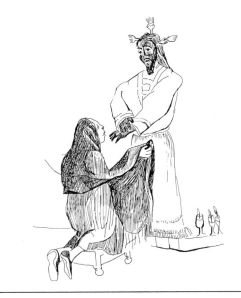

Fig. 3 *Prayers*, pen drawing, 11 by 14 inches, Betty LaDuke.

Fig. 4 *Market Day*, pen drawing, 11 by 14 inches, Betty LaDuke.

Fig. 5 *Market Day*, pen drawing, 11 by 14 inches, Betty LaDuke.

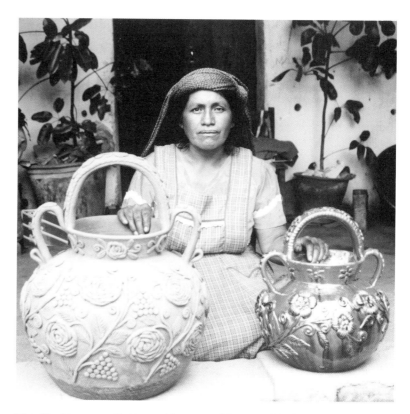

Fig. 6 Atzompa Pottery, Atzompa, Mexico, 1990.

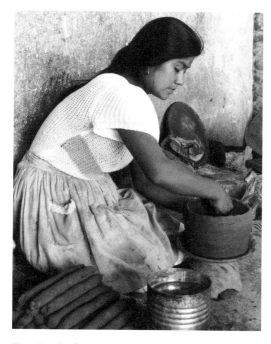

Fig. 7 Coil Construction.

The women make their pottery with a coil method while the few men who produce pottery between periods of agricultural work use kick wheels. The rainy season slows the clay-drying process and firing, also affecting the family income. Wholesale dealers with trucks regularly bring these wares to Mexico City.

Pottery-making skills are passed from one generation to the next by the parents. Seated on floor mats indoors or on a shaded verandah, most women make pottery, interspersed with child care and household chores, approximately four to eight hours daily, except Sunday, the day reserved for church and rest. They use a matrix or flat inverted saucer, placed upon a large plate that permits rotation. The pottery base is formed by punching and flattening a small clay ball and then adding *longas* or clay coils to raise the walls according to the desired form and function (Fig. 7). The figurative forms are hollow and also created with this same coil method (Fig. 8).

When applying surface decoration or "embroidering" the clay with thread-like coils, the timing is crucial. The basic form must remain sufficiently moist so that the embellishments will bond. Completed pieces require at least a ten-day drying period. Only on the day of firing are the pots carried outside for several more hours of drying in the intense sunlight. They are then loaded into the kiln, from the top, and interspersed with clay shards until completely covered. *Acahual*, or long, thin wood scraps procured from a nearby mill, are placed in the kiln opening beneath the pottery (Fig. 9).

During the short, two-and-one-half-hour firing period the heat is slowly raised, intensified during the last hour, until black

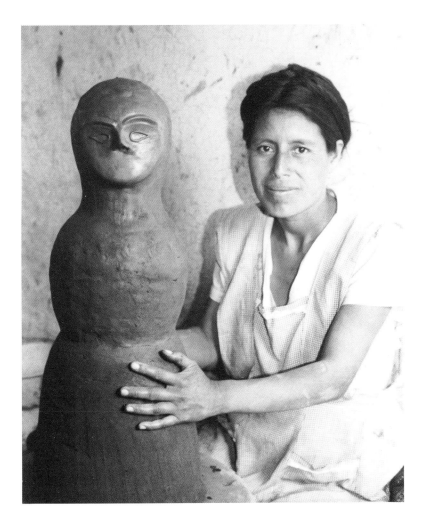

Fig. 8 Constructing *Market Woman*.

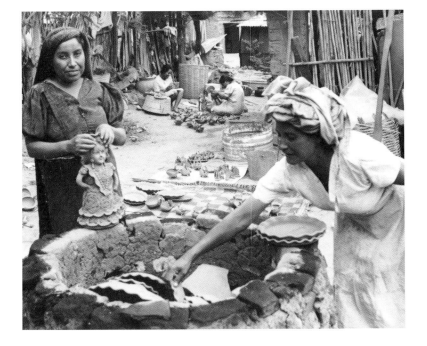

Fig. 9 Loading the Kiln.

Fig. 10 *Market Woman*, by Teodora Blanco, Atzompa, Mexico, approximately 5 feet tall, 1976.

smoke billows forth. After a brief cooling period, the kiln is uncovered with the use of two long paddles (one contains a metal hook) for the removal first of the shards and then the pottery. Men, when available, assist with the firing process.

The mythical magical legacy of Teodora Blanco began with her mother Carmen Núñez Ramírez, who came to Atzompa as a child, later marrying Amado Blanco and having five children. At eight years, Blanco learned from her mother to work with clay by making small toys or figures to illustrate the stories told by her grandparents. As a young girl, Blanco's feisty spirit was evident when she decorated ashtrays produced for market with original love poems that others helped her write as her own education was brief. When her father became ill, her clay work was an important supplement to the family income. Fortunately, her unique ashtrays were well received, and she was asked to make larger and more varied forms. At first she decorated ashtrays

Fig. 11 *Angel Flower Holder*, by Teodora Blanco, Atzompa, Mexico, approximately 12 inches, 1970.

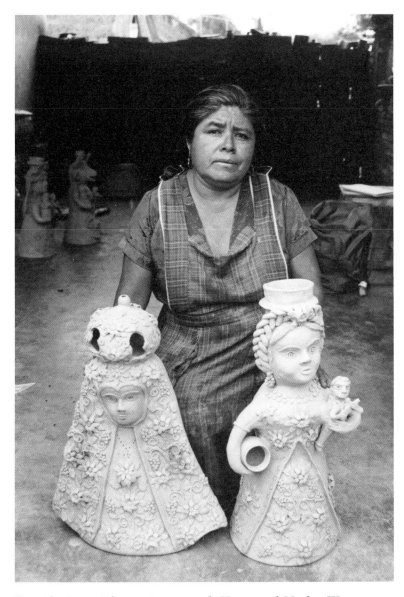

Fig. 12 Berta Blanco Núñez, with *Virgin* and *Market Woman*, Atzompa, Mexico, 1990.

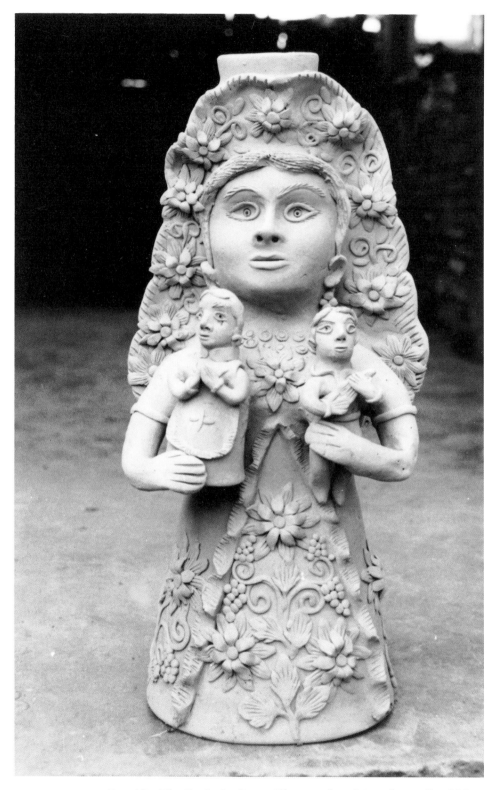

Fig. 13 *The Bride*, by Berta Blanco, clay, 24 inches tall, 1990.

with little figures and eventually created the larger and more personal forms of Market Women which she gradually adorned with flowers and animals. The demand for her work steadily increased.

The potting area was her stage where she loved to talk about the figures and tell stories as she formed them. They related to aspects of her life, the *mercandoras*, market women, mothers with babies, women and their *nahuales* and caricatures of people.[6]

Blanco's son Luis recalled, "Mother used to say she was not alive unless she was working with clay." He also noted, "On her weekly trip to Oaxaca City she sometimes went to the archaeological museum to look at collections from Mitla and Monte Albán."[7] Surely she was inspired by the anthropomorphic figures in those collections, reflecting her own indigenous heritage.

During the decades after World War II, Mexico underwent many changes. With the construction of the Pan American Highway and cheaper air transportation, tourism increased, followed by a demand for souvenirs. Foreign markets for craft production also opened up, and the Mexican government began to encourage artisans to develop quality products. Annual regional and national competitions were initiated, and the Museo de Artes Populares e Indiginistas was established in the 1960s. Blanco's

Fig. 14 *Woman Holding a Man Who Plays the Violin*, clay, 24 inches tall.

Fig. 15 *Bull with San Lucas*, by Berta Blanco, clay, 16 inches tall, 1990.

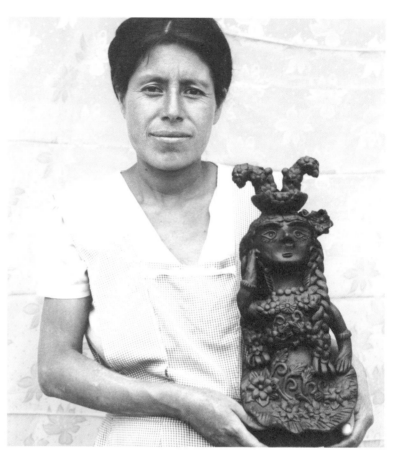

Fig. 16 Irma García Blanco, with clay sculpture, Atzompa, Mexico, 1990.

Fig. 17 *Market Woman*, Atzompa, Mexico, 1990.

work soon became famous not only in Oaxaca but also in Mexico City, and she was invited to participate in national and international competitions.

In her personal life, Blanco and Antonio García Reyes had five children, but they never married. Antonio eventually left Blanco to marry Angelina González Cruz with whom he had ten children. He also taught Angelina the pottery skills he had learned from Blanco. But, according to Luis, Antonio still accompanied Blanco to many official events, but Blanco, alone, was responsible for the maintenance of the children.

Through the years Blanco won many prizes, medals, awards, and diplomas for her extraordinary figures. Two events highlight her career. Irma Blanco recalls how in 1975 she accompanied her mother and García Reyes to a World Ceramics Meeting, held in Morelia in the state of Michoacán. Blanco was invited by the government to represent Mexico, to exhibit and compete for the world prize awarded for the actual construction of a clay form. She became a world finalist, competing ultimately against an American. The American's wheel-formed pot was very tall and grand, but, much to everyone's amazement, it fell down, which disqualified him. Indeed, Blanco with one of her anthropomorphic *Market Women* won the coveted world prize.

Martínez-Virgil recalls, "Teodora never gave much importance to her collection of diplomas and awards. They were never

Fig. 18 *Three Regional Women of Oaxaca*, by Irma García Blanco, Atzompa, Mexico, black clay (unfired), approximately 2 inches tall, 1990.

displayed but casually stored, like any ordinary papers." She also remembers Teodora being "unusually open-minded and a very strong woman who held the family together."[8] Everyone worked for Blanco in the family house, which was also their workshop. Luis Blanco recalls that "Teodora preferred to work from three until eleven A.M. When she began a figure, the images would just flow from her imagination. She had a talent, a gift from God."

The second major event her son described occurred two years before Blanco's death at fifty-two, when Nelson Rockefeller came to Atzompa to meet her. Luis proudly showed me the photograph in which he stands between his mother and "Señor Rockefeller," who through the years had collected over 175 pieces of her work. The family was told the day before Rockefeller's visit to expect him. And sure enough, police on motorcycles and bodyguards arrived first, followed by helicopters. Then, "ten minutes later, Señor Rockefeller arrived in a chauffeured car." Her son remembers his mother saying to Rockefeller: "How is it possible that a millionaire would come to visit a simple, humble woman like myself?' Rockefeller told her how much he appreciated her work and, "It is my pleasure to meet a woman as famous as you, whose work I really value. I came especially to meet you." Rockefeller then invited Blanco to New York to see his collection and display of her work, but she

Fig. 19 *Virgin of Asuncion*, by Irma García Blanco, clay, 24 inches tall, 1990.

Fig. 20 *Market Woman*, by Irma García Blanco, clay, 24 inches tall, 1990.

declined as she was then already too sick to travel. Unfortunately, an intermediary interceded so she never received all of the money Rockefeller paid her for the new pieces he bought during this visit. According to Luis, Blanco was taken advantage of, many times.[9]

Blanco suffered severely for two years before her death with several kidney operations. The last year was particularly difficult, with the family spending most of the year in the hospital at her bedside. Blanco was also worried that someone had cast an evil spell upon her as there were many who were jealous of her success. She died penniless; she had enjoyed spending her money on her children's weddings and for the patron saint's day fiestas in Atzompa.

Marian Harvey in *Mexican Crafts and Crafts People* describes Blanco:

> a warm hearted happy person and a serious energetic artist... At times her interest in rich baroque decoration resulted in a banquet of form and detail. Teodora's

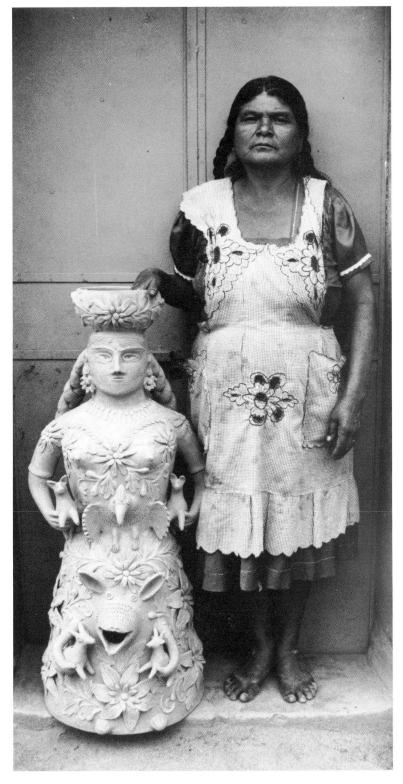

Fig. 21 *Siren*, by Irma García Blanco, clay, 24 inches tall, 1990.

Fig. 22 Angelina González Cruz with her *Market Woman*, Atzompa, Mexico, 1990.

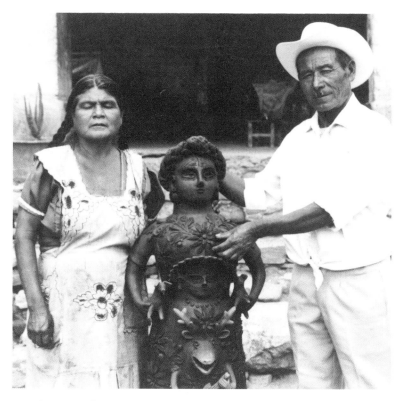

Fig. 23 *Angelina González Cruz with Antonio García Reyes and Market Woman.*

Fig. 24 *Market Woman with Porcupine,* by Angelina González Cruz, Atzompa, Mexico, clay, approximately 54 inches tall, 1990.

sculptures were indeed a part of herself... She reflects the Spanish as well as Indian heritage.[10]

Mulryan discusses the significance of Blanco's work from another perspective:

> Blanco's figures of nurturing women and tutelary deities were meant to be protective, guarding the spirits of the people of Atzompa and others who experienced her work... She also expressed a sense of humor and her positive attitude toward life or her beliefs about the soul.[11]

The darker side of the mother or guardian spirit that can be linked to illness and impending death was revealed in one of Blanco's last clay figures completed a year before her death. This *Market Woman* (Fig. 10), over five feet in height, remains in her son's collection along with an *Angel* (Fig. 11). Most unusual is the formation of the woman's head within the open jaws of a jaguar, whose teeth form a scalloped edge around her face. However, the woman's gaze is calm, as if acknowledging and accepting her fate. She wears thick clusters of earrings that hang like ripe fruit, and her dress is ornately embellished with flowering vines and paired doves. The hands are large as each finger is solidly formed, peasant-worker hands. One holds a rooster playing a violin and the other, a hen playing a guitar.

Luis informed me of a major commission he and Teodora completed, an eight-foot tall Fertility Goddess, for the 1975 inauguration of a government building in Oaxaca, the Casa de Cultura or House of Culture. This figure with multiple breasts

was never fired, and, through the years, it was mishandled and parts were broken off. However, I found it standing in an alcove along a broad stairway and once again noted the thick, strong fingers of this figure, her hands reaching out to the world. In the House of Culture there is also a bronze bust of Blanco (unlabeled), with kind and smiling features, her thick hair braided in a traditional style with ribbons encircling her head.

I regretted there was no accompanying exhibit of her work or photographs to preserve her aesthetic achievements as she is indeed a folk heroine, a significant role model for future generations. Her vision was extraordinary, as her creative expression dignified women as strong, powerful individuals, a refreshing contrast to commercial media exploitation of women as passive sex objects. Blanco also dignified working with clay.

For the past ten years Blanco's descendants have continued to create sculptures of *Market Women, Virgins, Angels*, and *Sirens*, that reflect individual expressions including humor. Their self-pride is always evident, as their connections with the world beyond Atzompa continues to expand through exhibits, competitions, and commissions that benefit the entire family. It is hoped that they will be encouraged to risk exploring new themes and emotions.

Berta Blanco Núñez

Berta Blanco Núñez (Teodora's sister) is a stocky, cheerful woman whose face frequently lights up with a broad smile (Fig. 12). At forty-six, she has received fame and recognition in her own right, though her early career was overshadowed by Teodora. In the family workshop, her productions were signed with Teodora's name, her fame commanding a higher price. This is a commonly agreed-upon practice, but resentment did arise when one of Berta's clay sculptures won first prize in a competition, and Teodora received the recognition.

For the past twenty years Berta has been working on her own but feels she doesn't "produce too much because I take a long time with all the details." She is also proud that apprentices from the United States and Europe have come to live and work with her and that photos of her work appear in the Dutch anthropologist Wer Denton Besult's book, *Cerámica Mexicana* (1986).[12]

Berta's sense of humor is one of her special characteristics evident in the following three pieces (all candleholders, twenty-four to sixteen inches in height):
1. *The Bride* (Fig. 13), in which a veiled young woman clutches to her breast two small figures, a priest and the groom;
2. *Woman Holding a Man Who Plays the Violin* (Fig. 14), which portrays a woman in charge of her destiny. Her head is just slightly tilted as she embraces a man who is playing a violin.
3. *Bull with San Lucas* (Fig. 15), features the head of a bull perched upon a woman's body, carrying a small figure of Saint Lucas under one arm and a small cow, playing the violin, under the other.

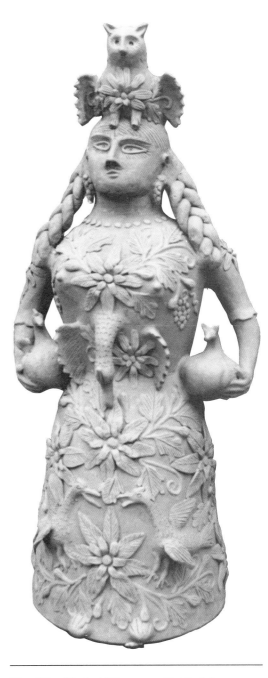

Fig. 25 *Market Woman with Owl*, by Angelina González Cruz, Atzompa, Mexico, clay, approximately 54 inches tall, 1990.

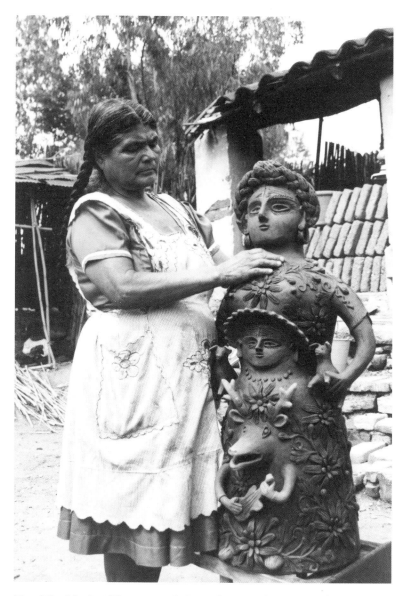

Fig. 26 *Market Woman with Deer*, by Angelina González Cruz, Atzompa, Mexico, clay, approximately 54 inches tall, 1990.

Irma García Blanco

Irma García Blanco (Figs. 16, 17) maintains her mother's legacy through her own clay images which are lively and full of detail. She currently completed a series of black clay figures approximately twenty-four inches in height to represent the seven regions of the state of Oaxaca. Each figure is portrayed with typical regional garments and hair styles. Lavishly ornate, Irma's female figures sometimes contain an over abundance of decorative details on their proportionally short torsos (Fig. 18).

Irma claims she is never bored with thematic repetition, because each time she does them a little differently. Some examples include the *Virgin of Asunción* (Fig. 19), which seems overwhelmed by a large crown; *Market Women* (Fig. 20), depicted with three little pigs, one on her head and one under each arm;

Fig. 27 Angélica Vásquez with *The Wedding*, Atzompa, Mexico, 1990.

Velorios, which depicts a deceased person in a coffin surrounded by a grieving family; *Nativity* scenes; and the *Sirens* (Fig. 21), a rare expression of sensuality.

Irma, as most village potters, has only a second grade education, but her children have the opportunity for more education and other professional possibilities. As Mexico undergoes rapid modernization, strongly influenced by the United States, Irma's representations of traditional women continue to reflect pride in her cultural heritage and serve as a refreshing affirmation of her self identity.

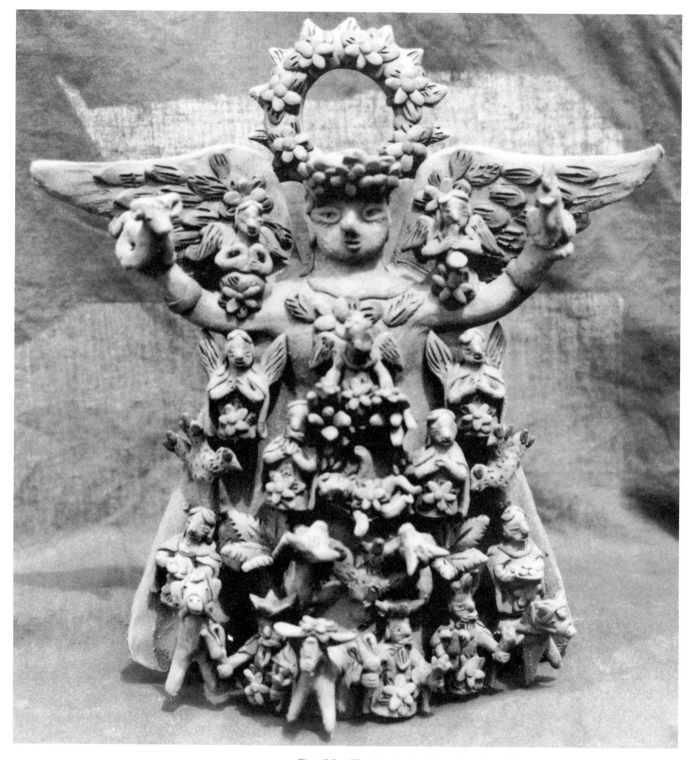

Fig. 28 *The Natividad*, by Angélica Vásquez, Atzompa, Mexico,
clay, approximately 16 inches, 1990.

Angelina González Cruz

At sixty-five, Angelina González Cruz (Fig. 22) has been creating clay images for forty-two years, beginning after her marriage to Antonio García Reyes in 1948. In addition to farming, where sometimes, Antonio says, "everyone's hands are needed," he, like most Atzompa men, mines the clay, procures the wood, loads and fires the kiln, and then packs the figures for shipping. He makes all of the business contacts. The market for the family pottery has expanded, and for many years the family has received large annual commissions from shops in New York City (Fig. 23).

Angelina recalls that, when their ten children were small, she frequently created clay sculptures while carrying them on her back. Working on the open verandah of the family home, Lourdes, age seventeen, assists by forming the clay strips or coils with which Angelina constructs her four-foot to five-foot monumental figures.

Angelina's recent group of four *Market Women* (Figs. 24, 25, 26) is impressive, not only because of their size, but because of the sense of proportion and balance achieved between the upper and lower parts of the body. The *Market Women*'s heads are large, and their eyes gaze ahead. Their lips are usually tightly closed, but breasts protrude, emphasizing nurturance.

Myth and fantasy envelop each sturdy *Market Woman*; emerging from their ample bodies are a great variety of *nahuales*: armadillos, cats, owls, sheep, lizards, and porcupines. Facial expressions vary; some are tight-lipped while others smile. A fantasy parade of *nahuales* moves down the center of their bodies, and the long trunk of an elephant reaches upward to snatch a large flower below a porcupine's nose. Each *Market Woman* is well designed; the hollow spaces between arms and body, thick braids and neck, are well balanced with the ample skirted torso below. Each projects an aura of vitality and spiritual harmony with nature. Angelina insists they have no special significance, other than her experiences: "Vámonos al mercado," or "Let's go to the market."

Angélica Vásquez

Angélica Vásquez's intricately detailed ceramic sculptures are small in scale but monumental in conception (Fig. 27). At thirty-two, Angélica, a petite but very articulate woman, is the sole support of four children. All her sculptures are mentally conceived before she begins to create. She says, "I love to work. It gives me pleasure and I can forget all else. I am always thinking and dreaming about what I should do next."

She frequently awakens at two or three in the morning to create her images. She told me, "I base myself strongly in my religion," evident in her detailed symbolic portrayal of *The Wedding* (Fig. 27), eighteen inches in height. A winged angel's form encompasses approximately twenty-five ceremonial participants including the bride and groom, in-laws on either side carrying presents of coins and a flower wreath to unite the couple, and the bride's parents and godparents who hold a *metate* for grinding corn and a chest for storing clothes. Beneath them is a woman supporting a large bread-filled basket upon her head

Fig. 29 *The Church*, by Angélica Vásquez, Atzompa, Mexico, clay, approximately 16 inches.

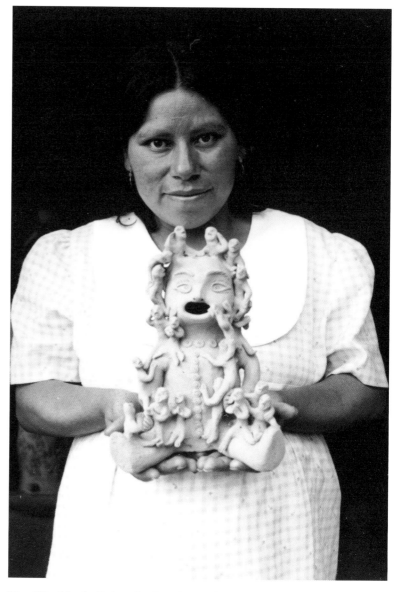

Fig. 31 María Rojas de García, with *The Narrator*, Atzompa,
Mexico, 1990.

while others carry turkeys and jugs of strong liquor and *atole*, a
drink made from corn. Below, in a semicircular shape supporting
the wedding group, stand a large band of musicians playing
instruments.

In the *Natividad* (Fig. 28) once again an angel's form encom-
passes the traditional nativity scene while in the angel's upraised
palms rest a small ram and a rooster. There is a maze of figures,
but all are harmoniously contained within the well-proportioned
contours of the angel's body. *The Church* (Fig. 29), Angélica's
least complex clay sculpture, also has many finely rendered
details, a trademark for which she is gaining recognition in
prizes and awards in regional and national competitions. This
has been of major personal and economic significance which
may lead to the international attention she merits.

Luis Blanco and María Rojas de García

Most of Luis García Blanco's early life was intertwined with Teodora Blanco's career. As a young child he learned to work with clay under his mother's tutelage (Fig. 30). Later, toward the end of her life, he assisted her with major commissions, until her death in 1980. Luis was then twenty years old and, although he had the opportunity to study accounting and English in secondary school, he chose to make work in clay his career.

When Luis and María Rojas de García (Fig. 31) were married in 1978, they lived with Teodora, during the last two years of her life, in order that María could learn to work with clay from Teodora. They now have five children and have encouraged their three oldest to make clay figures and toys. Luis told me, "Now many people don't want their children to work with clay. It's hard, demanding work. But I do. It's a wonderful talent to develop."

After Teodora's death there were many difficulties for Luis in reestablishing commercial connections with galleries and stores, and he feels that his work is now better known in the United States than in Mexico. In 1984 he was invited by the Museum of Folk Art in Santa Fe (where Teodora's work is in the permanent collection) to exhibit and offer workshops demonstrating his clay

Fig. 30 Luis García Blanco with *Angel*, Atzompa, Mexico, 1990.

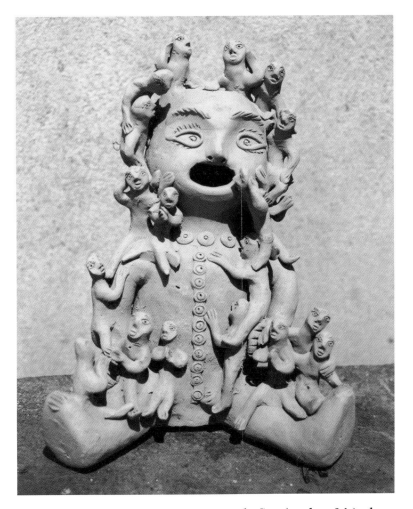

Fig. 32 *The Narrator*, by María Rojas de García, clay, 14 inches tall, 1990.

Endnotes

1 All interviews with Teodora Blanco's family took place in Santa Maria Atzompa in July 1990.

2 Leonore Hoag Mulryan, *Mexican Figural Ceramists and Their Work 1950 to 1981*, Monograph series #16 (Los Angeles, Calif.: Museum of Cultural History Gallery, University of California at Los Angeles, 1982), 99.

3 Angélica Vásquez, interview with author, Atzompa, Mexico, July 1990.

4 Ibid.

5 Dora Martínez-Virgil, Interview with author, Oaxaca, Mexico, July 1990.

6 Ibid.

7 Luis Blanco, interview with author, Atzompa, Mexico, July 1990.

8 Martínez-Virgil.

9 Blanco.

10 Marian Harvey, *Mexican Crafts and Crafts People* (Cranbury, N. J.: Associated University Presses, 1987), p. 85.

11 Mulryan, 99.

12 Wer Denton Besult, *Cerámica Mexicana* (Amsterdam, Holland: Katalog zur Ausstellung zeitgenossuchen El Puente Omlik Artesanel Tultenango und Autoren, 1986), 52, 53.

techniques. In 1990, he completed a commission of a clay cross for the museum's permanent collection, approximately two feet in height "with very fine detail," which was "well received."

Meanwhile, María has continued to develop her talent, but all her work is signed Luis Blanco in order to bring a better price. In her series of strong *Market Women,* she has incorporated turtles and lizards, but more unusual is *The Narrator,* an example of cross-cultural exchange (Fig. 32). *The Narrator* consists of a mother who sits, with her legs spread wide, with many little children clambering over her and each other to listen to the story she is telling. Luis explained, "Sometimes when I play my guitar and tell my children stories, they are very happy and dance." Therefore, *The Narrator* is a natural theme for María to explore, one whose image I'm sure, in time, she will personalize. A possible influence is the work of Helen Cordero of Santa Fe, New Mexico. Luis admits to having seen the work of this famous Native American ceramic sculptor, who has created very similar "Grandfather-Storytellers" for several decades.

Luis plans to expand his house (formerly Teodora's) to include a gallery dedicated to her, but it may be many years before he can realize this dream. Meanwhile, he and María enjoy the challenge of developing new themes for select competitions and commissions expanding both the Blanco family name and the legacy of earth-magic in Mexico and abroad.

Breaking
Boundaries

Native American Painters
Pablita Velarde and Helen Hardin

Tradition and Innovation

PABLITA VELARDE and Helen Hardin are among the few contemporary women artists of Native-American heritage to receive national and international recognition. Their paintings are at opposite ends of the artistic spectrum as Velarde, considered traditional, is known for her historically accurate and detailed images of Pueblo Indian life, while Hardin is modern, and her abstract geometric forms leave one with a feeling rather than a story.

During my visit with Pablita Velarde at her home in Albuquerque, New Mexico, in 1987, I became aware of the emotional relationship between Velarde and Hardin, as they are mother and daughter. Velarde, now sixty-eight, has painted consistently for more than half a century, while Hardin's career was cut short; she died in 1984 at forty-one. The first Native-American woman to insist she be considered an artist and not a craftsperson, Velarde can say, "I opened many doors for women. When I first started painting, there was no public interest or market for Indian art, but I was stubborn enough to stick to it, and then it took hold somehow."[1] Hardin first achieved recognition as "Pablita's daughter" when she began to show her little paintings with "Mom" at age nine. Later, Hardin opened a new door, rejecting traditional painting and developing her own style.

At present the strain of time is revealed in Velarde's deeply lined face, but she maintains her sense of humor, frequently revealed when she and her twenty-three-year-old granddaughter, Margarete Tindell, shared aspects of their family history. In her small adobe home, Velarde's walls are completely covered with a selective collection of her own and Hardin's paintings, "a legacy for my grandchildren." She also displays some of her large prize-winning dolls dressed in traditional Pueblo Indian garments (Fig. 1). Velarde told me, "I have always stitched cloth dolls while resting my eyes from painting." I also learned that Velarde is in demand in the Albuquerque public schools as a storyteller, "with my reward," she says, "making little kids happy. I like to watch their faces. When they like something, they show it so openly!" Storytelling is not only their family tradition, but through the years the storyteller has evolved for Velarde as an archetypal image.

During my intense two-day visit with Velarde and her family, I gained many insights into the personal development of two extraordinary American artists. Each artist, inspired by her Pueblo heritage, evolved unique means for making myths and

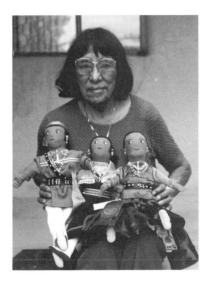

Pablita Velarde.

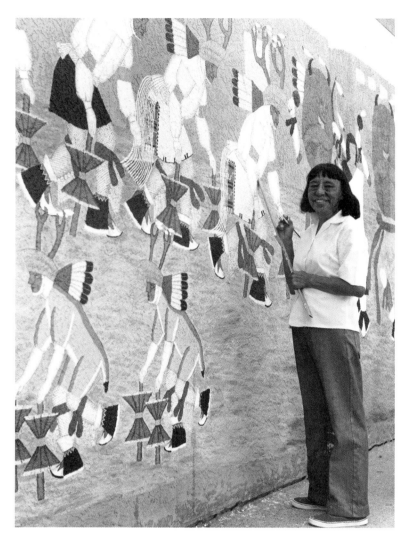

Fig. 1 Pablita Velarde painting *Buffalo Herd Dance Mural*,
Pueblo Indian Culture Center, Albuquerque, N.M., 1977. Photo
courtesy Pablita Velarde.

realities visible to a broad audience. In recent years, mainstream
appreciation for traditional and contemporary Native-American
art has increased, but the United States government still persists
in chipping away at Indian land, the root of their art and culture.

Pablita Velarde

Pablita Velarde was born 19 September 1918 at Santa Clara,
New Mexico, one of nineteen closely clustered Pueblo Indian com-
munities. Velarde's Indian name, Golden Dawn, was given to her
by her grandmother Gualupita, a Pueblo medicine woman. When
Velarde was very young, she temporarily lost her sight because of
an eye disease. She explained, "Temporary darkness made me
want to see everything. And I trained myself to remember, to the
smallest detail, everything that I saw." Velarde was five years old
when her mother, Marianita Chavarria, died, leaving Herman
Velarde with four young daughters. Unable to care for his chil-
dren alone, Herman, a farmer and rancher, persuaded the St.

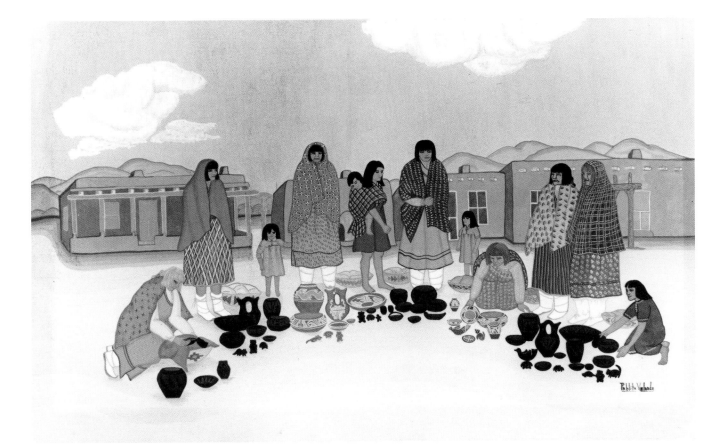

Fig. 2 *Pottery Sellers*, Pablita Velarde, opaque watercolor on board, 1947. Photo courtesy Philbrook Museum of Art, Tulsa, Oklahoma.

Catherine's Mission School, twenty miles away in Santa Fe to accept and board the girls. This was their first exposure to Anglo society and English; at home only the Pueblo language Tewa had been spoken. However, their cultural roots remained strong as each summer they returned home to Santa Clara.

It was fortunate for Velarde that, after completing the sixth grade, she was transferred to the United States Indian School in Santa Fe when Dorothy Dunn, a graduate of the Chicago Art Institute, began to teach there. "Determined to establish a studio devoted to Native painting, Dunn became the single most influential teacher for an entire generation of Indian painters." For many years, the Bureau of Indian Affairs had "barred all teaching of art to Indian children or any instruction in their native culture."[2] Pablita recalls that she and her older sister Rosita "were the only two girls in Dunn's art class, and the boys were so mean to us. If it were not for Dunn, I would never have been interested in painting, and I became determined, no matter what, that I was going to paint." Another significant career stimulus came from Tonita Peña (1895-1949), the first Native-American woman painter, who boarded for a few days at the school in Santa Fe while completing a mural project. Peña and Velarde became good friends as a result.

Being sensitive to her students' ethnic heritage, Dunn helped them use it to advantage. She believed her students should not

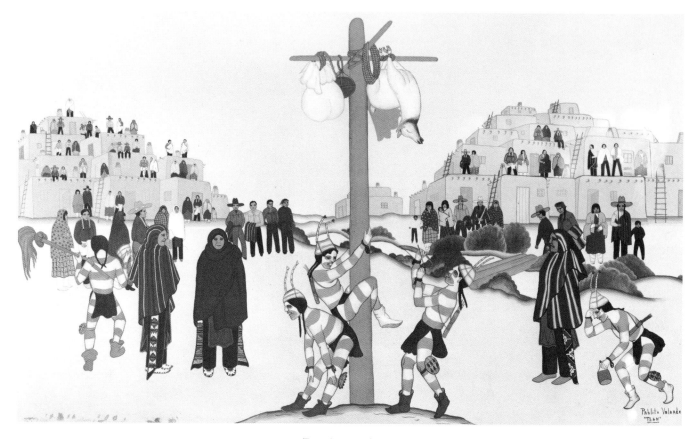

Fig. 3 *Koshares of Taos*, Pablita Velarde, opaque watercolor on board, 1947. Photo courtesy Philbrook Museum of Art, Tulsa, Oklahoma.

work from a model but from the memory of what they saw and experienced to develop self expression and self-esteem." She "used the radically advanced ideas of progressive education in an effort to overcome the students' feelings of inadequacy which stemmed from their sense of cultural minority."[3] Dunn also instructed them in the ancient method of grinding pigment from the local stones, a technique which Velarde still uses. Dunn's notion of what Indian painting should be was largely influenced by the rediscovery in the mid-1930s of prehistoric wall paintings from the Pueblo site of Kuana (Coronado State Monument), New Mexico. Her visual theory is exemplified by Velarde's paintings: "disciplined brush work, particularly a firm and even contour line; the flat application of opaque water-based paints; and the lack of shadowing except for the barest sculptural detail."[4]

Velarde's early paintings focus upon the daily activities of the Santa Clara women, including the production of black pottery for which they are still famous. Later she turned to her childhood memories of the annual seasonal ceremonies held in the plaza, the horses that she rode, or the birds, deer, and other animals that had often appeared at her door. It was as if she became a spectator of her past, in order to tell about her native culture to others. Velarde also assisted with several mural projects, and Dunn exhibited some of Velarde's early paintings in New Mexico and in Washington, D.C.

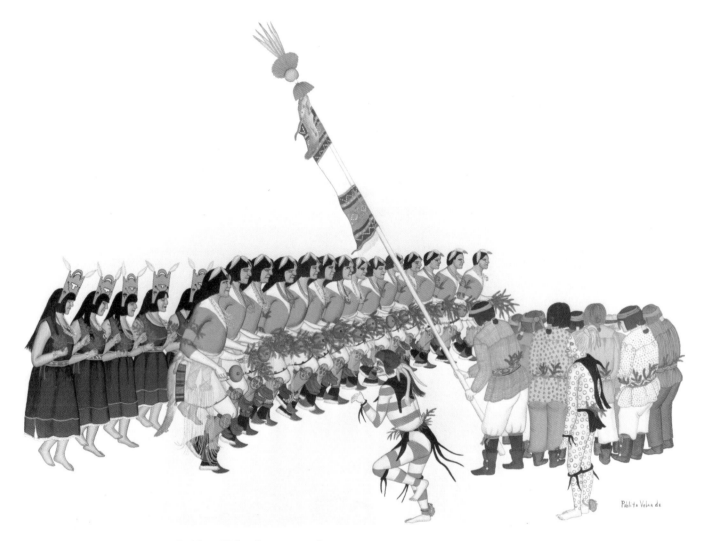

Fig. 4 *Keres Corn Dance*, Pablita Velarde, watercolor on paper, glued on board, 17 by 26 inches, 1949. Photo courtesy Philbrook Museum of Art, Tulsa, Oklahoma.

Velarde, the only member of her family to graduate from high school, returned to Santa Clara after her 1936 graduation, where she was employed part-time to teach crafts in the elementary school. She continued painting and was pleased when Dunn visited occasionally, offering encouragement and even replenishing some of her art supplies. During the 1930s, Velarde felt fortunate to display work on the porch of her home or the portals of the Santa Fe Civic Center and was especially grateful when "someone bought a painting for one dollar." Velarde was disappointed that her sister Rosita no longer painted. She explained, "Her husband was superstitious and made her quit. He believed that if his wife painted during pregnancy and made a mistake, left a finger off a hand or misshaped a person, the baby would be born with these deformities." Her other sisters, Legoria and Jane, have become renowned traditional potters. Velarde proudly displays their pottery in her home, along with a special collection of paintings, her own and Hardin's.

Further exposure to Anglo life occurred when Ernest

Fig. 5 *Old Father, The Story Teller*, Pablita Velarde, casein on board, 20 by 30 inches, 1955. Photo courtesy Pablita Velarde.

Thompson Seton, founder of the Boy Scouts of America, asked Velarde to accompany him and his family on their tour of the eastern and southern states. Velarde enjoyed her travels while taking care of the younger Seton children. Upon her return to Santa Clara, she began to construct her own home, adding rooms as she could afford to pay for the materials, most unusual for a single woman! In 1939 Velarde participated in the Federal Art Project, painting a mural of Santa Clara Pueblo life on the front of Maisels' Trading Post in Albuquerque. She was then asked by Dale King, the Park Service Director of Bandolier National Monument, commemorating the archaeological site of the ancient Indian Cliff Dwellers, to paint a mural at the Bandolier Museum. Velarde worked for nearly a year on a series of masonite panels, researching and painting her ancestral history with detailed accuracy. This project came to a temporary halt in 1940, when park funding decreased as the war had begun in Europe.

Velarde's next job was in Albuquerque as a telephone operator with the Bureau of Indian Affairs where Anglo-American Herb Hardin was also employed as night watchman. They married in 1942.

Mary Carroll Nelson summarizes Velarde's formative experience: At Santa Clara, the girls are free to choose their own husbands. The Indians do prefer that their daughters marry other Indians, either from Santa Clara or from other Pueblos. Pablita did not follow this preference, just as she had not followed other accepted ways of the Pueblo. She had not married young. She had not gone to the day school in the Pueblo, but instead had gone all the way through high school in the city. She had built her own home. She had taken jobs that led to travel and living away from home. She had used her talent to develop a reputation as an artist, an occupation thought of especially for men. Pablita was an independent person by nature, and something of a rebel in her own quiet way."[5]

When Herb Hardin was drafted into the army, Velarde followed him to Texas where their daughter Helen was born May 28, 1943. Velarde returned to Santa Clara for Herb Junior's birth in 1944. After the war, the family moved to California where Herb attended the University of California at Berkeley, majoring in criminology. However, as the moist climate posed health problems for Velarde, she returned with the children, leaving Herb to complete his studies. During the next five years she was able to continue her mural project at Bandolier National Monument where, she feels, "The public first got interested in my art." Many enjoyed observing her paint and became fascinated by her knowledgeable portrayal of Pueblo dress, homes, craft production, and ceremonial rites. In 1947, the family was reunited in Albuquerque where Herb found employment with the police force. The house into which they then moved and subsequently bought has been Pablita's home ever since. At first, her studio was in the kitchen, but now her easel is in one of the small bedrooms which also contains her collections of books, pottery, and plants.

For Velarde, a major career break came in 1949 when she won second prize at the Philbrook Art Center in Tulsa, Oklahoma, during the fourth Indian Annual Exhibition, for her painting *Keres Corn Dance* (Fig. 4). Velarde commented, "this is the first time that the men let a woman win." Soon this prize was followed by numerous other annual awards for her paintings. Velarde received the Palme Academique Award from the French government for her outstanding contribution to the field of art, and in 1955 she won all the top prizes at the competitive Inter-Tribal Indian Ceremonial in Gallup, New Mexico.

A sense of accurate detail and rhythmic unity is conveyed in *Keres Corn Dance*, a nineteen by twenty-six inch composition. Featured are a long line of male dancers followed by women, all in ceremonial dress. They are confronted by a Koshare, a clown who represents the trickster aspect of the psyche as he is unpre-

Fig. 6 *Dance of the Avayu and Thunderbird*, Pablita Velarde, watercolor, 12 by 15 inches, 1955. Photo courtesy Philbrook Museum of Art, Tulsa, Oklahoma.

Fig. 7 *Rabbit Hunt*, Pablita Velarde, casein on board, 20 by 30 inches, 1958.

dictable in behavior and is both humorous and mischievous. A group of men play the drum, one of whom faces the dancer carrying a long pole decorated with corn stalks.

In a 1947 painting, *Koshares of Taos* (Fig. 3), the background features the step-like Pueblo homes and ladders with people standing outside their doorways. They observe the antics of the Koshare in their black-and-white striped attire as they cavort around a pole from which sacrificial sheep are suspended. Also from this period is Velarde's *Pottery Sellers* (Fig. 2), a somewhat smaller, opaque watercolor on board. The women portrayed could be Velarde's sisters or aunts with their children, standing beside their pottery, displayed on the ground before them. The clay pieces vary from miniature children's toys to large bowls.

While receiving recognition for her art, Velarde also experienced the sting of racial discrimination from Anglo neighbors who referred to her children as "dirty Indians." Velarde's wise response to such situations was: "Accept what you cannot alter and work at what you can." In 1956, Velarde was commissioned to paint a mural for a restaurant in Houston, Texas, composed of masonite panels twenty-one feet in length. Much to her husband's consternation, she worked on this mural project in the driveway of their home. Because of personal conflict and career pressures, Velarde's marriage ended in 1957. Velarde took custody of the children while Herb Hardin, now employed by the federal government, was sent to Latin America.

Fortunately, consistent support for Velarde came in 1959 from the art dealers Margaret and Fred Chase of the Enchanted Mesa Gallery of Albuquerque, who began to exhibit and promote her paintings. She still shows at their gallery and considers them "close friends," fondly saying, "We're getting old now, but we've had some good times together. They helped me, I helped them." Velarde also recalls the years of struggle. "I painted like a fool day and night and tried to sell my paintings door to door, shop to shop, but," she sighs, "I made it!" Velarde distinguishes between "quick pictures to make sales to the general public" and her

"serious art for serious collectors." She has been known some years to complete over one hundred paintings, but now she does only what she wants and happily admits, "I sell everything I paint, even before they're finished and I've put on the last touch." Not only is Velarde prodigious, but she has achieved a position of professional acclaim open to few artists in our society. Dunn summarized Velarde's achievements in a 1950 review of her exhibit for *El Palacio*, the journal of the Museum of New Mexico: "Pablita Velarde's one-man [sic] show reveals the strength, depth and versatility of this Santa Clara woman as artist. This is not the work of a follower, but of a pace-setter."[6]

Velarde initiated another project in 1955 in conjunction with her father, a renowned storyteller. He was growing old, then seventy-eight, and she worried that the legends he had frequently shared with the Santa Clara Pueblo children during her childhood would soon be forgotten. Therefore, she decided to record and illustrate them. *Old Father, The Story Teller* (Fig. 5) was published in 1960 and selected in 1961 as one of the best Western books of the year. For many years this archetypal image of her father as teacher, philosopher, and storyteller surrounded by children listening to the Tewa creation myths has constantly reappeared in Velarde's work.

In another painting, *Dance of the Avayu and Thunderbird* (Fig. 6) Velarde has turned to the geometric patterns of Pueblo pottery for her theme and inspiration. In this symbolic composition, the avayu, a mythical serpent, spirals around two thunderbirds. Above, drops of water from rain clouds fall between the thunderbirds' pointed feathers. In *Rabbit Hunt* (Fig. 7), a "memory painting," painted on a twenty-by-thirty-inch board with casein, every aspect of the hunt is carefully portrayed, from the search and discovery of the rabbits in their holes to their final demise. The composition is very complex, and I agree with Nelson that "The unifying factor in Velarde's work is her design control. She is aware of both positive and negative areas in her compositions and handles them deftly."[7] *Deer Dancer* (Fig. 8) and *Buffalo Dance* from the 1960s are examples of Velarde's "earth paintings" for which she grinds a variety of stones into powder pigments on a metate or stone slab. She then combines each pigment with water and white glue in her muffin tin palette. After drawing her design in pencil on a masonite panel covered with pumice, Velarde applies as many as seven layers of color in her forms which she completes with a thin black outline. In each painting, the simple beige background suggestive of Pueblo symbols, homes, or rain clouds contrasts with the brightly detailed dancers and their ceremonial dress.

In discussing her intense work habits, Velarde humorously recalls, "My children, in self defense, learned how to cook so they didn't have to wait for Mama to stop painting." Velarde candidly remembers the conflict between herself and Helen. "I yelled and she yelled back. Helen's learning about art at home from mama was not enough. She needed to solo on her own. Once Helen got started with her art, nothing could stop her. I told her, `The world is big enough for the two of us.'" In 1960 Velarde was commissioned to create a series of four paintings on the Nativity for the Christmas edition of the *New Mexico Magazine*. With dominant blue and velvety purple tones, she portrayed Mary, Jesus, and Joseph as Indians in a New Mexico setting. Velarde is

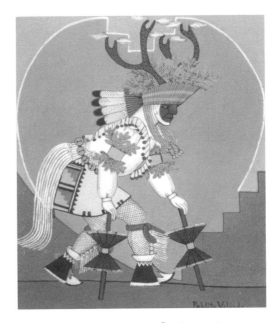

Fig. 8 *Deer Dancer*, earth pigment on masonite, 18 by 24 inches, 1962. Photo courtesy Pablita Velarde.

Fig. 9 Pablita Velarde with *Buffalo Herd Dance Mural*, Pueblo Indian Center, Albuquerque, N.M., 1983.

Fig. 10 *The History of the American Indian, Old Grandfather, Storyteller,* Pablita Velarde. Design for Franklin Mint Coins, ink on cardboard, 18 by 18 inches, 1975.

Catholic; "we were all baptized, we had no choice," she said. Nevertheless, the article points out, "The relationship Velarde has made between the Christian and Indian cultures infuses these paintings with a deeply emotional feeling, for it is a relationship she has experienced in her own life."[8]

In 1972 Velarde designed a poster depicting traditional Pueblo craft production, weaving, pottery, and jewelry, in support of a fund-raising campaign for the Pueblo Indian Culture Center. When this center, composed of a series of buildings, a theater, and a restaurant, was completed in 1977, Velarde painted a large acrylic mural in the courtyard. Velarde has said that the significance of the twelve by sixteen-foot *Buffalo Herd Dance* (Fig. 9), "is to honor the spirit of the animals killed in the hunt." She has also included a realistic portrait of herself as one of the dancers positioned between two hunters, wearing huge buffalo headdresses. This mural and four others, including one by Hardin, were partially funded by a grant from the National Endowment for the Humanities. In addition, Velarde created for the center's permanent collection four panels depicting the Tewa creation myths. In the 1975 celebration of International Women's Year, Velarde was included, along with Georgia O'Keefe, in the Albuquerque Art Museum's exhibit of outstanding New Mexico women artists, and she was also honored by the New Mexico Women's Caucus for Art. In 1977 Velarde received the Governor's Award for Outstanding Achievement in the Visual Arts and the following year an honorary doctorate from the University of New Mexico. Velarde and Hardin have been the subjects of several excellent documentary films produced for public television. Together Velarde and I viewed a video about Helen Hardin containing dramatic poetic interpretations of Hardin's symbolic imagery. "None of that swing and sway for me," Velarde commented. "I told them to make my film plain, like me."

I also accompanied Velarde to Santa Clara where her sister Jane and her daughter were working together as Pueblo women have for many centuries, shaping and designing a variety of black pottery and animal forms. In Jane's collection of Velarde's paintings I discovered *The Sand Dollar,* ten by twenty-four inches on masonite, painted around 1950. Velarde told me, "I did this painting for me, a long, long time ago, looking at all my pretty seashells that I brought home after a visit to Florida." She symbolically interpreted the sand dollar as "the cross of Christ, who brought peace to the hearts of many people," the red coral in the background as "the blood of Christ," the white doves as "the birds of peace," and the other shells as "the music sung at birth or death."

Some of the major changes at Santa Clara since Velarde's childhood are the introduction of electricity and television, indoor plumbing and paved roads allowing the visits of thousands annually. However, some changes were initiated by the Pueblo elders themselves about ten years ago when they realized that the young people were gradually losing their ability to communicate in Tewa. Tewa is now taught in the elementary schools, and, with the revival of the Pueblo language, young people have begun to participate more eagerly in the traditional ceremonies and dances. Velarde still remembers from her childhood how the missionaries referred to the Pueblo Indians as "wild, ignorant, and dirty Indians. This was their way to conquer us and make us feel inferior." As a result, Velarde recognizes, "there has been

much alcoholism as it was confusing for us to deal with two cultures. But now," she says, "it is easier for us. We talk back if we don't like what somebody preaches."

Velarde feels, "Indian people are confronting their problems." For example, at Santa Clara there is an alcoholic treatment center and a senior citizens' center. The Senior Citizens' Center gives the older generation a place to come together, to make and do things during the day, but also serves as an historical repository where young people can hear Pueblo legends and learn of past traditions and customs. Velarde's poster, created in 1987 as a fund raiser for the construction of a new center, features *Old Grandfather, the Story Teller.* Earlier in 1975 this same motif was used in her design for a limited edition Franklin Mint coin on *The History of the American Indian* (Fig. 10).

Velarde says she is "slowing down" as her eyes are beginning to fail her. However, she still participates in two major annual exhibits, the Eight Northern Pueblo Annual Arts and Crafts Show and the Santa Fe Indian Market. The market, begun in 1919, is an annual, two-day event attended by thousands of people from all over the world, in which Velarde has won numerous competitive prizes, including a total of thirty Best-of-Show Awards. She often earns a significant portion of her annual income at the Indian Market and was asked for the second time in 1987 to be one of the judges. Independent and outspoken, Velarde continues to paint while remaining close to her family—her son, a

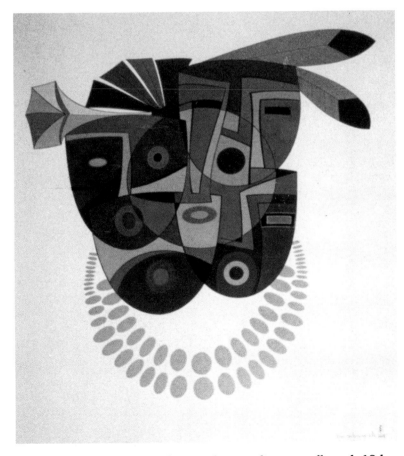

Fig. 11 *Indian Chant,* Helen Hardin, acrylic on cardboard, 12 by 18 inches, study for Pueblo Indian Culture Center mural, 1979.

metal sculptor, and grandson who live with her. Occasionally she is content to spend a day "looking through my books." She continues to participate in the ceremonial life of Santa Clara and is pleased that her seventeen-year-old grandson participates in the dances. In summarizing Velarde's career, Nelson points out that Velarde's paintings "have earned an international reputation and through her example, ancient barriers against women artists have come down. Today, painting is an open field for them, which pleases her."[9] Velarde, rooted in her culture and environment, remains modest about her accomplishments which are slowly being recognized within mainstream art.

Helen Hardin

For Helen Hardin, having a famous artist as her mother seemed both a blessing and a hindrance:

> I am not a traditional Indian—and I don't do traditional work. My mother is a great talent, but I don't wish to be compared to her. Our lifestyles are eons apart and so are our concepts. I almost decided against becoming an artist, because so many people used to say, "This is the work of Pablita's daughter." I wanted my own identity.[10]

Hardin first began bridging the gap between Native-American and Anglo cultures at six when she started school in Albuquerque. While majoring in art at St. Pius X High School, Hardin enrolled in a drafting class where she first began to use the architect's templates and other tools that later became integral to her personal image-making process. Hardin attended the University of New Mexico for one year, studying art history and anthropology, and then attended a workshop at the Rockefeller Foundation, Southwest Indian Art Project at the University of Arizona. However, she stated, "I never had any formal art training and I don't have to credit anybody; I am completely my own person."[11] Seeking motifs for her imagery in her Indian heritage, Hardin began to study Pueblo pottery designs and the ancient rock petroglyphs and pictographs. She was also influenced by Cubism through the paintings of Joe Herrera, one of the first Indian artists to incorporate cubist structure in his compositions of Indian life. A combination of acrylics, acrylic varnish, air brush, and ink washes became her principal media of expression. She signed her early paintings with her Indian name, Tsa-sah-wee-eh, or Little Standing Spruce, so that no connection could be made between herself and Velarde.

Hardin's first marriage in 1962 at nineteen was brief. After her daughter Margarete was born, as Velarde remarked, "Helen took life more seriously." By 1973, when she married Cradoc Bagshaw, a professional photographer, Hardin had already established herself as a professional artist. In order to promote Hardin's career, Velarde says: "I pushed Helen to visit her father in Bogotá, Colombia, in 1968 where he arranged her first show at the United States Embassy. Her show was a big success, and Helen was thrilled at being the center of attention. She sold twenty-three of her thirty paintings." Most of Hardin's early paintings were based on pottery motifs, but, after her Bogotá exhibit, Velarde believes, "She began to make better paintings. Later, she became interested in masks (as exemplified in her

Helen Hardin, photo courtesy of Pablita Velarde.

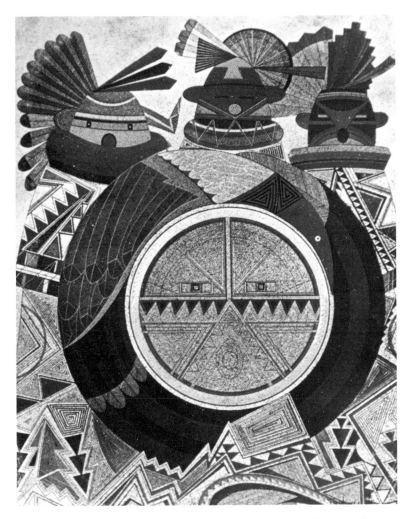

Fig. 12 *Carriers of the Father Universe*, Helen Hardin, acrylic, 20 by 16 inches, 1974. Photo courtesy Cradoc Bagshaw.

mural at the Pueblo Culture Center [Fig. 11]), a thing she could not let go, and I can't blame her... if that's what the public wanted to buy." Concerning art critics, Velarde says, "I close my ears and let them say what they darn please, but Helen was rebellious about ignorant and chauvinistic criticism and would fly into a rage."

In a review of Hardin's work, Lou Ann Farrus Culley states: Her use of symbols seems, if not actually forced, at least too self-conscious... however in Hardin's later works, these kinds of iconographical obscurities are simplified into a more sophisticated and effective approach in which the artist paints first of all to express her own feelings, her own "self" and then to share that self with her audience, Indian and non-Indian alike.

Early in her career—and she is only 35 years old now—Hardin developed a style which, proclaimed as professional and aesthetically exciting, has earned her a place among the leading contemporary artists.[12]

Typical of Hardin's early work is *Medicine Talk* (1968), in which three tall, blanket-wrapped men stand around a fire with

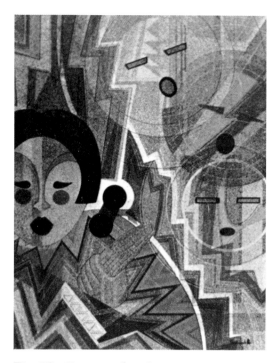

Fig. 13 *Prayers of a Blue Corn Mother,*
Helen Hardin, acrylic. Photo courtesy
Cradoc Bagshaw.

smoke drifting around them. Flowing patterns are imprinted on
their blankets, and the men's faces are realistically detailed. By
1972 Hardin had abandoned her curvilinear style for more con-
trolled, geometric forms and patterns, constructed with preci-
sion. Hardin gave clues about her imagery:

> A lot of my work has to do with fantasy and spiritual
> things, with giving a spiritual message. Sometimes that
> message was not even consciously intended, but it
> makes me happy when a painting does turn out to be a
> very spiritual thing. And it pleases me when people are
> touched by this.[13]

In *Carriers of the Father Universe* (Fig. 12), a symmetrical
composition, three tall red and green Kachinas are silhouetted
against a white background. The central Kachina, with arms
composed of eagle feathers, embraces a circular disc that can
represent the universe, a drum, or the sun. As Hardin's symbols
are not specific, it is possible to give them one's own interpreta-
tion. In her application of paint she juxtaposes flat against rough
textured surfaces that are reminiscent of desert sand or wind-
pitted rock. I particularly like *Prayers of a Blue Corn Mother*
(1974, Fig. 13), which is dominated by the partial figure of a
chanting woman holding aloft an ear of the sacred Hopi blue
corn. The background contains three other mask faces with over-
lapping patterns of circles, triangles, and rectangles. For the
Pueblo Indians, the corn plant is a living entity, known as their
mother, *Mother Earth,* or the Corn Mother. According to Jay
Scott, "*Prayers of a Blue Corn Mother* became a personal talis-
man, one of the few works along with *Chief's Robes,* that she
would not consider selling."[14]

Tricia Hurst Culley summarizes the broad appeal of Hardin's
work:

> These figures are more than representatives of one par-
> ticular religion. They can speak to anyone who has ever
> had a spiritual experience... Evoking the deities not of
> any one particular religion, but all religions.[15]

In Hardin's brief fifteen-year career she was to receive phe-
nomenal commercial success, recognition, and awards. A selec-
tive list of her one-woman shows includes: Heard Museum of Art,
Phoenix, Arizona, 1969; United States Information Service,
Guatemala City, Guatemala, 1971; Enchanted Mesa Gallery,
Albuquerque, New Mexico, 1971 and 1977; Kansas State
University, Manhattan, Kansas, 1977; and California State
University, Long Beach, California, 1980. She also exhibited in
1972 and 1973 with Pablita Velarde at the Enchanted Mesa
Gallery. When participating in invitational and competitive group
shows, Hardin repeatedly won Best of Show, the Grand Prize, or
First, Second, or Third Awards. Margarete Tindell told me that
"after age one, and until 40, my mother never missed the Santa
Fe Indian Market. It was the only public Indian exhibit that she
continuously participated in. She enjoyed the interaction with
the other artists and the buyers, though frequently her work was
sold while being unpacked from the car."[16]

Hardin became the subject of many reviews and articles and
is included in *Women of Sweetgrass, Cedar and Sage,* published
in 1985. Dedicated to Hardin, this is the first book to focus on
the work of thirty contemporary Native-American women artists
working in a variety of media, including clay masks by Lillian

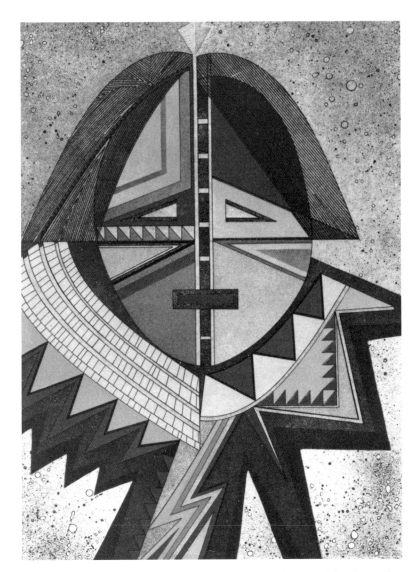

Fig. 14 *Listening Woman*, Helen Hardin, etching, 18 by 24 inches, 1982. Photo courtesy Cradoc Bagshaw.

Pitt, oils by Jaune Quick-to-See Smith, and beaded tennis shoes by Imogene Goodshot. In an interview with Tricia Hurst, Hardin offers the following comment in response to the question: "In what way, if any, does the fact that you are a female and an American Indian reflect in your work?"

"I'm a wife, a mother, and Helen Hardin, but I'm not aware of myself as a woman, woman, woman... and on top of that an Indian woman... In recent years there's been a lot written about the Indian artist and his or her *spiritual identity* (whatever the devil that is). I think many of the artists who lay claim to this are really mouthing the words to sell their work. It's what the white man wants to hear... I decided I would not be a bad Indian but a good person... I make the most out of two worlds and I think my work shows this."[17]

Further insights on feminism, art, and marriage were generously offered by her husband, Cradoc Bagshaw. "We both lived to work." However, Bagshaw stated, "Being a woman has never

Fig. 15 *Medicine Woman*, Helen Hardin, etching, 18 by 24 inches, 1981. Photo courtesy Cradoc Bagshaw.

been any big deal in Helen's career, yet in the end, she realized that was the key." Bagshaw particularly recalls some of Helen's early interaction with women gallery dealers who "preferred to play up to the Indian men artists." Bagshaw and Hardin were very supportive of each other's careers but especially enjoyed their times together, traveling across the country for exhibits or special events. Bagshaw commented, "At the beginning of her career, Helen did not pace herself very well, working long hours with little sleep." He also added, "Each painting—approximately 24 by 36 inches or smaller—took several weeks to complete, and she would have several in progress at one time... Though Kandinsky was her favorite artist, one of her paintings is titled *Masks After Picasso*."[18]

Bagshaw noted that Hardin started producing prints between 1970 and 1979 when "no one was doing etchings in the Indian art world." Helen worked at the El Cerro Graphics Studio creating images on copper plates which were then printed for her in editions of sixty-five. Her intricate use of color was developed with multiple etching plates to achieve effects of overlapping and

transparency. Several of Hardin's paintings have been made into etchings and posters, such as *Changing Women* (1981), for the Babe Dedrickson Memorial Golf Tournament to benefit the American Cancer Society. Bagshaw considers the four etchings of her *Women Series*, developed from 1980 to 1982, to be among Hardin's most powerful and personal images. They were created when she first began her battle with cancer. Hardin commented about this series, *Changing Woman, Medicine Woman, Listening Woman,* and *Winter Woman:*

> the only way I can describe it is that about every six years I become aware of myself as a woman, as a person growing through changes. I shift gears, I go through one stage to another and maybe stay on a slight inclination for a while—not a plateau, because on a plateau you are level—and then it is necessary to make a jump and go up to a higher plane. In this particular etching [Changing Woman], you see a full face, and you see a profile of half a person. Streaming from the mouth is the fact that something is going on inside me, I'm trying to say what is happening, but all I can say is that I'm changing.[19]

In *Medicine Woman* (1981, Fig. 15) and *Listening Woman* (1982, Fig. 14), sharp geometric designs permeate the interior of each circular face and then spiral out into the background, augmenting a sense of continuous movement in time and space. The overall design and color of each image hold the viewer's attention rather than any one specific detail or facial feature. The dominant yellow and tangerine orange tones are applied in both flat and textured layers. Hardin commented from her evolving feminist perspective, "What my series has to do with is all the capacities of woman. There is no body involved in this series, just brain."[20] She also added, "Women are also intellectual and emotional and sensitive, and that's what I wanted my series to be about—an intellectual series. My women do not have big boobs. (Or if they do, you don't see them.) My women have big brains. They are *all* brain."[21]

Her biographer, Jay Scott, describes this series of etchings as "a great synthesis, a powerful self-portrait: the artist as young woman and ageless Kachina. The geometry that sometimes dominated her work was more utterly subservient to an underlying emotion." Scott also notes that *Medicine Woman* and *Listening Woman* both focus close up on the features, but there is an added dimension:

> having been humanized and personalized, the women have become the repositories of a unique and unsettling combination of active anguish and covert ecstasy, *Medicine Woman* because her face is literally split in two, and *Listening Woman* because she appears, head hunched into her shoulders and eyes downturned, to have absorbed the sorrows of the universe... they are icons of the constancy of change, the timelessness of grief and the virtue of endurance.[22]

Margarete Tindell commented, *"Changing Women, Listening Woman* and *Medicine Woman* were her real deities. All the knowledge she had accumulated, everything she got out of her life, she put into these three women."[23]

Endnotes

1 Quotes from Pablita Velarde, unless otherwise noted, are from my interview with her conducted on 11 May 1987 in Albuquerque, New Mexico.

2 Jamake Highwater, *Song from the Earth: American Indian Painting* (Boston: Little Brown and Company, 1976), 74, 60.

3 Mary Carroll Nelson, "Pablita Velarde," *American Indian Art* 3 (Spring 1978), 51.

4 Highwater, 75.

5 Mary Carroll Nelson, *Pablita Velarde: The Story of an American Indian* (Minneapolis, Minn.: Dillon Press, 1971), 35.

6 Quoted in the introduction by D. Hancock in Pablita Velarde, *Old Father, the Story Teller* (Flagstaff, Ariz.: Northland Press, 1960), 14.

7 Nelson, 55.

8 "The Christmas Story, "*New Mexico Magazine* 38 (December 1960): 12.

9 Mary Carroll Nelson, *American Indian Art* 2 (Spring 1977): 57.

10 Quoted in Maryel De Lauer, "Helen Hardin," *Arizona Highways* 52 (August 1976): 44.

11 Ibid.

12 Lou Ann Farrus Culley, "Helen Hardin: A Retrospective," *American Indian Art Magazine* 4 (Summer 1979): 75.

13 Quoted in Lou Ann Farrus Culley, "Allegory and Metaphor in the Art of Helen Hardin," *Helicon Nine, A Journal of Women's Arts and Letters*, no. 5 (Fall 1981): 64.

14 Jay Scott, *Changing Woman: The Life and Art of Helen Hardin* (Flagstaff, Ariz.: Northland Publishing, 1989), 127.

15 Lou Ann Farrus Culley, "Crossing Bridges: Jaune Quick-to-See Smith, Helen Hardin, and Jean Bales," *Southwest Art* 10 (April 1981): 85.

16 Margarete Tindell, interview with author, Albuquerque, New Mexico, 11 May 1987.

17 Quoted in *Women of Sweetgrass, Cedar and Sage* (New York: Gallery of the American Indian Community House, 1985). This book was based on the exhibit "Contemporary Art by Native American Women." The introduction by Harmony Hammond and Jaune Quick-to-See Smith reads, "It is because of her strong sense of individuality, her early visibility as an Indian woman painter and her commitment to her work that we dedicated this exhibit to Helen Hardin (1943-1984)."

18 Cradoc Bagshaw, interview with the author, Albuquerque, New Mexico, 11 May 1987. All quotes from Bagshaw are from this interview.

19 Quoted in *Women of Sweetgrass, Cedar and Sage*, and excerpted from Jay Scott, "Helen Hardin's Subtle Revolt" *Toronto Globe and Mail*, (21 August 1982).

20 Ibid.

21 Scott, *Changing Woman*, 138.

22 Ibid., 137.

23 Ibid., 138.

24 Quoted in *Women of Sweetgrass, Cedar and Sage*.

25 Helen Hardin, American Indian Artists Series, PBS, produced by KAET Television, Arizona, 1975.

26 Scott, *Changing Woman*, 140.

27 Tindell.

Her husband reported that even when Helen was sick, she never refused interviews. Hardin told Scott in 1982

> Painting is my job; and it's my life. I don't want to be rich and famous; I want to be best. A lot of people consider me the number one woman Indian artist. I'm categorized as an Indian and then I'm categorized as a woman. So I have to try harder."[24]

In discussing her childhood, Tindell emphasizes that regular meals were seldom shared, but "there was always time for discussion, always time for each other." During the last six months of her mother's life, Tindell came home to care for her and noted, "When Mom got sick, she didn't have time to do it all. She continued to paint almost till the end from 7 AM until 5 PM... We also spent more time together... we would stop at Grandma's for coffee." Hardin's husband added, "In the end Pablita and Helen were reconciled." In the video of Hardin made in 1975, it is evident that she is secure in her talent and achievements: "I don't fear death. I'll always be here through my paintings... I want to be good at what I'm doing—the reward of living—and for those that survive me, it's the only thing I can give that's me."[25] In the spring of 1984, near death, Hardin said, "*Listening Woman* is the woman I am only becoming now. She's the speaker, she's the person who's more objective, the listener, the compassionate person."[26] Hardin achieved another one of her goals—recognition in the New York art market. "She made it," her husband believes, "and notices of her death appeared in the *New York Times* and *Washington Post* on June 7, 1984."

I was sorry to realize the burden of an artist's legacy for the living. Margarete Tindell, a multi-media artist now pregnant with her first child, hopes to achieve recognition "not as my mother's daughter but as myself." At present she feels "stuck with my commitment to continue promoting my mother's unsold work. It shouldn't be a priority in my life, except that mother's reputation is so outstanding, I have to keep it going for now." She also hopes that Hardin's work will be purchased for more public rather than private collections.[27]

At the end of my intense visit with Velarde and Tindell, I felt that I had been with three women; the presence of Hardin is still vital and strong. Velarde and Tindell are close, and Velarde smilingly tells me, "I can hardly wait to hold my first great grandbaby in my arms."

Chinana Artist
Patricia Rodríguez
Public Murals, Private Visions

IN 1974, Patricia Rodríguez (Fig. 1) was one of the original founders of the group Mujeres Muralistas—Women Mural Painters—and so realized her childhood dream of becoming an artist on a monumental scale. This collective group of seven women artists of mixed Latin heritage began to work together out of a shared common need. It is currently responsible for eighteen major murals in San Francisco's Mission District, executed on the walls of elementary and secondary schools, in parking lots, and in housing developments. Their first murals were painted on the garage doors and back alley fences of Balmy Alley where Rodríguez lives. I first met Rodríguez in 1983. While visiting her in 1991, I became aware of the deterioration of some of the murals which had weathered and had been defaced by graffiti. However, Rodríguez informed me that she had recently been commissioned by the city to restore one mural. One hopes others will be restored since they are a unique part of San Francisco's cultural legacy.

Rodríguez was born in 1944 in Marfa, Texas, where her grandfather had come from Mexico in search of work. She recalls that at home "I always helped to do craft work." Her mother and her grandmother, whom she considers "folk artists," were constantly involved in embroidering cloth, sewing dresses, decorating cakes, and painting signs for political campaigns. Rodríguez went to school "off and on" and observes that "my folks were farm workers and we migrated through the Southwest."[1]

"I started school officially at age 13, a little embarrassing being so old, but I was determined to go on. It was difficult. I was put in a special class for the mentally retarded, a room for repeats, for minority kids. I decided not to let that bother me."

Under these conditions, it is surprising that Rodríguez not only finished high school at Oxnard, California, where the family had moved but also dreamed of going to college.

My folks wanted me to get a decent job, to be able to buy good clothes and have a car ... but I wanted more. My folks said, "Girls don't go to college. They get married, have babies," and my mother insisted that I become a secretary... I really wanted to become an artist, but I was programmed not to be one by my family, teachers, the priest, and my peers. Then I realized I had to take that step for myself.

Her dream came true when she won a scholarship to the San Francisco Art Institute in 1970. Several factors in her education-

Fig. 1 Patricia Rodríguez, 1990, San Francisco, California.

al experience there led to the formation of the Mujeres Muralistas in 1974. Rodríguez received no support from her instructors. They told her, "Your colors are so bright"; "We don't want your work to be so emotional." She also recognized that many of her Chicano male colleagues were getting exhibits. "We (women) were left out. We were on the same level, but we weren't getting invited." Finally she urged several of her Latina artist friends, "Let's do something about this. Let's paint a mural, do it big, with fanfare, and set the stage for recognition."

The Latino background shared by the Mujeres Muralistas enabled them to work well together. In their countries of origin—Mexico, Guatemala, Bolivia, and Venezuela—several generations of women have traditionally had to support one another in the same household in order to maintain the heritage of the family unit as well as that of the culture. Therefore, when the Muralistas obtained their first major commission, a wall twenty by seventy-five feet at a Mission District public housing project, they were able to develop a creative approach that not only incorporated all of their individual ideas but also presented a unified vision.

They recognized that their working together is really important because it takes us beyond the level of individualism. The

works of art no longer belong to the artists, they cannot be kept in private collections nor can they be sold in galleries. The walls belong to no one. They are there for the community and to the sight of everyone.

Prior to each mural project, the Mujeres Muralistas research the different aspects of their theme for the exact details of clothing, geographical environment, or activities represented. Because most murals are usually designed by one artist, the collective aspect of Mujeres Muralistas was challenging and produced unique results, the constant exchange of ideas, the discussion of the sharing of space, and the adaptation of their individual easel painting skills to large wall spaces.

Victoria Quintero described a Muralistas project painted on a long parking lot wall of the neighborhood restaurant Paco's Tacos in *The Potrero* on 13 September 1974: never before had San Francisco witnessed women "put scaffolds together, climb them, mix the paints, dream the dreams and in an attempt to capture the magnificence of their visions, surround us with colors and images of life."[2] The central theme of the Paco's Tacos mural, *Para el Mercado* (*To the Market*), is food production and distribution portrayed through a montage of images featuring the Indian, Mestizo, and Black peoples of Latin America. Women, children, and men plant, harvest, fish, cook, or market their produce. Women carry huge baskets of bananas on their heads, and men use their machetes to cut bunches of bananas from plants (Figs. 2, 3, 4). The background behind the diverse figure groupings varies from lush tropical vegetation of palm trees filled with parrots to more arid soil where chickens scratch or to clean streams of water where fathers and sons are fishing. Many women are shown wearing their unique traditional, embroidered

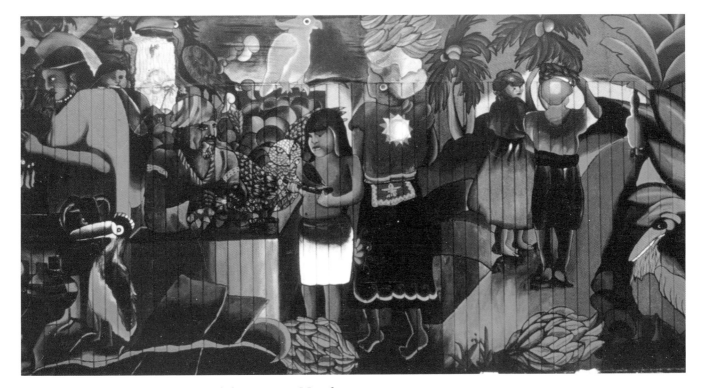

Fig. 2 *To the Market*, mural detail, by Mujeres Muralistas, Paco's Tacos, Mission District, San Francisco, California, 1974.

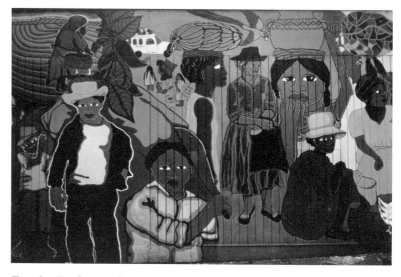

Fig. 3 *To the Market*, mural detail, by Mujeres Muralistas,
Paco's Tacos, Mission District, San Francisco, California, 1974.

garments while others wear contemporary urban clothes. These
colorful scenes reaffirm a rich cultural heritage in an area where
fast-food chains are increasingly penetrating.

The Mujeres Muralistas have responded to criticism of their
work:

> Many people have told us that our work is pretty and
> colorful, but that it is not political enough. They ask us
> why we don't represent the starvation and death going
> on in Latin America or even the oppression of women...
> Our intent as artists is to put art close to where it needs
> to be: close to the children, close to old people who often
> wander the streets alone, close to everyone who has to
> walk or ride the buses to get to places. We want our art
> either out in the streets or in places where many people
> go each day: the hospitals, health centers, clinics,
> restaurants. We feel it is important that the atmosphere
> of the world be surrounded with life: WE OFFER YOU
> COLORS WE MAKE.

Bruce Nixon considers mural painting to be "the first public
sense of a true, emergent Chicano art," which "proved to be a gal-
vanizing force for both trained and untrained artists living in
Chicano communities." The symbols and motifs integrated into the
murals are part of a communal heritage that reflects the artists'

> social responsibility and an irrevocable sense of commu-
> nity... creative motives that Europeanized artists, with
> their romantic view of the artists' role, cannot truly
> understand or even appreciate.[3]

By 1980 Rodríguez came to the realization that she had
other needs to fulfill: "I also had to do something personal for
myself, to create more intimate work for gallery exhibits that
could reflect self-exploration." Her turning inward for inspiration
also coincided with "a growing number of feminist art galleries,
and the possibilities for exhibitions of smaller, more intimate
works." From the outset of the "privatization of Chicano art,"
positive images of active women began to appear, "heroines from

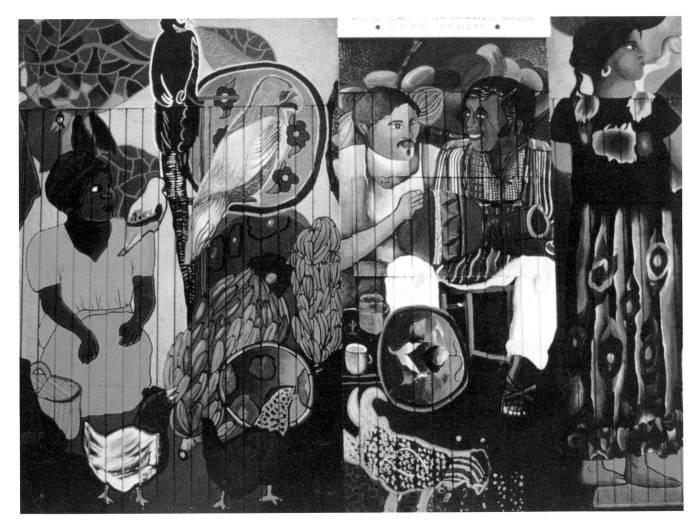

Fig. 4 *To the Market*, mural detail, by Mujeres Muralistas,
Paco's Tacos, Mission District, San Francisco, California, 1974.

the Mexican Revolution, women associated with alternative schools and clinics, working women, women in protest, active women who shape their lives and environment."[4] Shifra Goldman notes that Frida Kahlo became an important role model:

> The whole feminist movement was fascinated by Frida Kahlo; but for Chicana artists she provided a needed role model. Not only was her art of great interest and beauty, not only did it incorporate or absorb the pre-Columbian and folk imagery of Mexico which were vital strands of Chicano cultural nationalism in the seventies, but her whole life lived as a work of art, was intriguing... and use of the self portrait as a mode began to appear in many Chicana works.[5]

In her 1980 one-woman show Symbolos y Fantasias at the Mission Culture Center, Rodríguez featured easel paintings, sculptures, and box-assemblages. According to Rodríguez, the art critic Thomas Albright of the *San Francisco Chronicle* referred to her work as "taco art." Rodríguez comments, "Our art doesn't fit into any European art history category that he studied. He likes it, but he doesn't know why. Yet he gave us visibility and

Fig. 5 *Chicana-Mexicana*, oil on masonite, 24 by 36 inches, 1978. Photo courtesy of Patricia Rodríguez.

recognition even when he was putting us down culturally. He considered us 'powerful in the symbolism and imagery' that we project."

A powerful two-by-three-foot oil painting from this exhibit, *Chicana-Mexicana* (Fig. 5), features a woman with two heads which Rodríguez describes as representing "our duality, both inside and outside of ourselves as we strive to become conscious of who we are." One head is cast downward in repose while the other is open-eyed or conscious. Both heads are connected to a single transparent heart and spinal column the latter of which supports the full breasts of both women. The wild strands of hair suggest the Mexican eagle, a symbol of power.

In Nixon's discussion of "the inherent power of symbols of myths and common motifs" in Chicana art, he considers them "abbreviations that are packed with significance for those who know how to recognize them." In response to outsiders who "may feel that Chicano artists have hidden some of their individuality behind this ready-made symbology" as a "ready convenience," he responds, "That's precisely the point," and refers to the artist as a "social functionary in regard to mural painting, with a sense of responsibility to the community."[6]

During the 1980s, Rodríguez turned exclusively to creating boxes and assemblages in order to explore communal as well as personal images, remembrances, and dreams. Her boxes are related to the tradition of home altars that are rooted in the ancient Mayan and Aztec cultures and, in more recent centuries, in Catholicism. Home *nichos* usually contain a statue of the Virgin or a saint, flowers, votary candles, photos of family elders, and small mementoes. Rodríguez began her early boxes by creating plaster masks of artists such as Rene Yaenz, director of Galeria de la Raza, and other Chicanos/Chicanas who were friends and important role models within the community (Fig. 6). She then incorporated mementoes from their lives or related social events. "I fell in love with this medium," Rodríguez said, "and then I began to play with it." Her boxes vary from a depth of four to six inches to twenty or more in height, and approximately ten in width. The exterior can resemble a church, house, or tower. Some have doors that open to reveal assemblages composed of both collected and handmade objects: plaster mask-portraits, dolls, bones, pottery fragments, nails pounded into objects (sometimes hearts), photos, jewelry, varied fabrics, textures, any item related to the box theme or person.

Within the box, *Tribute to My Grandmother* (Fig. 7, 1982), is another small, vertical white box that is open, revealing a painting of Rodríguez's grandmother in a long white dress. Nailed around the box lid are little metal cutouts of arms, legs, and hands associated with the custom of painting retablos that describe a miracle cure surviving a disaster. It also contains a small sewing machine and a miniature basket on a white shelf bordered by small red hearts. A piece of crochet fills the background, while rusty metal scraps are nailed to the bottom of the box, a symbol of the land of Marfa. She considers this box an "altar piece, an offering to someone I love."

In reviewing the exhibit, Objects and Apparitions, Tomas Ybarra-Fausto describes Rodríguez's link to poetry, she composes disparate objects into metaphors:

Her mask-shadow boxes are strong statements of origi-

Fig. 6 *Artists*, box, mixed media, 30 x 15 x 12 inches, 1980.

nality, personal invention and exorcism. They both reveal and conceal. The shadow box construction is like a diminutive theater. It is three-dimensional, with a mask-personage enclosed within a proscenium. There are props but there is no action save the triggering of the imagination. Sumptuous conglomerations of objects and talismans related to the person evoked by the mask yield up notions of nostalgia, invocations of historical moments, lyrical flights and playful paradoxes. Flashes of ironic wit and humor attest to the strength and iconoclastic vision of the personalities presented.[7]

California Art Commissioner Amalia Mesa-Baines, also recognized for her elaborate altar constructions, offers a feminist historical perspective on Rodríguez. She traces two strands of women artists' involvement in ritual:

> "*part of a continuous tradition of domestic folk ritual*" within minority art communities and the "*reclamatist*" phase instigated by the latest wave of feminism, which has pursued the secret history of women. These altars become the most political of statements. They were the outgrowth of the individualized oppression in the most private places of the domestic chamber, the bedroom and the kitchen.[8]

Fig. 7 *Tribute to My Grandmother*, box, mixed media, 18 x 24 x 5 inches, 1982. Photo courtesy of Patricia Rodríguez.

In 1986 Rodríguez participated in Chicana Voices and Vision, a national exhibit of twenty-seven Chicana artists from five states. Dr. Shifra Goldman, the exhibit curator, spoke of the need of Chicanas "to be able to share, to be listened to, but most of all, the need to see themselves... in works done by other

Fig. 8 *Rock Machismo* or *Rasquachismo*, 1988. Photo courtesy of Patricia Rodríguez.

Chicanas. La Chicana needs to come to know the many-faceted woman that she is."[9] From 1983 to 1991, Rodríguez participated in more than thirty regional, national, and traveling group shows, on the following themes: Miracles, Rites and Other Things; "Visible Truths," Traditional Sources within the Chicano Aesthetic; Ceremony of Memory; Chicano Art: Resistance and Affirmation; Echoes of the Spirit; Ancestors Known and Unknown; and Vinculos, Latin American Mysticism and North American Materialism. These group exhibits, frequently initiated in private or university galleries and occasionally in museums, traveled across the country with showings in Texas, Arizona, Louisiana, Georgia, Florida, and New York.

To support herself, as well as pay the rent for her studio, Rodríguez currently holds two jobs. She teaches part-time at various colleges and is full-time director of the YWCA Mission Girls Service Program within a local high school. This voluntary program focuses on teenagers who are experiencing severe problems and are potential school dropouts. Rodríguez offers them intensive personal and group counseling, help with homework, etc. She also has developed an extensive program of cultural stimulation that includes attending cultural events as well as meeting Latina dancers, artists, musicians, and actors. She also organizes workshops for her students encouraging them to explore their potential talent and skills. They have "high energy," Rodríguez says, and, in turn, "they give me energy."

At Rodríguez's Industrial Park Studio (a large space that she has shared with another artist for the past two years), I observed

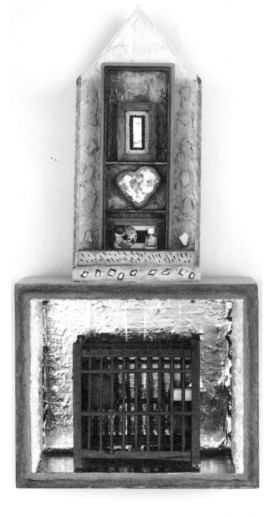

Fig. 9 *Recuerdos de Mi Casa*, box, 12 x 24 x 16 inches, 1990. Photo courtesy of Patricia Rodríguez.

Endnotes

1 All quotations unless otherwise cited are from interviews with Patricia Rodríguez at her home and studio in San Francisco in 1983 and 1991.

2 Victoria Quintero, *The Potrero*, (San Francisco, California) (13 September 1974). From news clipping in artist's possession.

3 Bruce Nixon, "Art with an Historic Mission," *Artweek* (San Jose, California) 25 (September 1990), 20.

4 Shifra Goldman, "Portraying Ourselves: Contemporary Chicana Artists," in *Feminist Art Criticism*, ed. Arlene Raven (Ann Arbor, Mich.: UMI Research Press, 1988), 194.

5 Ibid., 194.

6 Nixon, 20.

7 Tomas Ibarra-Fausto, *Metamorphosis*, Seattle, WA, 1981. From news clipping in artist's possession.

8 Quoted in Lucy Lippard, *Mixed Blessings* (New York: Pantheon, 1990), 82.

9 Goldman, 187-88.

a selection of her box projects from 1982 to 1991: *Porta Shuttle* (1989), which attempts "to take culture up into space"; *Greener on the Other Side* (1991), an exploration of "always wishing to have what others have"; and *Vanity Chest* (1991), which Rodríguez says "is dedicated to the spirits, of life. We have the tendency to want to take everything with us when we die." *Genocide* (1983, Fig. 8) is a long, narrow box, painted stark white, containing a series of cut-holes from which white doll hands emerge. When I asked Rodríguez why she painted everything white instead of black or brown, she said, "What difference does it make when babies die?"

In describing the contents of *Recuerdos de Mi Casa* (1990, Fig. 10), Rodríguez refers once again to her memory of growing up in Texas with her grandmother. Within the rectangular box which forms the base, there is a square black cage that symbolizes "the oppression of women." Perched above is a narrow, steeple-shaped box, bordered with fragments of broken tile and projecting nails. The three compartments within the steeple contain a small mirror, a heart, a padlock, and a glass jar filled with earth. While Rodríguez refers to the "beauty of growing up in Marfa," the cage also alludes to social controls and difficulties.

In *Rock Machismo,* or *Rasquichismo* (1988, Fig. 9), Rodríguez expresses "the poetic, funky side of Latin culture. It is a pun about the church." At the base of this symbolic church are a series of blank cartridge shells pointing upward. Suspended from the inner roof is a dismembered white porcelain doll. Rodríguez's boxes are filled with uneasy messages that make us reconsider family, home, and religion with non-stereotypical cliches. She says, "my works are a vehicle where spiritual messages are expressed. Each construction has its own self-consciousness that is both a personal, spiritual, and socio-political feminine statement."

Currently Rodríguez is also exploring the construction of larger sculptural floor pieces exemplified by *Venus/Quinciñera* (1991). This six-foot-tall structure is composed of an oval shaped frame, bordered with small oval light bulbs. Representing the symbol for women, it rests upon a cross composed of old railroad ties. *Venus/Quinciñera*, which evokes the traditional party for a fifteen-year-old girl, refers to her future, to "women's child bearing, suffering and oppression." *Venus/ Quinciñera* was displayed in Rodríguez's studio along with other works during a recent studio tour sponsored by the San Francisco Museum of Modern Art.

While Rodríguez is benefitting from the current national "Latin Boom," giving more than usual exposure to Latin artists, the historian Goldman is concerned with the future. She refers to mainstream exclusionary policies that have resulted in "a distorted view of the whole of modern art, generally, and the scope of art from the Americas in particular."[10] Does the current "Latin Boom" indicate a policy change for the future, or is it just another passing fad. Rodríguez's aesthetic commentary related to her Chicana roots indeed broadens our perception of American history, art, and life.

Yolanda Lopez

Breaking Chicana Stereotypes

Fig. 1 Yolanda Lopez, 1990.

Yolanda Lopez's art, "driven by love, rage, and a sense of irony,"[1] evolved in new directions between our two meetings in 1983 and 1991.[2] The small San Francisco apartment she shares with her husband, Rene Yanez, and their nine-year-old son Rio is cluttered with the art materials they share as well as an extensive collection of Lopez's found images. They range from ceramic knickknacks of sleepy Mexicans with large sombreros to examples of commercial packaging and advertisement featuring Latin American stereotypes. The ideas that Lopez (Fig. 1) generates from this collection are dynamic in scope; evidence of this scope appears when brought to fruition as gallery installations or in the form of slide-lectures and videos. Lopez's current multimedia presentations, along with her drawings, graphic designs, and paintings of the past two decades, have had a significant impact upon her community where she is the educational director for the Mission District Culture Center. Lopez is also visiting instructor at the California College of Arts and Crafts. She has taught at the University of California, Berkeley, in Ethnic Studies and has been a California Arts Council member. In addition, she has also participated in many local and national exhibits.

Raising public consciousness of the misrepresentation of Chicanos in mainstream American culture has been one of Lopez's consistent aesthetic goals. The term Chicano/Chicana evolved in the 1960s. It is related to the birth of a cultural movement stirred by the Civil Rights struggles and other political events such as the Delano, California, grape-workers strike led by Caesar Chavez. Chicano refers not only to Mexican Americans but also to their mixed heritage, both Native American and Spanish. In discussing a context for viewing Chicana art, historian Shifra Goldman points out that

> The pith and essence of what is presented by Chicana artists derives from a specific social history, the lived experiences of that history, and the matured reflections made on that history by artists born Chicana in "occupied America."[3]

Yolanda Lopez was born in San Diego, California, in 1942 and recalls "I've always made drawings. In first grade there was a chalk board, and, while the boys drew airplanes and bombs, I did little farm kids with straw hats." Spanish was spoken at home by her mother, three sisters, and grandparents, who came

Fig. 2 *Daughter: Yolanda Lopez* (*Three Generations of Mujeres*), charcoal and conte crayon on paper, 4 by 8 feet, 1977. Photo courtesy of Yolanda Lopez.

from Mexico. Their economic survival was precarious, depending primarily on Lopez's mother who worked for thirty-two years, first in a hotel laundry as a presser and seamstress and later at San Diego's Naval Training Center. Her grandmother cooked for the family and grew many of the fruits and vegetables they ate. Lopez's schooling proceeded with difficulty as she did not understand English and had to "repeat the first grade two or three times." However, her artistic ability was recognized early, and in high school she was encouraged by one of her teachers to apply to the College of Marin, north of San Francisco.

Lopez experienced "culture shock" at the College of Marin and then later when she continued her studies at San Francisco State University. There she heard Blacks and Chicanos "speak out" on various political issues. She realized, "I didn't know anything about my own history or Mexican heritage." Lopez joined student organizations to promote Ethnic Studies programs and more minority scholarships. However, she asserts, it was not until she dropped out of school and moved to San Francisco's Latino Mission District, "My art, politics, and personal history all came together." In San Francisco, she became involved in organizing a neighborhood health clinic, providing legal aid for Mission residents, recruiting for Vista, doing social work at the Bayside Settlement Housing Project, and acting as court artist for the political trial of "Los Siete" ("The Seven"). As a result of these formative experiences, Lopez found a direction for her art and "a sense of audience, who I was doing my art for. The streets were my gallery... posters, leaflets, lapel buttons, and graphic art for neighborhood newspapers. I saw my work everywhere, and unsigned." Ironically, when Lopez later exhibited many of these political images in a group show at Galeria de la Raza in 1970, it was a "mind blower" to her that people had assumed all along that all these unsigned graphic expressions were the work of a man.

After nine years of intensive political activity, Lopez experienced "total burnout." She then returned to San Diego and her family in order to focus on her own personal development as an artist. There she completed her Bachelor of Art degree, and, after receiving a Ford Foundation Fellowship in 1973, she entered the graduate program at the University of California at San Diego. Then she experienced another "culture shock." Lopez was humiliated by her teacher, Alan Karpow, who insisted "Ethnic art is dead, corny and a rehash." She feels that "I couldn't speak the same language as my teachers. I spoke theirs, but they wouldn't bother to learn mine."

Her earliest imagery evinced "double themes," "my own art work versus the work for school, as it took me a long time to get hip, to realize I could really do what I wanted to do." Chicana women in relation to mainstream society became the theme for her extraordinary three-part graduate art project. First, she created a series of larger than life-size drawings titled *Three Generations of Mujeres*. These four-by-eight-foot, realistic, non-idealized, monumental drawings of "ordinary women," *Daughter: Yolanda Lopez* (Fig. 2), *Mother: Margaret S. Stewart* (Fig. 3), and *Grandmother: Victoria F. Franco* (Fig. 4), were made to "work against traditional commercial stereotypes" of Latina women such as "the sexy bombshell or the passive, long-suffering mother."

In the extensive 1978 catalog to her graduate exhibit, held at the Mandeville Center for the Arts in La Jolla, California, Lopez

describes these monumental drawings:

> They stare right back at you. *Three Generations*: They know who they are and demand acceptance on their own terms... An exchange happens between the image and the viewer. Each women addresses the fact she is being observed. She is not shy or intimidated. The grand size of the image is complemented by the confidence each woman radiates, each in her own style... As Raza, as Chicanos/Latinos we yearn to see ourselves reflected as part of humanity.[4]

In describing the image of *Grandmother: Victoria F. Franco*, Lopez reminds us that "she is my grandmother. She is all our grandmothers," and that "qualities of a life lived with dignity and self-respect are not limited to my family. They are qualities shared by many women who are not part of the majority culture's concept of being female or feminine," and "as an artist it confirmed my belief that the subject of art resides within our own lives."[5]

The second part of Lopez's graduate project is a series of self-portraits titled *A Donde Va Chicana?* or "Where Are You Going Chicana?" Lopez depicts herself as *The Runner*, painted on canvas, approximately four by five feet, with acrylic and oil. These images are based on her jogging in order to lose weight and gain control of her body. In each painting the long, lean figure of Lopez, the runner, is depicted realistically, wearing shorts and a tee-shirt. The intense California sun casts shadows on her form as she runs by the Mandeville Center (Fig. 5). Lopez describes this series from the perspective of "a woman calling on her body in an assertive and physically disciplined manner as a power ally."[6] For Lopez, *The Runner* has a threefold significance: "It is female. It is Chicana. It is a self portrait. The metaphor extends from the symbolic fortitude of women to the literal image of a Chicana's struggle in a formidable institution."[7] Lopez compares a runner's "short-lived speed with women's psychological and physical sustaining power of endurance." She concludes, "Endurance is one of our greatest survival tools."

In her third series titled *Our Lady of Guadalupe*, Lopez utilizes the radiating light associated with Guadalupe, the perfect compassionate virgin and mother, as a means for creating symbolic transformation. She defies "the weight of tradition that immobilized woman as a mythic image and fixed her in the form of a statue, thus depriving her of any possibility of action or creative initiative."[8] However, in considering the surface disappearance of the ancient, indigenous, and supreme goddess of creation and her re-emergence as the Christian Virgin, Lopez notes that this ancient goddess was not totally suppressed but transformed.

> The Virgin of Guadalupe was the Americas' first syncretic figure... the pan-mexican icon of motherhood and *mestizaje*, a transitional figure who emerged only fifteen years after the Conquest as the Christianized incarnation of the Aztec earth and fertility goddess Tonantzin and heiress to Coatlicue, the "Lady of the Snaky Skirt," in her role as blender of dualities.[9]

Lopez transforms the Virgin of Guadalupe in her oil pastel series on paper, each approximately twenty-eight by thirty-two inches, celebrating the lives of ordinary women. In *Our Lady of Guadalupe: Margaret S. Stewart*, the rounded, stoop shouldered

Fig. 3 *Mother: Margaret S. Stewart* (*Three Generations of Mujeres*), charcoal and conte crayon on paper, 4 by 8 feet, 1977. Photo courtesy of Yolanda Lopez.

Fig. 4 *Grandmother: Victoria F. Franco* (*Three Generations of Mujeres*), charcoal and conte crayon on paper, 4 by 8 feet, 1977. Photo courtesy of Yolanda Lopez.

form of her mother is portrayed seated at her sewing machine stitching gold stars of hope upon Guadalupe's deep blue robe. An angel with striped red, white, and green wings, the colors of the national flag of Mexico, regards the viewer from under the robe on the floor. Tired and bespectacled, the mother at rest from her work also gazes at the viewer with the rays of light normally reserved for Guadalupe softly radiating behind her. Lopez composed this painting in homage to all working mothers (Fig. 6).

> I feel living, breathing women also deserve the respect and love lavished on Guadalupe... It is a call to look at women, hard working, enduring and mundane, as the heroines of our daily routine... We privately agonize and sometimes publicly speak out on the representation of us in the majority culture. But what about the portrayal of ourselves in our own culture? Who are our heroes, our role models? ... It is dangerous for us to wait around for the dominant culture to define and validate what role models we should have.[10]

In a second portrait, *Grandmother: Our Lady of Guadalupe*, Lopez portrays her grandmother seated on a chair covered with a blue-starred robe while a large aura of light emerges behind her. She looks at us as if to say "This is how it is." Upon her lap, her crossed hands hold a snake skin and a knife. These are both symbols of her enduring connection with the soil, in providing food for the family. Once again the winged angel emerges behind her as if trying to raise a garland of flowers for this virgin's head (Fig. 7). In contrast to the sedentary forms of her mother and grandmother, in the third painting, *Portrait of the Artist: Our Lady of Guadalupe*, we see Lopez holding the blue cape over one shoulder with one hand a live snake in her other hand, as she energetically seems to leap forward toward the viewer. She wears a dress that reveals her muscular legs. Rays of light emanate from behind her form, and her facial expression is confident and smiling (Fig. 8). *Portrait of the Artist: Tableau Vivant*, 1978, is another self-portrait, in which Lopez has created a "little scene for myself, like a stage set. I posed inside with my jogging clothes and paint brushes and then had a friend photograph me." Lopez not only commands her body but seems to predict her role as an artist who is not afraid of encountering social and political issues or using her skills to promote social change (Fig. 9).

In the 1980s after the birth of her son, Lopez began to work with mixed-media installations, performance pieces, and video pieces:

> *Rio's Room*, a 1985 installation at the Central Cultural de la Raza, San Diego, California, based on the drawings of her six-year-old son;
> *When You Think of Mexico*, a 1986 video exploration of identity, assimilation, and cultural change;
> *Cactus Hearts/Barbed Wire Dreams: Media Myths and Mexicans*, at the Galeria de la Raza in 1988, stereotypes of Mexicans as portrayed in common household objects, the media, and in advertising;
> *The Mission Is Bitchin'* in 1989 at Intersection for the Arts, the second annual Mission District Festival curated by Lopez; and
> *Things I Never Told My Son about Being a Mexican*, an installation in The Decade Show, 1990, at the New

Fig. 5 *The Runner* (*A Donde Va Chicana?*), acrylic and oil on canvas, 4 by 5 feet, 1978. Photo courtesy of Yolanda Lopez.

Museum of Contemporary Art, New York City. Lopez was also invited to present her video, *When You Think of Mexico*, and to participate on a panel.

In an unusual two room installation, *Rio's Room*, Lopez utilizes her son's art as a means to comment upon society. One room is composed of mural-size enlargements of Rio's drawings that are meticulously recreated by Lopez. The San Diego *Tribune* review by Susan Freudenheim notes the undercurrent of violence in Rio's drawings; as with much children's art, the pictures are filled with images of destruction. "To further amplify the foreboding, Lopez has scattered flashcards on the floor. Some of them are the traditional kind to teach school lessons. Others are cards about political terrorism, frightening new collectors' items for kids. But this political side of the work is almost an aside, yet another key into the boy's existence."[11] Leah Ollman of the *Los Angeles Times* comments on the emotional "encyclopedia of terror. Lopez seems to say this has become an integral part of today's educational diet, one that breeds fear and hostility more than it nourishes."

A mural of another world, a sunny, joyous place, can be seen through an imaginary paper window in one wall. This idealized

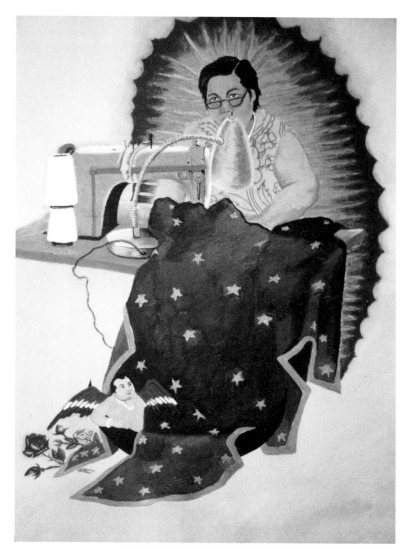

Fig. 6 *Mother: Our Lady of Guadalupe*, oil pastel on paper, 28 by 32 inches, 1978. Photo courtesy of Yolanda Lopez.

world feels far from the dramatic comic book battles and "Star Wars" weaponry that adorn Rio's room. But Lopez's provocative and disturbing installation makes it clear which scene is the more realistic.[12]

In her installation exhibit *Cactus Hearts/Barbed Wire Dreams*, Lopez first created a background for her collection of commercial stereotypes and knickknacks by painting the walls of Galeria de la Raza's two rooms to represent a stormy sky. She then painted at eye level several rows of barbed wire encircling each room before installing objects. In one room the objects portrayed a "romantic view of Mexico, and a nostalgic longing for a pastoral and mythological past," while in the second, she juxtaposed commercial stereotypes with printed statistics concerning the exploitation of Chicanos in jobs, education, and health. These objects and papers were all attached to the painted barbed wire. The floor space was filled with three-dimensional objects from cactus plant cutouts to table settings, all with stereotypical motifs. Nothing was randomly placed as Lopez carefully estab-

Fig. 7 *Grandmother: Our Lady of Guadalupe*, oil pastel on
paper, 28 by 32 inches, 1978. Photo courtesy of Yolanda Lopez.

lished connections between the visual objects and the printed
facts. Amalia Mesa-Baines refers to Lopez's *Cactus
Hearts/Barbed Wire Dreams* as "one of the most powerful exam-
ples of art of social commentary."[13]

Lopez's installations, festivals, and events have generated
much local involvement and publicity. In the *San Francisco
Chronicle*'s review "The Mission District Struts Its Stuff," the
Mission neighborhood is described as "a mixture of swagger,
style and visual vitality."[14] This comment refers to the *The
Mission Is Bitchin'*, a multi-media, three-day event, organized by
Lopez and featuring art, poetry, music, dance, comedy, and
panel discussions.

In reviewing New York's Decade Show, Julio Blanc notes that
Lopez's installation, *Things I Never Told My Son about Being a
Mexican*, and an accompanying video, *When You Think of Mexico*,
"are typical of Lopez's devastating critique of the patronizing eth-
nocentrism that is encoded in so many images that the United
States produces of Mexico, and of Latin America as a whole."[15]

Fig. 8 *Portrait of the Artist: Our Lady of Guadalupe*, oil pastel on paper, 28 by 32 inches, 1978. Photo courtesy of Yolanda Lopez.

The poster, "When You Think of Mexico," which is featured in the beginning and conclusion of the video, features a tall, smiling tourist dressed, in a traditional Mexican embroidered skirt, blouse, and shawl. She receives flowers from a simply dressed Mexican woman vendor, as she looks up from her flowers at the glamorous tourist (Fig. 10). Lopez told me that this photograph was a 1961 Eastern Airlines ad that appeared in the *National Geographic.*

Lopez states emphatically:

It is important for us to be visually literate... The media is what passes for culture in contemporary U.S. society, and it is extremely powerful. It is crucial that we systematically explore the cultural mis-definition of Mexicans and Latin Americans that is presented in the media.[16]

Lopez's controversial and informative multi-media images are continuing to gain national recognition. Her painting of the Virgin in the dress of a working class Chicana woman was featured on the cover of *Fem*, a Mexican feminist magazine (June-

Fig. 9 *Portrait of the Artist: Tableau Vivant,* by Yolanda Lopez, 1978. Photo courtesy of Susan R. Mogul.

Endnotes

1 Susan Gwynne, ed., "Artistas Chicanas" (Symposium on the Experience and Expression of Chicana Artists, University of California, Santa Barbara, California, 13 April 1991).

2 All quotes unless otherwise stated are based on interviews with Yolanda Lopez at her home and studio in 1983 and 1991.

3 Shifra Goldman, "Contemporary Chicana Artists," *Feminist Art Criticism: An Anthology*, ed. Arlene Raven (Ann Arbor, Mich.: UMI Research Press, 1988), 189.

4 Yolanda Lopez, *Yolanda Lopez: Three Generations* (San Diego, Calif.: Mandeville Center for the Arts, San Diego State University, 1978).

5 Ibid.

6 Ibid.

7 Ibid.

8 Claire Tron de Bouchony, *Women from Witch Hunt to Politics*, ed. Birgitta Leander (France: UNESCO, 1982), 165.

9 Quoted in Lucy Lippard, *Mixed Blessings* (New York: Pantheon Books, 1990), 42.

10 Lopez.

11 Susan Freudenheim, "Diverse Exhibition Puts Viewer on the Spot," San Diego *Tribune*, 23 March 1988. From news clipping in artist's possession.

12 Leah Ollman, "At the Galleries," *Los Angeles Times*, San Diego Edition, 8 April 1988. From news clipping in artist's possession.

13 Amalia Mesa-Baines, quoted in Lippard, 42.

14 "The Mission District Struts Its Stuff," *San Francisco Chronicle*, 28 May 1989.

15 Julio V. Blanc, "When You Think of Mexico, Latin American Women in the Decade Show," *Arts Magazine* (April 1990): 17.

16 "Cactus Hearts/Barbed Wire Dreams," *Galeria de la Raza*, Studio 24, 1 (Summer 1988): 1.

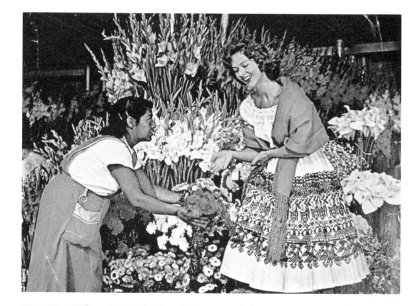

Fig. 10 *When You Think of Mexico*, ad from Eastern Airlines, 1961, *National Geographic Magazine*. Photo courtesy of Yolanda Lopez.

July 1984). Lopez has been the subject of articles in San Francisco's *Image* magazine, *El Tecolote*, and the *Santa Cruz Sentinel*. But since her work has been more educational and community oriented rather than personal (a point of view which she shares with her husband, Rene Yanez, also a multi-media artist and former co-director of Galeria de la Raza), the family's economic survival remains precarious. However, both parents take pride in their young son Rio, who manifests a love of art through his constant creativity and seems well on the pathway toward emulating his parents' careers. Rio also continues to provide Lopez with new themes for her art.

Lopez is increasingly disturbed by the militarization of children's culture. She has already begun to work on a new anti-war series as a response to the 1991 Gulf War and invasion of Iraq. As Lopez and thousands of others marched in San Francisco to protest the U. S. involvement in the Mideast, she began to photo-document the children of her friends who marched with their parents. "If we want kids to have a conscientious objector status for any future wars, we need to document them now," says Lopez. Although she is not sure how she will utilize these photographs in her art, her goals are clear, and I'm sure she'll find the means.

Mine Okubo

A Japanese-American Experience

I FIRST learned of Mine Okubo (Fig. 1) from the poet Lawson Inada,[1] when he presented me with an extensive catalog of her drawings and paintings, *Mine Okubo: An American Experience*.[2] This catalog was published in 1972 by the Oakland Art Museum of Oakland, California, in conjunction with her major retrospective exhibit. It was also this museum's first exhibit for a woman artist. The serene painting reproduced on the catalog cover was of Mine's mother, seated on a bench with a Bible in her lap and a plump cat nestled beside her. A tree-lined path, white frame houses, and a church in the background portrayed the rural tranquility of Riverside, California, where Okubo was born in 1912 and spent her childhood (Fig. 2).

But serenity and the possibility of living the American dream shattered for 110,000 west coast Americans of Japanese heritage when they were evacuated by the U. S. government from their urban and rural homes into remote relocation camps throughout the country. This occurred after the outbreak of World War II when the loyalty of longtime immigrants as well as nisei (first generation) and sansei (second generation) Japanese was questioned. In the camp, Okubo was identified as Number 13,660. Her bitterness turned into a survival philosophy, "I had the opportunity to study the human race from the cradle to the grave, and to see what happens to people when they are all reduced to one status and condition." She then made her "American Experience" visible in hundreds of pen-and-ink sketches, charcoal and pastel drawings and watercolor paintings, which told "the story of camp life for my many friends who faithfully sent letters and packages to let us know we were not forgotten."[3] These powerful images now serve as a unique historical documentation of a people's suffering, endurance, and ability to survive with dignity (Figs. 3, 4).

Mine Okubo: An American Experience concludes with a "Happy Period," based on another relocation for Okubo in 1944, to New York City, where she began her commercial art career as an illustrator for *Fortune Magazine*. However, within ten years she decided to strike out on her own as a "loner on an individual road." She explained this brazen move to me in 1986: "I have a contribution to make because I remain a whole person. I'm using art as my means to prove the truth of life, the highest visual order, the perfection, and to drop all the hash and trash that has been called art."

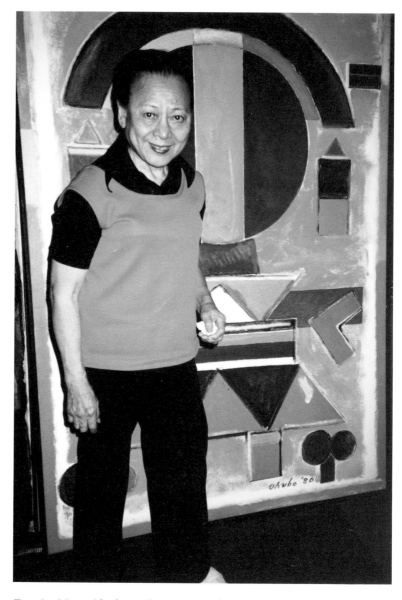

Fig. 1 Mine Okubo in her New York studio apartment with painting, *Festival Girl*, 1986.

Our friendship began in 1986 with my first visit in her small Greenwich Village apartment where she has lived alone for the past forty years.[4] At seventy-three, her intense gaze and youthful smile, evident in earlier photographs, had not diminished. Her dark brown hair, hardly touched by grey, was pulled back from her smooth, broad face. I was surprised that her sparse furnishings did not include a television set, but she told me, "I have no time for that." An immense accumulation of paintings was stacked along all the walls in the main room where she ate and slept and in an adjoining room. These works were the results of long years of production and her ongoing commitment to her art.

Daylight filtered pleasantly into her apartment through a broad network of plants and window panes, which also offered an exterior view of rooftops and two trees. The bird and squirrel inhabitants of the trees almost seemed like Okubo's friends. I

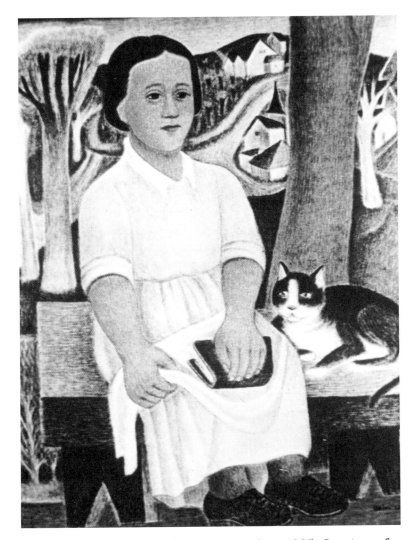

Fig. 2 *Mother and Cat*, oil, 24 by 36 inches, 1935. Courtesy of Mine Okubo.

was delighted when Okubo gradually began to pull innumerable drawings and paintings from various piles, stacks, and cartons that had accumulated in a smaller adjoining room. She gradually began to share examples of five decades of her art as well as her more recent work, all on the path to "finding my own hand-writing. If you can't find that, you're nowhere." It was astonishing to see the evolution of the style and content of her work from early figurative realism, followed by brief experimentation with abstract forms, and then a joyous burst of color in still life and portrait studies. At this time her evolution concluded with her acrylic paintings featuring simplified forms in a mood of playful but controlled calm. The theme of the cat as first depicted with her mother in 1935 was omnipresent.

In discussing her background and childhood, Okubo revealed that her mother was a calligrapher, painter, and graduate of the Tokyo Art Institute. Soon after coming to the United States, she married Okubo's father, a "learned man" who first owned a confectionery store but later worked as a gardener. Her mother's creative endeavors were submerged in her struggle to raise seven children, but she always encouraged Mine to pursue

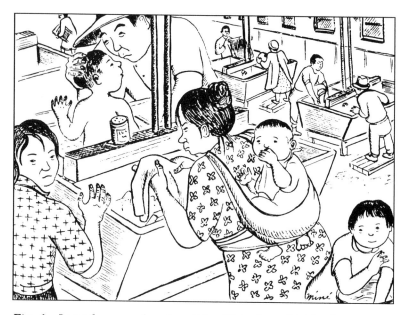

Fig. 4 *Laundry*, pen drawing, 9 by 12 inches, 1942. Photo courtesy of Mine Okubo.

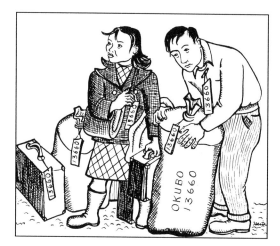

Fig. 3 *Citizen 13660*, pen drawing, 9 by 12 inches, 1942. Photo courtesy of Mine Okubo.

her interest in art. Okubo recalls her parents as "suffering and always living for their children." As a child, she says, "I was shy and no one could talk to me," but "among my own brothers, I learned to be a fighter, to have my feet on the ground."

Okubo considers "institutions and routines always a bother for a creative and constructive mind"; nevertheless, she attended the University of California at Berkeley. Her art training included classes in the techniques of fresco and mural painting, useful skills for the subsequent development of her art career. She graduated in 1936 with a Master's degree in Art and in 1938 was the winner of the University's highest art honor, the Bertha Taussig Traveling scholarship, affording her the opportunity to take a freighter to Europe. In addition to visiting museums, hiking, and bicycling, Okubo also produced many watercolor paintings which were a record of the people and activities she encountered. This year of travel was a turning point in her art as she began to use brighter colors and more expressionistic brush strokes.

After returning to San Francisco in 1939 at the outbreak of World War II, Okubo participated in the Federal Art Project. She created mosaic and fresco murals for the U. S. Army at Fort Ord, Government Island, Oakland Hospitality House, and Treasure Island, California. The completion of her murals coincided with President Roosevelt's Executive Order 9066 in 1942. Okubo and all west coast Japanese-Americans were given three days to condense all their worldly possessions into a few bundles. Okubo's family was split by the evacuation; she and one younger brother were sent to a camp in Topaz, Utah, her sister to Heart Mountain, Wyoming, an older brother was drafted into the U. S. Army! The impact of the forced relocation which severed people from their roots, dreams, and aspirations is described by Okubo.

We were suddenly uprooted—lost everything and treated like a prisoner with soldier guard, dumped behind barbed wire fence. We were in shock. You'd be in shock.

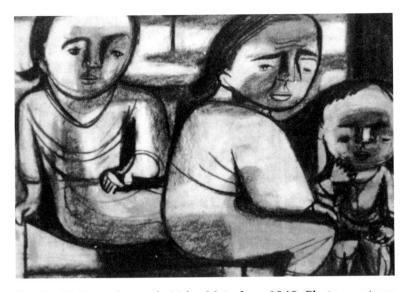

Fig. 5 *Waiting*, charcoal, 14 by 20 inches, 1943. Photo courtesy of Mine Okubo.

You'd be bewildered. You'd be humiliated. You can't believe this is happening to you. To think this could happen in the United States. We were citizens. We did nothing. It was only because of our race.[5]

In the camp Okubo began to document the emotional impact of this experience, the depersonalization, restrictions, depression, and shattered dreams. She graphically recorded the many adaptations made to cope with basic survival: communal eating and toilet facilities and mundane work. She depicted these scenes in a series of two hundred pen-and-ink illustrations accompanied by satirical commentary, which were first published as *Citizen 13660* in 1946 by Columbia University Press and republished three times during the 1980s by the University of Washington Press (Fig. 4). With a few brief strokes of her pen, she captured the essence of events. In the *New York Times Book Review* these drawings were characterized as

A remarkable objective and vivid art and even humorous account... In dramatic and detailed drawings and brief text, she documents the whole episode... all that she saw, objectively, yet with a warmth of understanding... Mine Okubo took her months of life in the concentration camp and made it the material for this amusing, heartbreaking book... the mood is never expressed, but the wry pictures and the scanty words make the reader laugh—and if he is an American too—sometimes blush.[6]

Okubo also completed hundreds of charcoal and gouache paintings in an attempt to reveal the psychological impact of camp life "so others can see so this may not happen to others."[7] During these years, she told me, "I hardly slept," and "I worked mostly all night. To discourage visitors I put a sign up on my door that said 'quarantined.'" Even in the camp, she continued her professional connections "sending pictures out." She proudly remembers that "before evacuation, I was winning prizes almost every year from the San Francisco Museum of Art." Okubo's European water colors were exhibited there in 1940 and 1941,

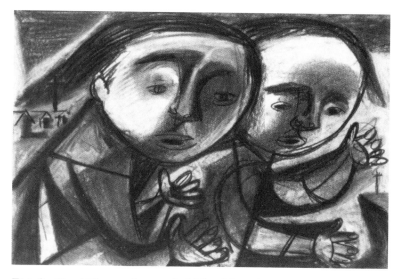

Fig. 6 *Dust Storm*, charcoal, 14 by 20 inches, 1943. Photo courtesy of Mine Okubo.

and she won the Anonymous Donor Prize, 1941; an Honorable Mention, 1942; Arts Fund Prize, 1943; Art Association Purchase Prize, 1944; and the Museum Annual Prize, 1948.

As part of her earlier training, Okubo explained that she had briefly experimented with abstract images, as is evident in some of her cubist-inspired, pencil drawings. Although she soon abandoned pure abstraction, many of her images of camp life are based on simplifying forms to basic rhythmic lines and shapes. In a powerful series of charcoal drawings on beige paper, fourteen by twenty inches in size, such as *Waiting* (Fig. 5) and *Dust Storm* (Fig. 6), both children and adults are portrayed with large, somber facial expressions, small empty hands, and the dismal camp barracks in the background.

Okubo's watercolors from this period are more realistic, exemplified by scenes of men with their harvested potatoes or camp residents lined up before the communal mess hall (Fig 7). In *Mine Okubo: An American Experience*, Shirley Sun says of these drawings and paintings:

> The exaggerated heads, the hunched backs, the inward staring eyes all pain, for us a psychological and social reality in the profoundest human terms so that no person seeing them can remain untouched. Notwithstanding, the dignity of men, women and children—however diminished—still comes through during this time of moral uncertainties, confusion and contradiction. Always, the human relations are kept intact—no matter how topsy-turvy the world. Indeed the life bond of men, women and children asserts itself more strongly than ever in face of the threat of annihilation.[8]

Trek, a literary magazine, was initiated in the camp by Okubo and several friends, including the writer Toshio Mori. As art editor Okubo created the cover designs and many of the illustrations which appeared in the three issues. When the editors of *Fortune Magazine* saw *Trek*, they were impressed by Okubo's illustrations. The magazine staff was searching for an artist to illustrate a fea-

Fig. 7 *Dinner Lineup*, watercolor, 18 by 24 inches, 1943. Photo courtesy of Mine Okubo.

ture story about Japan and arranged for her to leave the camp in 1944 (prior to the conclusion of the war). Once again she had but three days to pack her things and arrive in New York "with just what I could carry in my hands." Again Okubo felt as if she were "thrown in the middle of a desert," as she knew no one in New York. Her isolation did not last long. Soon her tiny apartment was to become a receiving center for many west coast Japanese-Americans relocating to the east after the war.

During the next ten years, Okubo successfully established her career in the commercial art field, working for *Fortune, Time, Life, Saturday Review, New York Times, Common Ground, Survey Graphic, San Francisco Chronicle,* and *Los Angeles Japanese American News.* For leading publishing houses, she illustrated a variety of books on subjects from medical anatomy to children's stories. The American Lines, a major shipping company, commissioned Okubo to paint four murals. Okubo has said of her commercial work, at first "everybody is friendly, but then it becomes establishment, where people are just out for themselves, and you're playing a game. I knew all the ropes before I told them all to go to hell." After less than ten years of commercial work, Okubo courageously risked economic security in order to "go back into painting, to dedicate myself to the highest ideals in art." She wisely said, "You can't serve two masters at the same time."

From 1950 to 1952 Okubo returned briefly to the west coast and to the University of California as a lecturer in art but declined a steady teaching routine. When she returned to New York, Okubo began to realize "If you're not following the current art trends (of abstract expressionism), they think you're really cracked." She abhorred art which glorified "throwing paint and putting titles on it," and "living in a fantasy." Instead she pursued her own inner vision of art, based on the "mastery of drawing, color, and craft," and "staying with the subject and reality, but simplifying like the primitives." In Okubo's paintings of the

Fig. 8 *Vases of Flowers*, oil, 43 by 52 inches, 1969. Photo courtesy of Mine Okubo.

Fig. 9 *Blue Girl, Blue Vase, Blue Dress*, acrylic, 24 by 32 inches, 1977. Photo courtesy of Mine Okubo.

late 1950s and 1960s, she turned to her Japanese heritage, folk traditions, and her childhood memories for inspiration. She also created impressionistic portraits, combined with still life and flower forms painted with light pastel tones and occasional deeper accents of pure bright color. In this "Happy Period," well exemplified by *Vases of Flowers* (Fig. 8), a forty-three by fifty-two inch oil painting on canvas, the subject and background are often unified through an interplay of line and shape, like an intricate rhythmic dance step that moves over the entire surface.

In a 1977 painting, *Blue Girl, Blue Vase, Blue Dress* (Fig. 9), intense red, blue, and pink tones dominate the composition. The seated girl with a bright red face merges with the red, blue, and pink flowers beside her. These forms are unified by the blue painted background and the deft, broad brushstrokes of line and color. By 1977, the tight, compacted shapes of Okubo's paintings expanded and seemed less fragmented. This is particularly evident in a series based on beach scenes. In *Girl, Fruit and Beach* (Fig. 10), the female form is bare-breasted as she relaxes beside a bowl of fruit with sailboats on the distant horizon. In *Lady, Red Pants* (Fig. 11), the woman's hands are raised above her head. She is also bare-breasted, with her legs covered with bright red pants as she gazes at sailboats. Each scene is bordered with an edge of flat color. Body proportions are not realistic, and, while

Fig. 10 *Girl, Fruit and Beach*, acrylic, 24 by 32 inches, 1977. Photo courtesy of Mine Okubo.

Fig. 11 *Lady, Red Pants*, acrylic, 24 by 32 inches, 1977. Photo courtesy of Mine Okubo.

heads are large and hands are small like her earlier camp charcoal drawings, the contrast in mood is striking between those sad and hunched figures and these bathers' sensual affirmation of life!

Okubo looks back upon the past and says that "up until 1960, people still had idealism," but since then, due to their "insecurity, fear, and ego, the gates closed, and people became locked up in themselves." In contrast, Okubo says, "I'm using painting to prove the truth of life," which she compares to "simplifying the content of the original creator's work. Subject matter

Fig. 12 *Festival Girl*, acrylic, 50 by 72 inches, 1980. Photo courtesy of Mine Okubo.

doesn't matter too much. You should never close doors because time always turns something around as nothing has changed since the beginning of time."

Once again in the 1980s there was a dramatic change in Okubo's style as her work evolved into more simplified and stylized forms. These new images exemplify what Okubo considers her "long forty-year search for the simple vision that we are born with, that gets messed up, so that I have to go back to the basics and find myself again." She admits, "You can't beat the primitives! It's born in them, but I have to arrive at simplification in painting through a more intellectualized process." These images all contain geometrically simplified forms in cheerful combinations of flat color applications, ranging from primary tones to more subtle combinations of pink, pale purple, and cerulean blue. Okubo's "search backwards to zero," "the simplest possible usage of my mastery of art," and "the uncomplicated vision" are exemplified by her 1980 cheerful and symmetrically composed *Festival Girl* (Fig. 12) in which bright yellow, orange, and red dominate. In contrast to Okubo's earlier bathers, *Reclining Girl and Cat* (Fig. 13) almost seems robot-like as head, breasts, belly, and legs are all geometrically simplified in pale blue, purple, and white tones that are applied flat and even. Faces are devoid of features other than a cross suggesting the location of eyes, nose, and mouth. Some of Okubo's canvases have long, narrow shapes, twenty-four by forty-four inches, such as *Animals, People, Birds and Flowers* (Fig. 14) which is vertically organized. These playful images dominated Okubo's production until 1989, the time of my third visit to her studio. As a pioneer and a survivor, Okubo has maintained both optimism and humor. "Nothing gets me down," Okubo says. "I can see I'm on the right road, though people think I'm crazy because I'm not on Madison Avenue." Lawson Inada's description of another camp survivor of Okubo's generation, the writer Toshio Mori, can be applied to Okubo. "It is the most human of qualities to laugh, to be able to laugh, to recognize the wisdom of humor; the humor of wisdom."[9] Also comparable are Mori's and Okubo's creative approaches: "No flab, no waste. It is not style for style itself."[10]

Fig. 13 *Reclining Girl and Cat*, 24 by 34 inches, 1980. Photo courtesy of Mine Okubo.

Several major early exhibits of Okubo's work include the Mortimer Levitt Gallery, New York City, in 1951; the Image Gallery, Stockbridge, Massachusetts, in 1964; and the Oakland Art Museum, California, in 1972. Throughout the years she has also participated in many significant group exhibits of art produced in the Japanese relocation camps such as *Expressions From Exile, Months of Waiting, A View From the Inside,* and *Evacuation Exhibit.* In 1974 the Western Association of Art Museums sponsored a two-year one-person traveling exhibit consisting of selected works from Okubo's Oakland Museum exhibit, *An American Experience.* She has also appeared often on radio and television shows including *The Nisei: The Pride and Shame* produced by CBS News Division and Walter Cronkite in 1965.

However, long years of isolation and rejection followed as Okubo explained to Shirley Sun:

> You either pursue the art business-show business system as a promotion game, or you're on your own, which often means that your works don't sell. I didn't follow any trend or any one. My work was not accepted because you are judged by those who play the "game"— the critics and the dealers. Because my paintings are different and don't fit into the ongoing trend, the museums and galleries don't know where to place me. Their doors were closed to me.[11]

"Luckily the people saved me—the little people from whom I borrowed money and the few collectors who helped me with rent. In many ways," Okubo wisely says, "I found that you're better off if you are a nobody. You can't learn until you realize you are nothing." When I asked her about her personal life, Okubo admitted to being a "universal mother," as she has a wide circle of friends that include the neighborhood shopkeepers and their families. She adds, "I am interested in people, but everybody is alone whether they like it or not." Through the years, she admits, "I have had many suitors and marriage proposals, but I'd rather be myself, doing what I want to do. I never bothered to get married since woman's role is second, no matter what you think of yourself. Why in the hell should I wash a man's socks?"

A major event in Okubo's career was her forty-year retrospective exhibit held at the Elizabeth Gallery in New York City in 1985 (Fig. 15). This unique gallery, also known as the Basement Workshop and Amerasia Creative Arts, was established in 1971 to offer Asian American artists, dancers, writers, and actors a place to "create an art and a culture reflective of our experiences and political sensibilities."[12] Fay Chiang, one of the founders, describes how in 1982 a series of Folk Arts Workshops evolved. "Often our emerging artists were frustrated by not 'making it.' We turned to our older folk artists to learn how they had integrated life with art in a lifelong working process. I was looking for a useful approach and sense of meaning to one's life within the context of this larger society, the forces of which tended to negate every aspect of our lives and arts; which tended to reduce them to insignificance."[13]

Okubo's exhibit contained over eighty examples of her art, including drawings and paintings from the camp experience. This gave Okubo the opportunity to look back upon her life's work and to affirm for herself that she is indeed "on the right path." She said, almost as if she had been a hermit, "I am barely

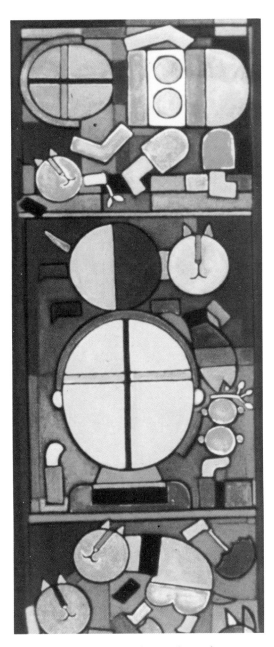

Fig. 14 *Animal, People, Birds and Flowers,* acrylic, 24 by 44 inches, 1986. Photo courtesy of Mine Okubo.

Fig. 15 Mine Okubo, Retrospective, Elizabeth Gallery, New York, 1985. Photo courtesy of Mine Okubo.

coming out now, after forty years of isolation to build myself up; 1986 will be my year for bringing works to the public. Unfortunately," Okubo added, "the research and study took so long that many of my friends who were rooting for me are long gone, but their faith in me has survived." "Good artists are full of anger," Okubo says. "They see the conditions of our time, the reality, the truth, and how they're up against it." She also optimistically feels that anger makes you fight, but believes that "If you do your best, you're bound to hit something. The world is all shot to hell, but you still have to go on hope." However, in the art work she showed me, sadness, tenderness, and humor dominated, rather than anger. Okubo's dedication to the highest ideals in art, parallels that of writer Mori. "The essence of Mori's wisdom is to go for it, to go for broke, to believe. In so doing, a person enlarges and determines his or her own life." Even so, Mori died in 1978 without the recognition he deserved from our literary mainstream. Inada has concluded, "Toshio Mori did not fail; others failed him."[14]

What about Mine Okubo and her art? With the activities of the younger generation and projects like the Basement Workshop and Elizabeth Street Gallery, Fay Chiang says, "Change is possible; visions can become realities; we do and can make a difference in our everyday lives for our communities, our friends and families, and in our individual journeys through life."[15] The decade of the eighties has not only propelled Okubo toward new aesthetic growth but backward through the years to

Fig. 16 *Song of Summer*, acrylic, 36 by 48 inches, 1990. Photo courtesy of Mine Okubo.

right a historical wrong. As an active member of the National Council for Japanese American Redress (NCJAR), she testified before the government commission on Wartime Relocation in Washington, D.C. in 1981 concerning her camp experiences. In 1987 she returned to Washington, D.C. with her sketchbook to record the proceedings of the NCJAR class action suit at the United States Supreme Court, and these sketches were published in several newspapers.[16] In 1988, redress became law as the Civil Liberties Act was passed, stipulating that camp survivors, as victims of racist official government policy, would each receive $20,000. The verdict was a victory, but the monetary award was anti-climatic as many of the older generation had died. However, the decision reaffirmed the commitment of the United States to democratic principles by publicly righting a wrong in order that this should not happen again, the action brought about because of the organization and persistence of Japanese-Americans.

However, I was disappointed by Vivien Raynor's 1989 *New York Times* review "Interned Artists, Devoid of Grievance" on a group exhibit of internment camp art held at the Municipal Building at Hastings-on-the-Hudson.

> In a history of cruelty, Executive Order 9066 would not rank high... Whatever the reason—a sense of historical perspective, an acceptance of racism as an inevitability, cultural identity or a mixture of all three—the artists in this show seem devoid of grievance.[17]

Did Raynor really look at the bent figures as they cover their heads in Okubo's *Constant Wind* and *Dust Storms* reproduced in the *Times*? It was good to learn that Raynor's view is not shared by others. In a significant attempt to give students an honest view of history, Okubo was selected in 1987 by the California

Fig. 17 *Meadow Lark*, acrylic, 36 by 48 inches, 1990. Photo courtesy of Mine Okubo.

Endnotes

1 Lawson Inada's collection of poetry is entitled *Before the War* (New York: William Morrow and Company, Inc., 1971).

2 Quoted in *Mine Okubo: An American Experience* (Oakland, Calif.: Oakland Art Museum, 1972).

3 Mine Okubo, *Citizen 13660* (Seattle, Wa.: University of Washington Press, 1983), ix.

4 Mine Okubo interview with author, New York, N. Y., 11 February 1986.

5 Quoted in Deborah Gesensway and Mindy Roseman, *Beyond Words: Images from America's Concentration Camps* (Ithaca, N. Y.: Cornell University Press, 1987), 66.

6 Book News from the University of Washington Press, "Citizen 13660 Drawings and Text by Mine Okubo," 1983.

7 Quoted in Gesensway and Roseman, 73.

8 Quoted in *Mine Okubo: An American Experience*, 23.

9 Lawson Inada, "Standing on Seventh Street," in Toshio Mori, *Yokohama, California* (Seattle: University of Washington Press, 1985), vi.

10 Ibid., xvi.

11 Sun, 42.

12 Fay Chiang, "Looking Back," in *Basement Yearbook 1986*, ed. Fay Chiang (New York: Basement Workshop, Inc., 1986), 7.

13 Ibid., 11.

14 Lawson Inada, "Standing on Seventh Street," xxiii.

15 Chiang, 12.

16 National Council for Japanese American Redress, IX, no. 4, Nov. 1987, Chicago, Ill., 4-5.

17 Vivien Raynor, "Interned Artists, Devoid of Grievance," *New York Times*, 15 October 1989, p. 18.

18 Quoted in *Mine Okubo: An American Experience*, 42.

State Department of Education as one of twelve women pioneers for *The History of California Poster* and *California Woman: Courage, Compassion, Conviction, An Activities Guide for Kindergarten Through Grade 12*.

I did not expect so many changes in Okubo's life and art when I returned to visit her once again in 1990. In the past five years she had encountered many health problems and was hospitalized twice, but her eyes sparkled and her spirit was strong. She also faced eviction from her home of almost half a century, as the building had sold, and Okubo remained the lone tenant with nowhere else to go. However Okubo was more anxious to talk about her new paintings, the stylistic changes denoting her return to roots. She summarized: "I was born Oriental, educated Western, followed the French, but now I'm returning to my Oriental background." Okubo had returned to nature in her prolific series of paintings such as *Desert Song, Rocks and Pond, Sand and Wind*, and *Summer Breeze*, that vary from twenty-three by twenty-five to fifty-four by sixty inches, painted on both paper and canvas. The paint flowed like the constant movement of clouds propelled by a gentle breeze.

The geometric and isolated shapes of people, cats, birds, and flowers had vanished as the surface became filled with an interplay of vibrant brush strokes and abstract, atmospheric soft layers of color stimulated by movement in nature. These paintings appeared like a joyous, spontaneous release of energy. Okubo said, "one should never force anything. Everything is male and female; it all fits together." This is evident in *Song of Summer* (Fig. 16) and *Meadow Lark* (Fig. 17). The first is dominated by a hot cadmium red background and the second by an intense ultramarine blue. Upon each colored surface, shapes and spontaneous calligraphy seem to dance to project varying moods.

Okubo emphatically insists, "Everything is a revelation by working hard, hard, hard." She has no set schedule, but her best hours for painting, when she is not likely to be disturbed, are between 12 and 3 A.M. or between 6 to 8 A.M. Her apartment is so small that when producing small paintings she sits on her bed and reaches down to paint as the paper is on the floor before her. Undaunted by events, she remains consistent in her search for truth and beauty in art, "the only two things which live on, timeless and ageless. You are always alone, only with God." Her personal goal is consistent: "My one dream is to really make it in painting."

Remaining "a whole person," Okubo would like her creativity to be judged from her total life accomplishments, rather than just the focus she has received for her relocation art. John Haley, Professor of Art Emeritus, University of California at Berkeley, has asserted, "Through her work Mine Okubo belongs to the future as well as to the present and to all of us who will look."[18] Will Okubo receive the mainstream recognition that she deserves, recognition her peers, the painter Yasuo Kuniyoshi and the sculptor Isamu Nouguchi, have received? Nonetheless, in 1991 she was honored at the National Museum of Women in the Arts, Washington, D.C., by the Women's Caucus for Art of the College Art Association for her lifelong dedication and achievement in art.

African/American Sculptor
Elizabeth Catlett

A Mighty Fist for
Social Change

MY 1990 VISIT with sculptor and printmaker Elizabeth Catlett (Fig. 1) at her home and studio in Cuernavaca, Mexico, was a personal pilgrimage: she and her husband, Charles White, were my first art teachers. They not only encouraged my aesthetic development, but I learned by seeing examples of their art. In addition, they introduced me to Mexico's contemporary mural painting movement. This early exposure to cultural diversity and to the art of social relevance was a significant formative factor, as it eventually led me to live and study art in Mexico. However, many years passed before I had the opportunity to renew my friendship with Catlett, now a Mexican citizen.

Elizabeth Catlett is part of a continuum of Black women figurative sculptors that include: Edmonia Lewis (1843-c. 1900), Meta Vaux Warrick Fuller (1877-?), Augusta Savage (1900-1962), Selma Burke (1901-), and others. But Freida High Tesfagiorgis laments the fact that "No major text exists on the art of Afro-American women. Neither does any major art historical text on American art include the art of Afro-American women. The dearth of information on this subject indicates the invisibility of Black women artists in the minds of conventional art historians and critics."[1]

The facts concerning Catlett's life and prolific career are well documented in Samella Lewis's biography of the artist.[2] However, my determination to visit Catlett was reinforced after seeing the author's extensive collection of Catlett's sculpture and prints. I then became intrigued by the artist's themes that varied from the tender bonding of mothers and children to visions of women with upraised fists, as symbols of Black Power, as well as their resistance to oppression. When I arrived in Cuernavaca I was welcomed by both Catlett and her second husband, Francisco Mora, the Mexican painter and printmaker to whom she has now been married for fifty-four years. I soon became aware that, while each maintained aesthetic independence, they were a devoted couple, sensitive to each other's needs, a rarity in artists' marriages. In her seventh decade, Catlett appeared tall and proud, though her face revealed the strain of recent surgery; however, when she smiled it seemed as if time had not progressed. Catlett's sense of humor prevails, although through the years her outspoken political and aesthetic views have brought both acclaim and pain.

In 1976, after Catlett's retirement from teaching at the

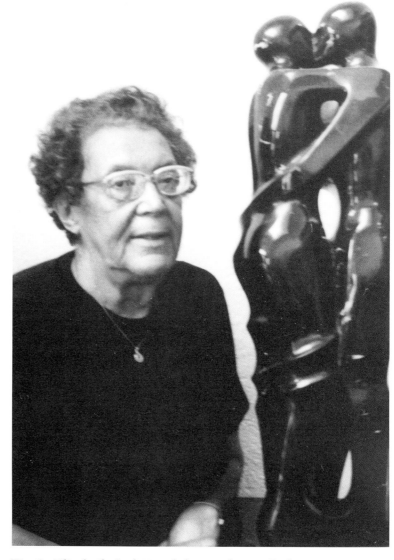

Fig. 1 Elizabeth Catlett with her sculpture *Embrace*,
Cuernavaca, Mexico, 1990.

University of Mexico, the couple moved from Mexico City into
this two-story, comfortable Cuernavaca hilltop home. Their stu-
dios of equal size are connected by a small patio allowing for pri-
vacy and ease of communication. In their family room where they
receive frequent visits from family and friends, the walls feature
Mora's large rhythmic charcoal drawings while the tables hold an
assortment of Catlett's sculptures, from small bronzes to a large
carving of *Maternity*. The time spent with Catlett was rewarding,
for I now had the opportunity to learn more directly of her per-
sonal and aesthetic development.

Catlett was born in Washington, D. C., in 1919. Her father,
John Catlett, a mathematics professor at Tuskegee Institute,
died shortly before her birth, but Catlett inherited his love of

music, drawing, and wood carving. In order to support her three children, Mary Carson Catlett, found employment in the school system as a truant officer. At an early age, Catlett became conscious of her heritage as she was told "her grandmother's grandmother had been on a beach in Madagascar with her daughter when the slavers came and took them away."[3] From 1924 to 1930, Catlett attended Lucretia Mott Elementary School, but it was in high school that she "became aware of art as art."[4] Since she excelled in her studies and passed the entry exams, Catlett hoped to continue her education at the Carnegie Institute of Technology but was rejected on the basis of color. However, her mother insisted, "Anything you want to be, you can be, and to get on with it!"[5]

Attending Howard University in Washington, D. C., was a positive formative experience, as Catlett was inspired by the art faculty, particularly James Herring, James Porter and Lois Mailou Jones. They were all "practicing artists, and dedicated to producing serious Black art." But most significant during this period was her exposure to African art and to Alain Locke, a professor of philosophy, "who led the movement to encourage Black artists to reclaim their ancestral heritage as a means of strengthening and enriching their own expressions."[6] At first Catlett majored in design with Jones, but then switched to painting after she was employed by the Federal Art Project to paint a mural. She was also inspired by Mexican art which she saw in library books. During these years Lewis notes that Catlett experienced a "political awakening. She found herself increasingly attracted to liberal politics, and concerned particularly for the plight of the poor and oppressed."[7]

After graduating from Howard University in 1937, Catlett went to Durham, North Carolina, to direct a high school art program. Two years later, Catlett decided to begin her graduate studies at the University of Iowa, where the well-known regional painter, Grant Wood, was on the faculty. She appreciated his methodical approach to form and composition and benefitted from his encouraging her to "paint what you know most about. I know most about Black people. That was when I began to focus seriously on Black subject matter."[8] Since Wood was also a master carpenter he awakened Catlett's sensitivity to three dimensional form and her eventual concentration on sculpture. At Iowa, Catlett was the first person to graduate with an M.F.A. in sculpture and won first prize for her thesis project, *Mother and Child*. This piece was exhibited at the 1941 American Negro Exposition in Chicago, and, subsequently, James Porter, author of *Modern Negro Art*, described the Black aesthetic qualities of this work as "undeniable," and asserted that "the work has poise and profound structure."[9]

Catlett began her career teaching in higher education in New Orleans at Dillard University. Samella Lewis was then Catlett's student and remembered her as "uncommonly aggressive. She stood up to everybody and involved herself in affairs that were unpopular at that time for both Blacks and women. Her immersion into civil rights movements, labor movements, and human rights in general was a threat to the status quo... she confronted police on brutality, bus drivers on segregated seating, and college administrators on curriculum."[10]

In the summer of 1941, Catlett left Dillard for Chicago to

Fig. 2 *Mexican Child*, charcoal drawing, 18 by 24 inches, 1949.

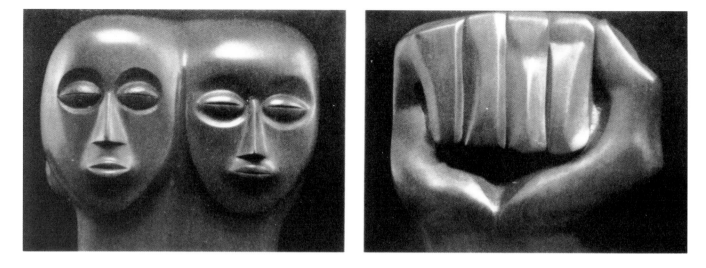

Fig. 4 *Black Unity*, cedar, approximately 2 by 2 feet, 1968.

Fig. 3 *Civil Rights*, linocut, 11 by 15 inches, 1950.

study ceramics at the Chicago Art Institute. It was in Chicago that she met Charles White, a painter who later became known for his drawings of African Americans as *Images of Dignity.*[11] After a brief courtship, they married and Catlett accompanied White to Hampton, Virginia. While White fulfilled a mural commission, Catlett taught at the Hampton Institute where Dr. Viktor Lowenfeld, the art department chairman, became a personal friend and mentor. Lewis notes: "His was an influence of thought rather than technique. Lowenfeld, a Viennese Jew, had fled his homeland when family members fell victim to the holocaust. He had an intense concern for human dignity. This insistence on dignity, a constructive solution to Elizabeth's concerns about injustice, has colored Catlett's work ever since."[12]

From Hampton, the couple went to New York City, where they had the opportunity to meet many Black writers, artists, and intellectuals, including Paul Robeson, Langston Hughes, Aaron Douglas, Jacob Lawrence, Ernie Crichlow and Romere Bearden. They considered themselves the heirs of the Harlem Renaissance of the 1920s and frequently discussed Black identity and the means of making a bridge in art between their African ancestry and their experiences as African-Americans. However, much to Catlett's disappointment, sexism prevailed. Catlett told Thalia Gouma-Peterson, "Though I was part of this group, I did not receive the same critical attention. As the female half of a husband/wife artist team, I was not taken as seriously as an artist as my husband."[13]

For Catlett, 1945 was intense both for personal and professional growth. She studied privately with the French sculptor Ossip Zadkine, absorbing concepts of Cubism and form simplification. She also studied lithography at the Art Students' League and recognized the potential of printmaking to express political and cultural concerns and to reach broad audiences. This coincided with her staff position at the Carver School in Harlem, a night school for working people, where she became even more convinced that art should not be elitist. By 1945 her biographer believes "the facets of the artist were complete. The basics from

Grant Wood; reason and feeling from Viktor Lowenfeld; sophistication from Ossip Zadkine; accessibility to her chosen audience from graphics."[14] For the next forty-five years Catlett would continue to build steadily upon this foundation.

When Catlett received a Julius Rosenwald Fellowship in 1945 to create a series of prints on the lives of Black women, she was able to use this grant money to travel to Mexico with White. There they participated in the *Taller de Gráfica Popular*, a collective print workshop concerned with the social function of art, whose aim was to "put art to the service of working people in their constant struggle against exploitation."[15] In addition to producing a portfolio of fifteen prints, Catlett also studied pre-Columbian ceramic sculptural techniques with Francisco Zúñiga. During these years Catlett and White grew apart, and their marriage terminated when they returned to New York.

Catlett's Rosenwald Fellowship was renewed for 1947 so she could complete her portfolio of fifteen prints, *The Negro Woman*. They have been described by Tesfagiorgis as "Women of the blues, women of intellect, women of servitude, women of revolution." This series is

> a landmark in the pictorial representation of Black women for it liberated them from their objectified status in the backgrounds and shadows of white subjects in the works of white artists, and from the roles of mother, wife, sister, other in the works of Black male artists.[16]

After Catlett's divorce from White, she returned to Mexico and soon married Francisco Mora, whom she had met earlier at the *Taller*. These were difficult years, as there were many cultural adjustments. They lived in a small apartment on a modest income as Mora, a graphic designer, was employed by the government. In the 1950s when their three sons, Francisco, Juan, and David, were young, Catlett cared for them while working at home producing drawings and prints. One of the works of this period is the drawing *Mexican Child* (Fig. 2), which was later incorporated into an exhibit poster. As soon as all three children were in school, Catlett told Mora, "I didn't get an M.F.A. to wash clothes and scrub floors. Do you mind if I get a job and give someone else the job of cleaning?"[17] At first, Catlett taught English part-time at a private school. But anxious to continue sculpture she studied wood carving with José L. Ruiz. During this period she created numerous works on the theme of mother and child.

In 1959, when there was an opening, Catlett applied to teach fourth year sculpture at the National School of Fine Arts of the University of Mexico. For the interview she presented four sculptures but was concerned about her acceptance by the administrators as she said: "First, I was a woman; second, a foreigner; third, they might think that the students would only create Black sculpture, and fourth, I could be considered inept because I asked questions."[18] In spite of her doubts, she was hired and became the first woman on the fine arts faculty. Within a year she was appointed chairperson of the Sculpture Department with a faculty of nine, and remained there until retirement in 1976. As her classes were small, Catlett managed to do her own sculpture in the same studio with her students. She also took much pride in promoting her students' individual expression and exhibiting their work. In 1962 Catlett had her own exhibit of prints and sculpture at the National School of the Arts (San Carlos) in Mexico City.

Fig. 5 *Homage to My Young Black Sisters*, cedar, approximately 4 feet, 1969. Photo courtesy of Estella Lauter.

Fig. 6 *Woman*, bronze, 18 inches, approximately 1962.

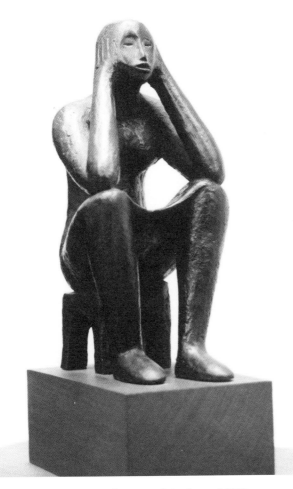

Fig. 7 *Seated Figure*, bronze, 9 inches, 1979.

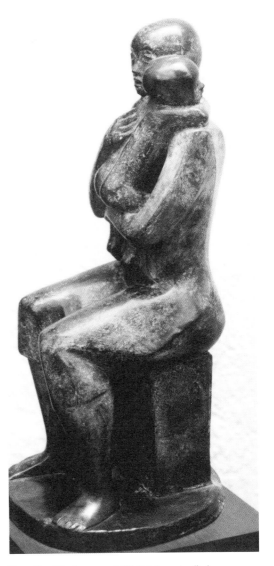

During the 1960s, Catlett's connections with the United States were severed when she was harassed by the House Unamerican Activities Committee for her political activities. To avoid problems Catlett decided to become a Mexican citizen in 1963. Later she was denied re-entry into the U. S. when she wanted to visit her mother who was ill. Finally, in 1971, the State Department granted her a visa after receiving much pressure from the art community; the Studio Museum in Harlem, which had organized a retrospective of her work; and Howard University, which desired to present her with their Distinguished Alumna Award.

Through the years, Catlett participated in international exhibits with the *Taller de Gráfica Popular* in Paris, Prague, Leipzig, Tokyo, Warsaw, Peking, Belgrade, Montreal, Berlin, and Havana, as well as many exhibits in the United States. In the past twenty years, Catlett has had thirty-seven one-person exhibits in museums, universities, and private galleries in the United States, Europe, and Asia. Her work is now represented in the following collections: Museum of Modern Art, Mexico; Museum of Modern Art, New York; Library of Congress, Washington D.C.; Howard University; Fisk University; Atlanta University; National Museum of American Art, Washington D. C.; and many other private and public collections.

During the period that Catlett was barred from the United

Fig. 8 *Mother and Child (seated)*, bronze, 9 inches, 1979.

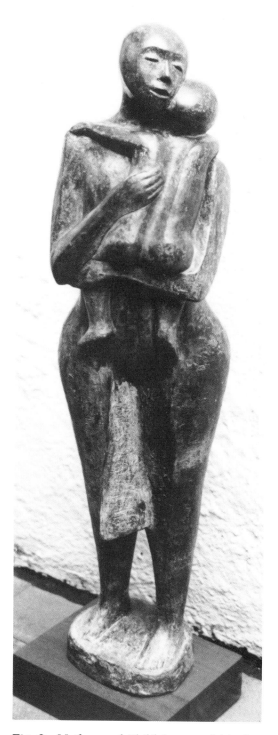

Fig. 9 *Mother and Child*, bronze, 24 inches, 1979.

States, she nevertheless produced significant prints and sculptures related to the social protests and civil rights struggles of the 1960s and 1970s. Catlett depicted these events in a series of literal political prints such as *Civil Rights* (1969, Fig. 3), in which a noose that envelopes a child is being removed by a member of the Civil Rights Congress, while a Ku Klux Klan member looks on from the distance. During this period she also carved *Black Unity* (1968, Fig. 4) and *Homage to My Young Black Sisters* (1969, Fig. 5), that became symbolic icons of Black activism and the struggle for social justice. *Black Unity* is composed of two heads that stare straight forward, but there is a clenched fist behind them, a "mighty fist," said Catlett: "If I show one finger, it means nothing. Two fingers have little strength. But if I make a fist, I can strike a mighty blow."[19] *Homage to My Young Black Sisters* is one of Catlett's most remarkable sculptures. Approximately four feet tall, a woman stands with feet slightly apart as her proud form rises and culminates with an upraised arm and clenched fist. Her rhythmically curved torso is pierced, forming an oval carved larger in front than the back. Her breasts are small; the head is upturned; the incised features suggest a mood of calm determination.

In *Feminist Archetypal Theory*, Estella Lauter equates *Homage* with a new feminine archetype, that of the independent woman "whose energies are freed from child-rearing." Lauter compares "the large womblike opening in the front and the smaller one in the lower back of the sculpture" with Henry Moore, but these hollow shapes "do not bring to mind the idea that she is empty, as Henry Moore's sculptures of women in the late 1940s do... Catlett's image is one of solidity, confidence, pride, idealism... to honor the struggle for liberation by black women..."[20] Tesfagiorgis writes from an Afro-female-centered world view, or Afrofemcentrism, in which "the Black woman subject is depicted by the Black woman artist." In discussing Catlett, Tesfagiorgis asserts:

> *Homage* reveals Catlett's compassion for Black women as it addresses their participation in the global struggle against racism and imperialism, particularly during the sixties. As a monument to "Young Black Sisters," its presence is impacting, communicating tensions of political activism juxtaposed with female attributes of character, strength and beauty, and the added sense of female bonding... This quasi-abstract standing female form figuratively portrays a Black woman subject in an arrested motion of protest. Its symbolic gestures, particularly the upturned head and the clenched fist that thrusts above it, are imbued with energy and hope, reinforcing the power conveyed in its subtly sensuous robust body.[21]

Tesfagiorgis stresses Catlett's aesthetic link with Africa when she compares the "dignified and spiritual" upturned head of *Homage* with Asante terra-cotta funerary heads made by women and concludes that *Homage* "reinforces woman's personage and action as foremost in her existence."[22] She expands Lauter's concept of the independent woman to include female bonding.

Characteristics of *Homage* persist in other sculptures of this period, such as *Woman* (Fig. 6). This figure, tilted slightly forward, stands with her arms behind her head, as her body stretches upward. This woman is propelled by her inner strength and spirit, echoed in the spiraling design of her dress and

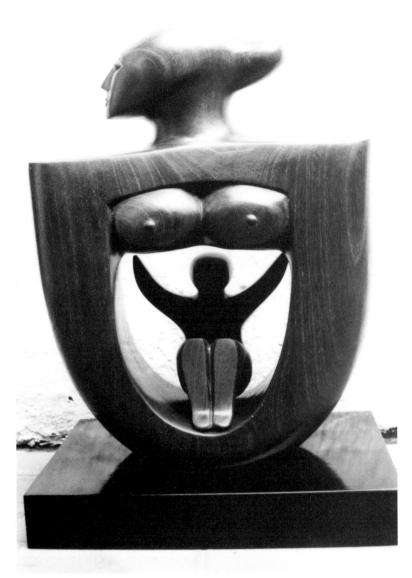

Fig. 10 *Maternity*, mahogany, 30 inches, 1990.

stance. The art historian Elton Fax considers Catlett's sculptures of women

> awesomely strong and, like her terse conversation, they are bereft of all non-essentials. Their heads tilt upwards at defiant angles, and their feet are planted squarely under them. And why not? Elizabeth Catlett learned early that to survive as an individual she would have to lift her own head and plant her feet firmly in the good earth.[23]

In contrast to these images of resistance, a mood of endurance dominates *Seated Figure* (1979, Fig. 7), created both as a large mahogany sculpture and a nine-inch bronze. Seated on a low bench, this woman's elbows rest on her knees while the hands reach up over her bowed head and blend in with the curvature of her head. She stares quietly—as if uncertain of the future.

For more than fifty years, Catlett has explored the theme of the *Mother and Child* with many variations. It remains a significant theme reinforced by the fact that Catlett and Mora now

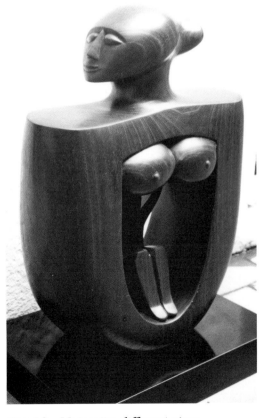

Fig. 10 *Maternity*, different view.

Fig. 11 *Lovely Twice*, lithograph, 22 by 30 inches, 1976.

have five grandchildren. In two small bronzes of 1979, one of a seated mother, the other standing, the child's face is revealed from behind the mother's form (Figs. 8, 9). The protective and tender relationship between the them is expressed through simplified curvilinear movement. A balance is maintained between the straight contour edges of the mother's arms in contrast to the ample curves of her hips. The energy is sensual and life-affirming. In Catlett's thirty-inch mahogany carving of *Maternity* (1990, Fig. 10), an exciting balance is achieved between abstraction and reality as Catlett is influenced by African sculpture and her own compelling powers of visualization. From the front a mother's calm, elegant face appears in profile, while her child is securely nestled in a hollow space beneath her breasts. Coleman considers this treatment of the theme novel as

> the bust is reduced to the shape of an effigy jar, prominently featuring breasts, and in the voice beneath is a child positioned as if in a swing. The artist organizes the arms of the figure into volumes and subtle reliefs that suggest protective motherhood, and at the same time present forms that range from traditional, freestanding, realistically sculptured images to semi-abstract, surrealistic expressions.[24]

Fig. 12 *There Is a Woman in Every Color*, linocut, 22 by 30 inches, 1975.

In discussing the inescapable twentieth century aesthetic influences upon Catlett's sculpture, Coleman refers to "organicist and constructionist art styles" in the tradition of Henry Moore, Constantine Brancusi, and Hans Arp. These artists, like Catlett, avoided European realism and instead responded to the "aesthetic qualities of African and pre-Columbian art." While constructionism is an art style derived from Cubism, "Catlett's art is also organicist in its suggestion of a core, a seed-like center generating larger bromorphic solutions."[25] This is also reflected in Catlett's treatment of materials, her attention to the wood grain. The surfaces are all smooth and highly polished to enhance the natural qualities.

In reviewing Catlett's prints I noted that in 1975 and 1976 Catlett produced several double portrait lithographs. The background in *Lovely Twice* (Fig. 11), consists of spontaneous textures, suggestive of a flower garden. Emerging in front is a young woman's face which is turned toward the viewer and then repeated in profile. In *There Is a Woman in Every Color* (Fig. 12), two exact heads of the same woman are printed side-by-side, but one is in black and the other white. Their austere profiles are contrasted with a series of small rainbow-colored goddesses with upraised arms. They are printed sideways along the edge of the composition, like playful paper dolls.

Fig. 13 *Chile #1 (Homage to Victor Parra)*, linocut, 11 by 15 inches, 1980.

Fig. 14 *Chile #2*, linocut, 11 by 15 inches, 1980.

In discussing the feminist movement, Catlett is clearly concerned with the plight of Black and Chicano women in the United States as well as in Latin America, Africa, and the Far East. In contrast to artists who concentrate on the beauty and refinement of middle-class women's bodies, Catlett says, "I think there is a need to express something about the working-class Black women, and that's what I do... Living in Mexico, I know that Latin American women want to be liberated along with Latin American men. They are all in prisons, whether they are women or men."[26]

Catlett produced several prints symbolically expressing the brutality of the Pinochet dictatorship in Chile, where in the 1970s and 1980s thousands disappeared, were tortured, or exiled. The print titled *Chile #1* (Fig. 13), was dedicated to the widow of Victor Parra, a musician whose hands were chopped off while imprisoned. Catlett depicts Parra's severed hands in the upper part of the composition as a series of clenched fists rising upward from the blood-drenched soil. Below, Parra's head is dramatically silhouetted against the white paper background, beside a helmeted soldier. As in all Catlett's linoleum prints, the rhythmic tool-cuts in the process of creating her forms add to the vibrant intensity of each image. In her second print of her *Chile* series (Fig. 14), the desperate angular form of a prisoner with upraised arms is reinforced by the angularly-designed background space. Catlett's incredible mastery of the human form combined with a dramatic use of positive and negative space adds formal power to her potent images.

A recent sampling of Catlett's prints take themes from her New York experiences. *On the Subway,* 1986, (Fig. 15), features a profile of a young Black woman wearing a beret and staring straight ahead. The background texture, which is soft and scribbly, contrasts with her realistically-rendered features. *Begonia Leaf,* 1986, (Fig. 16) combines the gentle profile of a young Mexican man (Catlett's and Mora's gardener) beside a large green leaf imprinted from an actual begonia plant. *Fiesta,* 1988, (Fig. 17) depicts a man playing a guitar. His form is partially repeated as a silhouetted shape on the bottom corner of the composition while above him are two ballet dancers, almost bird-like in flight.

Jeff Donaldson, Dean of Fine Art at Howard University, summarized Catlett's goals in a 1973 exhibit catalog:

> Black artists have, some have committed their art to the Struggle for Survival/Victory of Black and Third World Peoples over their oppressors. Elizabeth Catlett has made that commitment. She made it even before she said, "I believe that art should come from the people and be for the people" (1952). Even before, she said, "I believe that art is important only to the extent it grows out of and affects the society of its time" (1946). Elizabeth Catlett has no problem with priorities. Her work speaks to the needs and concerns of Black and Third World Peoples. Her work is a visual bridge connecting our common ancestry.[27]

In addition to exhibiting in formal art spaces, Catlett believes, "Making my work available in non-established art spaces where it is accessible to Black working people is very important to me."[28] She has exhibited in libraries such as the Main Public Library in Las Vegas, Nevada, 1979, and in Miami, Florida, 1984. She responds to various criticisms including the informality chosen for exhibit spaces in *Reimaging America: The Arts of Social Change*:

Fig. 15 *On the Subway,* lithograph, 15 by 19 inches, 1986.

Fig. 16 *Begonia Leaf*, lithograph, 22 by 30 inches, 1986.

I have been criticized for being old-fashioned, for not contributing anything new to art, and for exhibiting in places where there are no galleries. To me, such criticism is absurd. I continue to try to bring art to my people and to bring my people to art as I recognize my debt and our need. There has to be something for us outside the mainstream and something of our lives we can offer to others.[29]

Through the years, Catlett and Mora have had combined exhibits: Saxon Summer Palace, Dresden, Germany, 1973; The Gallery, Los Angeles, California, 1976; Arizona State University Museum, Tempe, Arizona, 1987; and, more recently, the Mississippi Museum of Art, Jackson, Mississippi, 1990. This Mississippi exhibit was titled *A Courtyard Apart* and consisted of two retrospectives: Mora's water color and oil paintings, especially of his vivacious dancers, a series of African-inspired images created since his 1960 trip to Guinea in West Africa, and Catlett's prints and sculptures including one of her most recent pieces, *Embrace*. Catlett told me, "When I exhibit, Black people come. When Pancho (Mora) exhibits, Mexican people come. White people always come. Between them Blacks and Mexicans fight enough. If we exhibit together, it brings us all together."[30]

In the past twenty years, Catlett has had many private and

Fig. 17 *Fiesta*, lithograph, 22 by 30 inches, 1988.

public commissions and recently completed *Embrace* for the twenty-fifth wedding anniversary celebration of Bill Cosby and his wife. *Embrace*, 1990, (Fig. 18), in black onyx, is approximately three-feet tall and elegantly portrays the rhythmic energy that unites an embracing couple. Coleman states "In this work the abstract qualities and elemental forms come together as the artist seeks to strip visual descriptions of the subject to the very essentials"[31] *Dancing*, 1990, (Fig. 19), also a commissioned work, is an embossed, horizontal lithograph created for the Stevie Wonder Foundation. The composition emphasizes the vibrant body movements of one dancing couple, with other dancers portrayed on each side. In 1976 Catlett completed a ten-foot bronze statue of Louis Armstrong for the City of New Orleans. Her 1990 Atlanta City Hall commission consists of a nine by thirty-four foot horizontal bronze wall sculpture *The People of Atlanta*. The plan for this piece was first carefully sketched out to scale on a roll of white paper. It reveals a cross-section of Atlanta's diverse population and is composed in segments. There are a series of portraits, as well as full-length overlapping images of people with

Fig. 18 *Embrace*, black onyx, 30 inches, 1990.

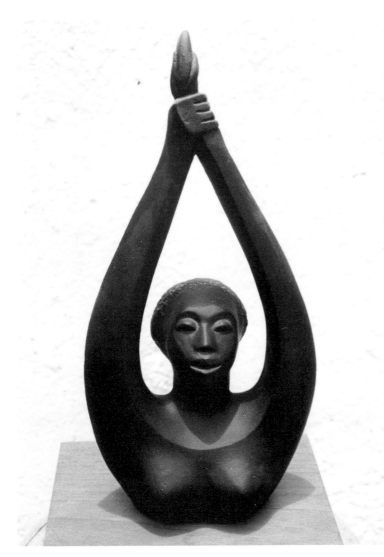

Fig. 20 *The Immortals*, bronze, 16 inches, 1986.

Fig. 19 *Dancing*, embossed lithograph, 22 by 30 inches, 1990.

their professional identifications varying from briefcases to hammers, but Catlett has not overlooked the tragic aspect of our society as, to the far right, standing apart, is a homeless person. Catlett has also created "little monuments" such as *The Immortals* (Fig. 20), a sixteen-inch bronze, commissioned in 1986 by the Association of Black Charities to give as awards to "the women that make it happen."[32] *Singing Head* (Fig. 21) was created for the National Council of Negro Women.

> Lewis sums up Catlett's position as a Black woman artist, and as a member of an important splinter group of American Artists, black and intent on using their art as a cutting edge for cultural advance. They intend for their work to explore deep life—experiences, subject matter—external appearance is merely an outlet, a passageway as it were, for the inner meaning to escape into view."[33]

Catlett and Mora are planning to visit her "roots" in Madagascar in 1991, and it will be interesting to see if related images emerge when she explores the impact of this journey in prints and sculpture.

Endnotes

1 Freida High Tesfagiorgis, "Afrofemcentrism and Its Fruition in the Art of Elizabeth Catlett and Faith Ringgold," *Sage* IV (Spring 1987): 25.

2 Samella Lewis, *The Art of Elizabeth Catlett* (Los Angeles: Hancraft Studios and Museum of African American Art, 1984).

3 Ibid., 6.

4 Ibid., 8.

5 Ibid., 9.

6 Ibid., 157

7 Ibid., 11.

8 Ibid., 14.

9 Tesfagiorgis, 27.

10 Lewis, 15.

11 Charles White, *Images of Dignity* (Los Angeles: P. Ritchie Press, 1967).

12 Lewis, 17.

13 Thalia Gouma-Peterson, "The Power of Human Feeling and of Art," *Woman's Art Journal* 4 (Spring/Summer 1983): 49.

14 Lewis, 18

15 Ibid., 21.

16 Tesfagiorgis, 27.

17 Elizabeth Catlett, interview with author, Cuernavaca, Mexico, 17 and 18 June 1990.

18 Ibid.

19 Ibid.

20 Estella Lauter, "Visual Images by Women: A Test Case for the Theory of Archetypes," in *Feminist Archetypal Theory*, ed. Estella Lauter and Carol Schreier Rupprecht, (Knoxville: University of Tennessee Press, 1985), 77.

21 Tesfagiorgis, 28.

22 Ibid.

23 Elton Fax quoted in *A Courtyard Apart, the Art of Elizabeth Catlett and Francisco Mora*, ed. Floyd Coleman (Jackson, Miss.: Mississippi Museum of Art, 1991), 33.

24 Coleman, 25.

25 Ibid.

26 Elizabeth Catlett, quoted in Lewis, 102.

27 Jeff Donaldson, *An Exhibition of Sculpture and Prints by Elizabeth Catlett* (Jackson, Miss.: Jackson State College, 1973).

28 Elizabeth Catlett, "Responding to Cultural Hunger," in *Reimaging America: The Arts of Social Change*, ed. Mark O'Brien and Craig Little (Philadelphia, Pa.: New Society Publishers, 1989), 249.

29 Ibid.

30 Catlett, interview.

31 Coleman, 19.

32 Catlett, interview.

33 Lewis, 152.

34 Tesfagiorgis, 29.

35 Coleman, 35.

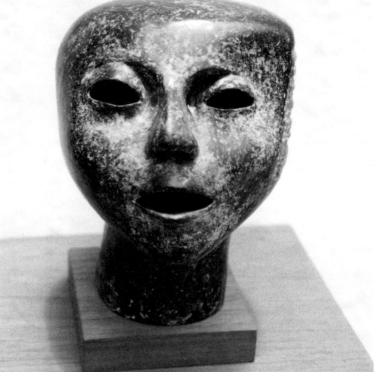

Fig. 21 *Singing Head*, bronze, 12 inches, 1986.

I returned from this pilgrimage inspired once again by Catlett, the artist-humanist, and the link between her personal life and portrayal of "Black women as real-type individuals who are thinkers, feelers, human beings."[34] Coleman notes that Catlett has

> earned a singular place as a master sculptor without the support of a circle of rich patrons, or of the infrastructure that has supported white male artists. Her superior talent, her keen intellect, her dogged determination to set her own course and her commitment to art as a humanistic endeavor of the highest order have propelled her career forward."[35]

However, the lack of Catlett's inclusion in the mainstream and in contemporary American art history texts is a lamentable loss.

Art and Nationalism

"Unity is a deliberate act of commitment, bridging the differences and emphasizing elements of common understanding. Unity must be constructed in a manner which establishes a sense of trust and shared experiences between various groups."

— Manning Marble

Yugoslavia:
Nives Kavuric-Kurtovic

Looking at Your Own Contradictions

WHILE VISITING Yugoslavia's major art museums in Belgrade, the capital, and Zagreb, an industrial center, in 1986, I saw the work of Kavuric-Kurtovic,[1] one of the few women painters represented. Kurtovic's figurative images were a radical departure from the past and from the stereotypical portrayal of women as stylish wives, virtuous madonnas, or enduring peasants struggling with the earth for survival. In contrast, Kurtovic's focus is personal and reveals her existentialist view of life. After meeting with Kurtovic I also became aware of national social issues in relationship to Yugoslavia's growing number of contemporary women artists.

The seven ethnically diverse states, both Christian and Moslem, that compose Yugoslavia (Croatia, Serbia, Slovenia, Bosnia, Herzegovina, Montenegro, and Macedonia) became unified as a nation in 1918. After World War II, Yugoslavia, under Soviet Russian domination, became a socialist republic with Josip Broz Tito as President from 1945 until 1980. In the arts, the influence of Soviet social realism was brief as relations between the two nations were severed in 1948. Yugoslavia then became a leader among the non-aligned nations. Nationally, aesthetic diversity was encouraged but with strict limitations.

Historically, throughout the nineteenth century academic realism dominated the visual arts until 1945 when dynamic changes began to occur. It was during this period, according to Miodrag B. Profic, the director of the Museum of Modern Art in Belgrade, that "Yugoslav art took its place in the modern world" as "a blend of the old and the new, the national and the universal." Ethnic factors were important "as these painters frequently localized their symbols and mediums."[2] According to Profic, characteristics attributed to Zagreb or to Croatian painters are "the impulse of geometric abstractions emanating from the German Bauhaus school," whose goals were "to replace subjectivism with the objectivity beautiful, to create a fresh visual reality."[3]

In contrast to Croatian aesthetics, "the magical, the metaphysical, and the surreal" are characteristics of Nives Kavuric-Kurtovic's paintings which are aligned with Belgrade or the Serbian school. These characteristics are disturbing as they are considered "the aesthetics of ugliness, torture and sadism, provocation and protest... Their highly subjective alogical visions frequently preoccupy them more than compassion... and contribute less on the narrower plane of form than on the level of

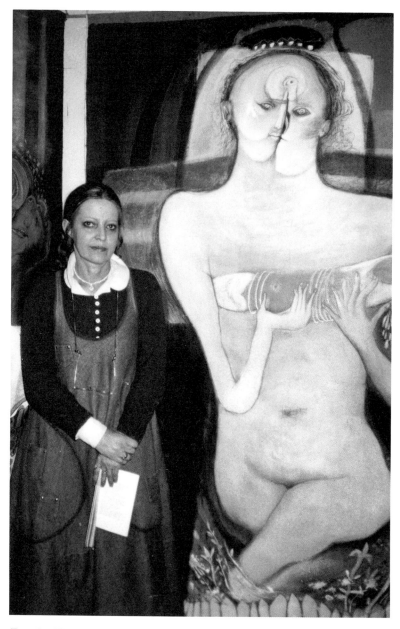

Fig. 1 Nives Kavuric-Kurtovic, Zagreb, Yugoslavia, 1986, with her painting *Pieta*.

content—psychologically, semantically, and sociologically."[4]

In the arts, a popular and liberating view of women emerged during World War II and was partly responsible for inspiring Kurtovic's life and art. One example appeared on a poster appealing to the population to resist collaboration with the invading Germans and to join the partisan movement. The poster was revolutionary in effect, as a mother carried a rifle in one hand and a baby in the other. After the war, past routines were altered as, for the first time, large numbers of middle class women worked outside the home and became partially liberated from domestic roles. This freedom took root and extended to the next generation, though there was no organized feminist movement until the 1980s. Nezavisni Savez Zena and Florence Howe

articulated the position of Yugoslav women, "Traditionally absent from politics and surrounded by patriarchal values and morals ... and are once again facing the danger of manipulation in the name of so-called 'universal' aims—Nation, State, Freedom, and Democracy."[5]

Kurtovic's art can be considered feminist in that she daringly explores women's relationship to family and society at large. She is also self-exploratory. Her surreal and satirical images are disturbing in their sensuality and eroticism and test the limits of Yugoslavia's freedom of expression. Yugoslavian journalist Slavenka Drakulich explains:

> According to accepted theories about the relation between sexuality and repression, women are less threatening to the state if they are publicly represented only in the role of mother. But if sexuality is separated from motherhood, women become a potential danger to the family as a basic social unit. Sexuality, especially female sexuality, has to be programmed in a patriarchal way if a state—East or West—wants to continue its present form.[6]

Most of Yugoslavia's professional artists are represented by unions. Therefore, in Zagreb, Perusho Bogdanic, the secretary of the Croatian Union of Artists facilitated my meeting with Kurtovic, whom he considered "the best feminist artist of Yugoslavia." He also noted that she "grew up in a famous family and has always had everything. She has never had to fight for anything, although she has experienced all the advantages and the best of our society including the tragic moments of our history."

Kurtovic (Fig. 1), petite and graceful, smilingly guided us into a small room adjoining her studio where the chairs and tables were also works of art. They were painted with fluid figurative forms that seemed to have spilled out from one of her many paintings covering the walls, hanging alongside childhood photographs of her son, now a college student.

In discussing her work, Kurtovic admits that her themes are "a little outside the popular art movements" as they are also related to literature and philosophy. Fond of the existential writers, Kafka, Sartre, and Camus, she even embraces the despairing Beckett as "my bible" and says that her images are not "pleasing" but reflect "life as it is." Kurtovic was born in Zagreb in 1938. She has always lived in the same two-story, small but modern home that her father, a Bauhaus-trained architect, designed and constructed. Kurtovic vividly recalled that as a child "I liked to draw and was encouraged by my father especially when he told me 'You are making good things.'" Unfortunately she was only three years old when he was killed by the Nazis. During the war, her father was a leader in Yugoslavia's underground resistance movement, and, because he died without revealing the names of the others in his group, he was considered a national hero. A prominent Zagreb boulevard is now named after him. Kurtovic offered no personal comments about her mother or her older sister, who is a doctor.

At Zagreb's Academy of Fine Art, Kurtovic majored in drawing and painting and graduated in 1962. For the next five years she continued her post-graduate studies in the Master Workshop of Krsto Hegedusic (1901-75), a much beloved and respected artist and teacher. Hegedusic is linked with the

Fig. 2 *Not Enough Happiness for a Love Story* (detail), 48 by 52 inches, 1967.

Fig. 3 Untitled, acrylic, 12 by 18 inches, 1986.

Fig. 4 *Looking at Our Own Contradictions #1*, acrylic, 36 by 36 inches, 1981.

Fig. 5 *Looking at Our Own Contradictions #2*, acrylic, 36 by 36 inches, 1981.

Belgrade Surrealists—poets rather than painters—who, aware of the "crisis of civilization" and inspired by the example of Andre Breton, demanded a revision of all the norms and values of the bourgeois order... Members of the group drawing their inspiration from Bosch, Breughel, Grosz, and translated anecdote and narrative into plastic terms.[7]

Hegedusic also drew his inspiration from Yugoslavian folk traditions, including both the joyous and tragic elements, as can be seen from his paintings in the Zagreb Museum, *Church Feast in My Village* (1927) and *The Flood* (1932). Though his work was rooted in peasant life, his approach in teaching was not rigidly academic. Kurtovic believes, "He gave me an invitation to explore my own potential." Determined to "make something very alive but very different," Kurtovic turned inward for her inspiration. She said, "I work without thinking. My hand goes before me; then afterwards I see what I have created." She also added, "I develop images not as a pre-determined vision but during the act of creation."

A shy person brought up in the "classic" tradition, Nives married a man with whom she grew up at twenty-five. He is now a distinguished law professor. She considers their marriage "something mystical." Their son was born in 1967. "Having a child," she relates, "meant a major change in my life and habits." Nevertheless, her productivity seems not to have been effected. In 1963, while still at Hegedusic's workshop, she joined Zagreb's prestigious Forum Gallery and has since participated in more than three hundred national and international exhibits, both solo and group. Her work is in prominent collections, and she has won many major prizes. Kurtovic refers to herself as someone "marked to be an artist, but an artist without hope." Though she considers her present work "different," she adds that "it's all the same as there are only two or three subjects in your whole life with which you really deal. Only the approach changes."

Kurtovic categorizes her work into three periods. The first is "black and pathetic." The second is "more humorous," and her present phase is the most "cynical," but not political. "If you are political you must conform and fixed thinking is neo-fascistic. I want to remain a free thinker." She added, "Dark roots are very much a part of our lives, and sometimes we don't have any real reasons for saying, 'Things are no good,' but cynicism and skepticism in Yugoslavia are cultural by-products."

In an early painting, *Not Enough Happiness for a Love Story*, 1967, (Fig. 2) at Zagreb's Modern Art Gallery, an ambivalent, frightening relationship shatters the archetypal vision of mother and child. The dominant feature of the sobbing male child is a large, open mouth; the child's head tilts back, merging with the mother's. Her mouth is set in resignation; one eye also appears resigned while the other focuses on the child as if sharing his anguish. While the child reaches to embrace his mother, her restive, distorted body seems to be twisting and turning, partially in flight. Below, as if emerging from under the mother's skirt, a big bald male head appears in profile, with a thin white band around his neck. His vision is focused on the hole of a tool handle, a wrench. Is Kurtovic suggesting that this man is better able to handle mechanical rather than emotional difficulties? Kurtovic offers no specific clues other than the graffiti written across the

Fig. 6 *Rolled Up by Life or the Cake-Roll of Life*, acrylic, 6 by 40 feet, 1986.

child's lower abdomen, "Keep peace with your soul." The forms are created with black, intersecting contour lines that are imposed over acrylic washes of beige, pale blue, and white. Nothing is hidden, from the first moment of the image's conception, revealing Kurtovic's process of digging into and exploring her theme.

One corner of Kurtovic's small, eight-by-twelve-foot studio contained a large table cluttered with drawings and an assortment of pens, colored pencils, paints, and brushes. Paints and brushes were also on the floor covered with a black rug, where she works on long unstretched canvases. Leaning against the wall was a stack of smaller stretched canvases containing a series of portraits in progress. These smaller studies are less complex; in one a man's head and a horse's head are integrated, but each looks unhappily in a different direction (Fig. 3).

Kurtovic works on several projects at once. She describes her earlier paintings as based on a "discourse between two or more figures. At that time I was thinking about communication, but now I see solitude and a black future before me." Pessimistically she adds, "I began early, now I am finished. I am without hope." At first these dramatic pronouncements seemed incongruous with her professional achievements, but with increased exposure to her work, her Sartre- influenced existentialist position, *No Exit*, becomes more evident. This is exemplified by *Looking at Our Own Contradictions* (Figs. 4, 5), which was the title of her 1981 exhibit at Galeria Spektor in Zagreb. In the exhibit catalog the art critic Vlado Buzancic commented about the featured series of portraits created from 1978 to 1981:

> When someone works so concentratedly, so passionately, for so many hours, almost every day, always following her own imminent inward handwriting, and the way she has systematically developed her inward sensitivity and experience through her work, these three or four years seem like a minor epoch of her creativity filled with the subtleties of her primary painter's nature.[8]

In one of these disturbing images reminiscent of the figure distortions in Francis Bacon's paintings, a man's hands are raised to his open mouth from which a cherry-red tongue pro-

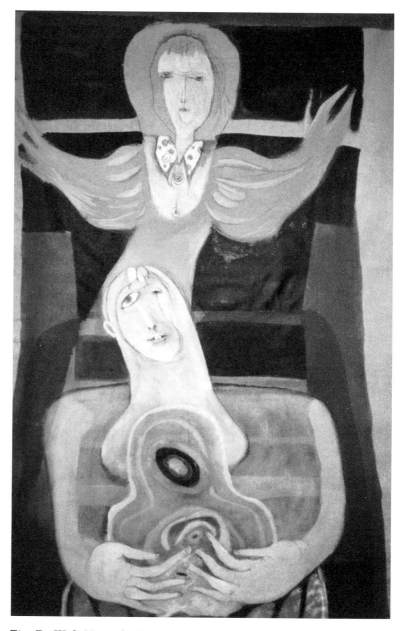

Fig. 7 *With My Naked Soul I Testify to the Traces of Life*, acrylic, 48 by 62 inches, 1986.

trudes. Dark holes suggestive of eyes peer out from his elongated white head upon which is superimposed a rectangular frame. This rigid enclosure suggests either a window for looking out or a plastic container for confinement. The painting's thinly applied dominant colors are pink, sky blue, and earth brown. In contrast, the flesh tones are painted with a thick layer of white. In another work from the series, *Looking at Our Own Contradictions*, a double portrait, two aspects of a person's inner struggles are portrayed. A deep grey bubble encloses a white face which is contained within a larger face shown in profile. The profile, painted with beige skin tones, has bright red lips, and one hand with long, crescent-shaped fingers is held at the level of the chin, while the other hand blends into the features. A bubble encloses

Fig. 8 *Man*, acrylic, 48 by 62 inches, 1986.

this double portrait but a few wispy strands of hair break free and drift into the black background.

In contrast to these easel paintings, two of Kurtovic's recent paintings are mural size in scale. They are both on rolled canvases, six feet in height, and one is twenty feet and the other forty feet in length. Titled *Rolled Up by Life or the Cake-Roll of Life* (Fig. 6), they were painted like a scroll, one section at a time, on her studio floor. In reference to these paintings, the art critic Tonko Maroevic states,

Kurtovic's intimate confessional interior monologue is comparable to an Etruscan mummy wrapping, as this scroll simultaneously reveals and covers up ... because mummies jealously guard their secrets... Not all the clues are given to us, but we have to connect the painting with the person that produced it, and we can only try to guess to what extent it was filled with the elements of real life and to what extent it is the projection of some other dreamed, desired or threatened world.

The images often appear wet, slimy, warm, pink, gentle and soft ... the figures spill out and grow. There is no beginning or end, therefore they cannot be contained in a frame as they go on forever overlapping and emerging.[9]

In *Cake-Roll of Life* the bottom edge of the canvas forms a ground line that supports a procession of figures that are sensually reclined, upright or floating in an undefined space. In this

Fig. 9 *Table of Vampires*, acrylic, 48 by 62 inches, 1986.

parade we find embracing lovers, an old woman with a shopping bag, the Virgin Mary, and the infant Jesus. Some forms are metaphorically merged with mules, calves, or dogs. What emerges is a personal mythical sage of life, love, and war. Through Kurtovic's compelling vision we become witnesses to some aspects of our own unvoiced screams and passionate longings, as well as to Kurtovic's sense of eventual doom. Could she have been prophetically forecasting future political events such as the Chernoble disaster with its radioactive fallout which drifted over Yugoslavia in 1986 or the brewing ethnic conflict that has once again erupted between Serbians and Croatians? Kurtovic's smaller series of unstretched paintings, *Blankets for Dreams without Sleepers*, are forty-eight by sixty-two inches and are equally provocative. Four of them were hanging on her studio wall and were almost longer in length than the artist. Devoid of expressions of tenderness or joy, they probe the psychological depths of her marriage and motherhood.

In *With My Naked Soul I Testify to the Traces of Life* (Fig. 7), the underlying compositional structure is a black cross upon which are superimposed the torsos of a mother and child. This male child positioned above the mother has wing-like hands that are upraised. A pale grey halo surrounds his head, merging with his thin body. The mother has one eye wide open and the other closed. Her long fingers pull open a symbolic womb composed of concentric circles or labia. This painting is comparable to the archaic mother goddess of the prehistoric vessels from Vinca, as she points to her womb in a life-welcoming gesture. These neolithic Vinca vessels also contain circle and spiral motifs. The historian Oto Bihalji-Merin comments that in Eastern religious imagery, the "circle serves as an instrument of meditation designed to establish the link between man [people] and the universe ... and the spiral was the symbol of life's course through the labyrinth of fate, the end meaning death and, in religious terms, redemption."[10] Also of interest are the anthropomorphic pottery lids in which two enormous eyes appear, possibly "to protect the content of the vessel from evil spirits or spells."[11] Is Kurtovic's painting autobiographical, and is she the one-eyed archaic mother and protector of her son?

In *Man*, 1986, (Fig. 8), a seated figure, partially dressed in a formal black jacket, embraces three heads. The paint stops abruptly along his waist and his lower foreshortened torso is left exposed. Surrounded by folds of cloth, suggestive of wrinkled underwear, this man's flaccid penis, thinly outlined with black paint, hangs down between his spread legs. Two heads which he embraces glance at his passive face, with their mouths open like choir angels. They each have a halo composed of light and transparent blue wings, while the head between them has only one eye, that stares into space. As usual, Kurtovic's paintings raise more questions than they answer. "Man," Kurtovic says metaphorically, "is a dreamer who dreams about taking care of what he takes in, but ultimately he is not very useful, or sensitive. He is very automatic in his approach to life, and he lets things fall down." "Man tries his best, but without results."

Table of Vampires, 1986, (Fig. 9), also from this series, is a complex figure group. Commenting on this work, Kurtovic blurted out enigmatically: "I make many fights. I can also think about myself as guilty and responsible, not in a right way." Here a small child's head emerges from the rear of a lace covered table. He seems to be the focus of an angry debate going on around him, from which no solutions seem forthcoming. At the front of the table a figure leans over a blood red rectangle containing non-defined squirming forms, perhaps the child's entrails as he is being verbally dissected.

In another work from this series, *Pieta*, 1986, (Fig. 1 and 10), religion, eroticism, and condemnation merge as a woman's vertical rectangularly shaped torso rises from a garden that is enclosed by a picket fence. The long, thin loaf of bread which she holds against her breasts extends horizontally like the arms of a cross. In the background, the white upper part of the cross frames her head which also has a halo above it. The head is actually composed of two faces in profile—their common nose, a penis, points upward with an eye-like opening. Kurtovic explains that bread is symbolic of "a child, or life's foundation and our culture. In the past bread was made daily in each household, but

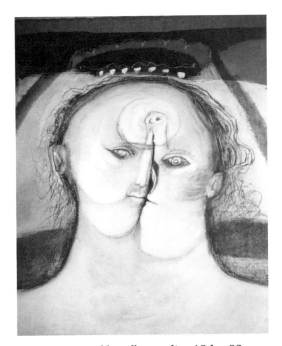

Fig. 10 *Pieta* (detail), acrylic, 48 by 62 inches, 1986.

Fig. 11 *Everybody Possesses His Own Loneliness*, pen drawing, 9 by 12 inches, 1976.

now it is mass produced and is therefore without personality or merit." Bread is a metaphor for individuals and society, as she compares bread to "a person's big wish, that culminates with less, and that the results are sometimes very bad. I'm confused," she said, "as before there was a sense of synthesis and believing, but now everything is in question."

Scorning national and international feminist movements, Kurtovic said "Women's sensibility is innately different from men's, but I'm very angry when we say, 'women's art.'" In the animated discussion that followed, Kurtovic's friends pointed out that women's rights in Yugoslavia were legally guaranteed by their constitution after their 1945 revolution. "Women are ostensibly equal, but the underlying patriarchal structure of our society is still very much intact. Women as individuals are still oppressed. Not only are women breadwinners, but they must also be good mothers, housewives, cook and clean." They also felt that "husbands are less willing to share domestic and child care responsibilities than husbands in the United States."

Kurtovic describes her life as a "hurricane" as she is not only creating "like a maniac" but is constantly exhibiting and selling almost everything she produces. Kurtovic has managed to juggle her traditional professional independence with her domestic role by being "well organized. I am also a maniac for work. By 8 A.M. I have completed my housework and prepared the lunch for my husband and son." Happy respites in her intense work routine are the annual month-long family vacations, when they drive to various European countries to visit friends and museums. During this period Kurtovic does not draw or paint but rests and absorbs from the exhibits all the changing major international art trends.

In 1983, Kurtovic accepted a new challenge by joining the faculty of Zagreb's Fine Arts Academy. There she teaches drawing to a small group of advanced students for daily three-hour sessions but is only required to be there part of the time. Kurtovic tries to convince her students "that anatomy is not as important as seeing basic human characteristics and shapes in order to interpret life with freedom." She also says, "I do not impose, but I tell my students to have a dialogue with things close to them." She hopes, "My truth will help them, maybe not at this moment, but for their future." At present more than half of the Fine Arts Academy students are female, but Kurtovic was the first woman to be appointed to the fine arts faculty since the school's founding in 1908. The curriculum is divided into Plastic Arts, a five-year program which consists of painting, sculpture, and graphics, and a four-year Applied Arts program which is based on design, ceramics, and crafts. Art history is required for all students, while teacher education classes are optional.

Acceptance to the Academy is highly competitive, based on a strenuous, week-long examination, both written and in studio performance. In addition, students must present a portfolio of work. The school's enrollment is limited to approximately 120 students in order not to inundate society with too many unemployed artists. All graduates of the Academy are automatically accepted as members of the Union of Croatian Artists, which was formed about one hundred years ago. In Zagreb there are 780 members and the Union maintains forty art galleries, while only eight are privately owned. Approximately three hundred artists

are classified as "free-lance," which means they survive "meager-ly" as full-time artists, while the others teach or are graphic designers, book illustrators, or craft producers. Anyone can apply for Union membership by presenting a portfolio of work to a commissar of the Union, which is composed of artists and art critics. The applicants must first have achieved some profession-al recognition: participation in collective exhibits or having an individual show. Union benefits include social security, medical care, and retirement. Artists can petition the Union for an indi-vidual exhibit, which can include a stipend to help with the cost of materials. The Union also maintains shops which serve as the artists' outlets for more consumer-oriented products.

Bogdanic, the Union secretary, explained that it is unaccept-able to the government for an artist to create anything insulting about Tito, Yugoslavia's former president, or to criticize through art the government's present political policies which are in flux. Bogdanic said, "Art that promotes the separatism of Serbia and Croatia or is against national unity is also forbidden." He also explained that there is no censorship of erotic or even mildly pornographic art, but hard core pornography or sado-masochis-tic art is not permitted. Bogdanic and Kurtovic both agreed that artists should have more government financial support, but in contrast to Kurtovic, Bogdanic, who visited the United States, is glad that "at least we are not victims of the gallery system as in the U.S." They both agreed that art is more accessible to the public in Yugoslavia but lamented that "bureaucracy and admin-istration are felt too strongly in the organization of the arts." Disappointedly they added, "Bread is bought first, not art."

Over the last two decades Kurtovic has collaborated with poets, resulting in the publication of ten books. In 1976 a unique collaboration took place between Kurtovic and one of her art crit-ics, Biscicpic Kobescak, in order to produce the first album of drawings by a modern author on contemporary Croatian art. Titled *Nives Kavuric-Kurtovic*, the book "opens a window to unknown and hidden landscapes of the human soul."[12] Kurtovic's comments in an interview with Biscicpic are illuminat-ing: "Drawing enables me to express my deepest human self. I feel a line is like an incisive cut into silence to relieve the burden, to sharpen my ears so that I can smell better."[13]

In answer to Biscicpic's question about "artists that explore the dark side of man's destiny," Kurtovic answers:

Morbidity? I feel sick with the mad desire to be healthy—but healthy in the penetration of the essence of things and in harmony without chimeras... Dante did not descend into the Inferno in order to strike a friendship with morbidity, but rather to understand the world, or the world's conscience.[14]

A broader public view of Kurtovic's art was partially revealed when Biscicpic asked: "Though your painting is 'figurative,' it is sometimes illegible so that it sometimes fails to find acceptance in the general public. Some people wonder why your pictures are 'deliberately distorted'... and feel repulsed by what one might term 'ugliness.'"[15] Kurtovic responded:

I do not know what is ugly, because I see beauty in the moving force and always in a delicate balance. A dia-logue with the mystery of life necessarily touches the reverse side too. This is not the face: the face can be

Fig. 12 *Thanks for the Creative Cooperation*, pen drawing and brown wash, 9 by 12 inches, 1976.

Fig. 13 Untitled, mixed media drawing on paper, 1986.

Endnotes

1 Uncited quotes are from an interview with Nives Kavuric-Kurtovic in her studio in Zagreb, Yugoslavia, March 1986.

2 Miodrag B. Profic, "The Twentieth Century," in *Art Treasures of Yugoslavia*, ed. Oto Bihalji-Merin (New York: Harry Abrams, 1969), 404.

3 Ibid., 406.

4 Ibid.

5 Nezavisni Savez Zena and Florence Howe, "The More Things Change," *Women's Review of Books*, VII (July 1990): 3.

6 Slavenka Drakulich, "Wanted: A Nude Glasnost," *Nation* 244 (20 June 1987): 846.

7 Profic, 403.

8 Vlado Buzancic, *Looking at Our Own Contradictions Exhibit Catalog*, (Zagreb, Yugoslavia: Galeria Spektor, 1981).

9 Tonko Maroevic, *Nives Kavuric-Kurtovic Exhibit Catalog* (Zagreb, Yugoslavia: Umjetnicki Paviljon Gallery, 1983).

10 Oto Bihalji-Merin, "Horizons, Limits, and Boundaries," in *Art Treasures of Yugoslavia*, 17.

11 Dragoslav Srejovic, "Art in the Age of Metals," in *Art Treasures of Yugoslavia*, 62.

12 Biscicpic Kobescak, *Nives Kavuric-Kurtovic Autografija* (Zagreb, Yugoslavia: National and University Literary Printing Office, 1976), 153.

13 Ibid., 157.

14 Ibid., 156.

15 Ibid., 159.

16 Ibid., 155.

17 Ibid., 162.

improved with various aids to make it more attractive, but true life lives only in its back side and is swelling with its inner swarming and humming.[16]

In discussing her creative process, Kurtovic reaffirmed: "I have sought my models not in the finality of order but in the act of creation."[17] In these drawings a wide range of emotion is expressed through the technique of delicate pen and ink cross hatching combined with fluid, bolder lines and ink wash. Fingers, hands, and legs surprisingly stretch, twist, and metamorphose into an endless variety of playful and humorous forms. This is also accomplished through juxtaposition of size, when small figures are incorporated within a face. Chairs frequently appear as props, but Kurtovic's figures seldom sit in them conventionally. In a drawing titled *Crucifixion* a woman is suspended from a cross; in another drawing a woman wrings her hands which emerge from her body like enlarged, gnarled tree roots. In another drawing, *Everybody Possesses His Own Loneliness* (Fig. 11), the elongated forms of a woman and her canine companion silently contemplate her hands. Ironically, as one hand reaches out, the other holds it down. Throughout the book figures fly through the air, rush to meet one another, but seem to miss contact, as though nothing quite works out as it should. Erotic fantasy is an integral component, especially when fingers and penises seem almost interchangeable. The last drawing in the book, *Thanks for the Creative Cooperation* (Fig. 12) features the profiles of Kurtovic and Biscicpic with their noses tenderly touching.

Kurtovic's need to maintain emotional control is evident from her comment. "There was a long period when my blood, my heart, was like a bursting stream, and felt full of vitality. Life is a fluctuation between stages of passion and calm. But you must calm your passion in order to maintain a constant stability with your work." When asked if, in retrospect, would she have done anything differently, Kurtovic answered, "No, life is fate, and I do all I can do. I have ideas about life, but change is not possible. I don't want to look at the past, only to what is ahead of me." She concluded, "I am a pessimist. I am not crying about my lost youth. I only must find my possibilities and go through the other phases of my life that are in front of me."

In opening up for public exposure the domestic scene as a battlefield of human emotions, Kurtovic reflects the current changes in women's reality and expectations. Her personal self-saving feature is that she is filled with her own contradictions as her position of "no hope" constantly yields to new explorations and possibilities that lie ahead. Her untitled 1986 drawing, reveals a combination of mystery and tenderness concerning her relationship with her son (Fig. 13). Kurtovic's work is aesthetically and emotionally provocative as she continues to push open the door to her secrets, perhaps our secrets as well.

Yugoslavia:
Milenah Lah
Sculptural Poetry

I VISITED Milenah Lah (Fig. 1) in 1986 at her compact, two-story studio filled to capacity with a collection of her smaller sculptures and works in progress. It was located in a residential area on a hillside overlooking Zagreb's industrial sprawl. Perusho Bogdanc, the bilingual secretary of the Croatian Union of Artists, of which Lah is a prominent member, accompanied me. When Lah greeted us, I immediately noted her energetic movements, the result of a long career of shaping, chipping, and carving forms from clay, cement, stone, and marble. As we spoke, her hands were in continuous motion as she patiently tried to explain in English, with Bogdanc's assistance, the inherent metaphors of her sculptural forms created during more than four decades of intense activity.[1] I also noted that her short, sturdy stature was highlighted by flaming red hair. She dressed flamboyantly wearing a white silk scarf, striped black velvet pants, and thick, wood-soled shoes.

In the history of Yugoslav sculpture, women are only credited with prehistoric innovations in creating and decorating pottery for utilitarian and ritual use. "Ceramic pieces and their ornamentation are the work of women's hands. The impression of women's fingers on the pottery." But a question arises concerning "sculpted idols":

> the fact that they are so numerous points to their having been fashioned, like the pottery, in the home, for the use of the individual household. However, certain examples of unusual dimensions, approaching lifesize, give us pause. Were they the work of exceptionally skillful individuals in the Neolithic settlements, or of special craftsmen who fashioned particular types of figures for the performance of cult rites on a large scale?[2]

This void in Yugoslav art history concerning women's creative contributions from ancient times until the present raises many questions, that only in the past two decades have been researched and answered by women art historians. However, to my knowledge they have not yet penetrated the Yugoslav void.

In the history of modern Yugoslav sculpture, the monumental, carved stone expressionistic figures of Ivan Mestrovic (1883-1962) are seminal. Many of his monuments, chapels, and shrines are visible throughout Yugoslavia. The style of Mestrovic's religious works and especially his compassionate

Fig. 1 *Milenah Lah*, Zagreb, Yugoslavia, 1984. Photo courtesy of Milenah Lah.

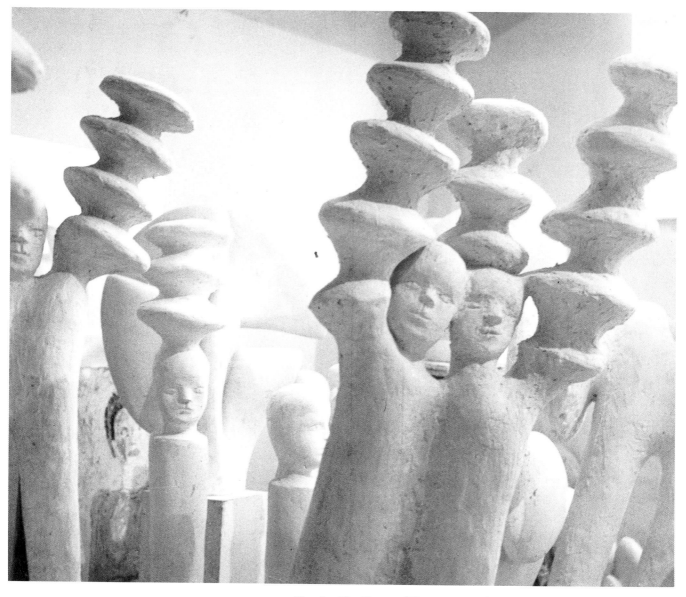

Fig. 2 *The Form of Experience after the Fall of Icarus* (studio view, detail), 34 gypsum carvings, 36 inches tall by 60 feet long, 1968-1973. Photo courtesy of Milenah Lah.

portraits of Yugoslav peasant women has been characterized as integrated and linear; these works range from realism and naturalism to expressionism. His work contrasts with other schools of art, described as having "Mediterranean balance and lightness of spirit" or emphasizing a "more realistic and psychological approach."[3]

However, in 1945 "with the coming of age of the younger generation, a major polarization of concepts took place, and Yugoslav sculpture was transformed."[4] These regional and ethnic divisions include those of Zagreb (Croatia), which evince "geometric abstraction" and a preoccupation with "sculptural symbol, internal and external space, and archaicism in figuration"; those of Belgrade (Serbia), which include "expressionistically slanted figurative works," curving and organic in form; and those

of Slovenia, where "sculptors translated the motif of social protest into symmetrical forms... in a closed, geometrically severe aspect."[5] In summarizing the major historical tendencies, Miodrag B. Profic notes that in all the schools of sculpture, the human figure is the most frequent point of departure. As "sculpture evolves 'from object to symbol' and is conditioned by cultural factors, it confirms the words of the philosopher who declared that poetry is the core of art."[6]

The number of women attending the Zagreb Fine Arts Academy dramatically increased after World War II, and, rather than settling for teaching careers, some, like Lah, opted to become professional sculptors. Her complex themes are frequently conceived as epic poems, constructed as a sequence of multiple units that are related to a specific outdoor environment or interior site. Her images transport the viewer through time and space; they are metaphors for ancient and contemporary journeys that explore the human condition.

Lah was born in the mid-1920s in the town of Krix, near Yugoslavia's beautiful Adriatic coast. Her aesthetic sensitivity to form and movement were influenced by two formative experiences: early observations and enjoyment of sea gulls in flight and a two-year period of dance study with a former student of Isadora Duncan, the modern dance pioneer. Lah asserts, "I started to think about sculpture when I was five or six, and by 1944 [then in her teens] I began to draw on my own." She was encouraged by her father, a motor mechanic who worked on ships, rather than her mother who focused on raising three children. After completing high school in Krix, Lah successfully competed in the entrance exam for the Zagreb Academy of Art, where she attended from 1946 to 1949. Although she began in art education, she soon changed her major to sculpture. During the first two years of her studies, Lah supported herself by working in a flower shop. While still a student, she married, and Lah describes her husband as being supportive of her studies and her career. Their son was born a few years later when their economic situation was less precarious, as her husband was promoted to a managerial position in a factory. "Our son grew up in my studio," said Lah, as she continued her professional career.

After completing her post-graduate studies in 1950, Lah had the opportunity to go on a study trip to Italy for nine months and then to travel to France, England, West Germany, Austria and Czechoslovakia, "always looking at sculpture." She was inspired primarily by early Greek sculpture and the contemporary work of Ivan Mestrovic. Lah's professional career was initiated in 1950 when she participated in a group show, which was followed two years later by her first public commission. By 1953, stone carving became her primary media of expression, and in 1954 she had her first individual exhibit. Lah feels that her husband's early support and philosophical views were crucial to her development as he encouraged her "always to do your work on the basis of Yugoslavia's history, and particularly the region where you were born." Unfortunately, he died in 1962; Lah did not remarry.

Studying the extensive photographic documentation of her work, I could see Lah's exploration of shape and form. In her early figurative sculptures she incorporated engraved lines upon her volumetric forms to add details, such as a woman's hands

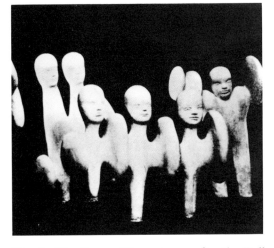

Fig. 3 *The Form of Experience after the Fall of Icarus* (detail), 34 gypsum carvings, 1968-1973. Photo courtesy of Milenah Lah.

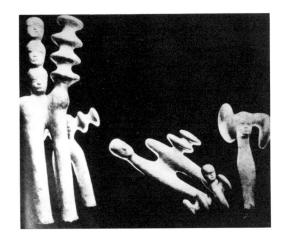

Fig. 4 *The Form of Experience after the Fall of Icarus* (detail), 34 gypsum carvings, 1968-1973. Photo courtesy of Milenah Lah.

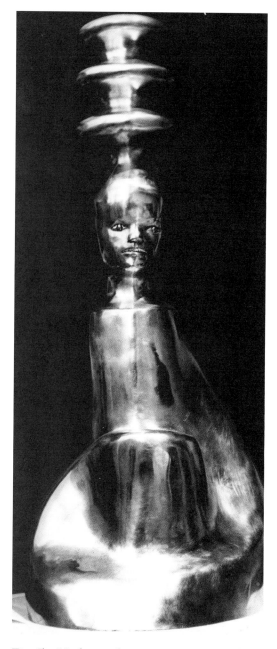

Fig. 5 *Madonna*, bronze, approximately 5 feet tall, 1972. Photo Marija Braut.

holding flowers. Lah holds that flowers are "a symbol of love always to be kept around the house." In other sculptures, the round breasts of female torsos or facial features are incised. Among her subjects are children, cats, and the winged forms of soaring sea gulls.

In the decades that followed, as most of Yugoslavia's sculptors became immersed in emulating contemporary international trends of abstract, minimal, and conceptual art, devoid of humanistic concerns, Lah persisted in developing her own vocabulary. In the extensive 1984 catalog produced by Galerija Spektor in Zagreb in conjunction with her exhibit, the art critic Ljerka Mifka described Lah's creative process as:

> a walk through time as Lah collects in her sculptural meditations, a specific mythological and anthropological language which she carves into a unique spiritual dimension that reflects her personal cosmology. However, Milenah Lah's vision incorporates many elements of time and space as she reflects upon diverse civilizations and mythologies... to point out the "mysterious and mystic center of thought." This process of reanimating the past is integral to Milenah Lah's sculptural poetry.[7]

From 1968 to 1973 Lah developed and completed the first of three series of complex and intriguing sculptural groups. One of them, *The Form of Experience after the Fall of Icarus*, consists of thirty-four separate pieces of carved gypsum, each one representing a stylized figure with a prominent head and simplified body shape. Approximately three and one-half feet in height, and extending over a sixty-foot surface area, each form seems propelled by a movement and spiraling energy linking it to the next (Figs. 2, 3, 4). Lah compares *The Fall of Icarus* to "the history of Yugoslavia" and to an "Adriatic odyssey that moves from a biological to a spiritual essence." Lah also relates this series to a "people in a war for freedom," and the flight of Icarus is comparable to a soaring sea gull. "Through risk and struggle there is always a rebirth and always hope."

Many of Lah's figurative images contain a three-dimensional, spiral-shaped aura that projects from them and symbolizes cosmic energy. She was motivated to explore this symbol by a story related to her by a friend who is a World War II veteran. During a close encounter with death, he experienced a vision that was based on his passage through a house surrounded by three circles of fire. These circles of flame were subsequently interpreted by Lah as auras of energy, and she has since utilized this theme in many ways.

In fulfilling a 1972 commission to create a bronze Madonna for a church in Banja Luva, Yugoslavia (Fig. 5), Lah bypassed the conventional interpretations and created a magical Madonna related to early Neolithic clay and stone sculptures of the earth mother or mother goddess. Though this figure was utilized in magic rites and fertility worship, Lah transforms the Madonna into a symbol of spirituality. Emerging from the top of her head are three rhythmic auras, "a corridor of cosmic energy." The Madonna's face, slightly tilted, contains engaging eyes that do not offer comfort but instead look toward us questioningly. The Madonna's arms do not contain the infant and instead merge with her gently curved and seated form, devoid of details. One's attention is focused upon her cosmic essence symbolized by the

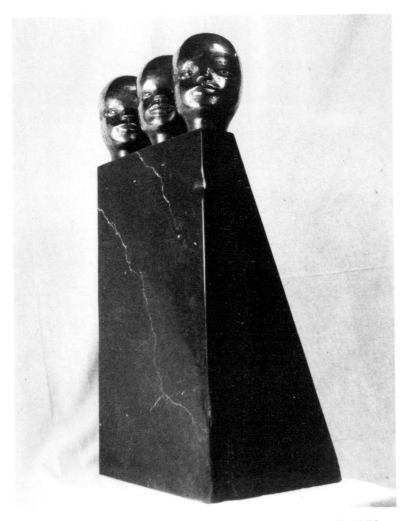

Fig. 6 *Time and Memory*, bronze and marble, 5 feet tall, 1976.
Photo courtesy of Milenah Lah.

magical spirals rising from her head. Lah confesses, "Most people don't understand this Madonna, and neither does the church hierarchy." Nevertheless, the Madonna remains a source of inspiration for those who do identify with the spiritual guidance, symbolized by her "magic circles—feelers of the universe."[8]

In contrast to auras and a sense of spiraling energy, another consistent image in Lah's work is an isolated, elongated head with small eyes and full lips, utilized singularly or within group arrangements. Lah relates that this "obsessive symbol" was first inspired by "a woman wearing a kerchief that was just passing by on the street, twelve or fifteen years ago." Since then this stark, almost child-like head has become a metaphor for sculpture such as *Time and Memory* (Fig. 6) and other works.

In *Time and Memory*, the three heads that dominate this serial piece seem genderless. They are elevated on a tall, angular red marble base that reflects the strength and simplicity of Doric pillars. These calm heads are placed at slight angles to each other as they stare into an infinite space. The art critic Ljerka Mifka comments,

[Lah's] vision is always universal... and always an

Endnotes

1. All quotes, unless otherwise cited, are from my interview with Milenah Lah, in Zagreb, Yugoslavia, April 1986.
2. Milutin Garasanin, "The Neolithic Age," in *Art Treasures of Yugoslavia*, ed. Oto Bijalji-Merin (New York: Harry Abrahm, 1969), 62.
3. Miodrag B. Profic, "The Twentieth Century," in *Art Treasures of Yugoslavia*, 407.
4. Ibid.
5. Ibid.
6. Ibid.
7. Ljerka Mifka, *Milenah Lah Sculpture 1973-1984* (Zagreb, Yugoslavia: Galeria Spektar, 1984).
8. Ibid.
9. Ibid.

attempt to discover the first principle of the moving power through which everything reflects and refracts. Memories in marble and bronze discover reflections in the "qualitative endlessness of nature," where a single exists in a total and a total in a single... to reveal the moment of today in which past and future are reflected.[9]

In a show, Symposia 1963-1978, Lah exhibited a collection of large photographs of her symposium sculptures that are located throughout Europe. Symposiums are annual events initiated in 1959 sponsored by government and private funding. Symposiums offer sculptors an opportunity to create works at specific site locations, such as public parks, gardens, and private estates. They take place in the summer, and those sculptors whose proposals are accepted are provided with materials, living accommodations, and an honorarium for a two- or three-month period. These experiences are stimulating as they provide the opportunity for an interchange of ideas with other sculptors from many European countries, as several can work at one site at the same time. There is also interaction with the public, as the sites are open to visitors while the work is in progress. Since the first European Symposium was held at St. Margarethen in Austria, Lah has now participated in over twenty symposiums. She works mostly on stone blocks of marble and granite from ten feet in height to eighteen tons in weight. Some of her recent themes are *Poetry of Space*, *Constellation of Stars*, and *Table of Peace*. Lah is also the current vice president of this European symposium organization.

A select list of twenty-eight of Milenah Lah's most important exhibitions and works from 1982 to 1985 includes themes such as *Revolution and People*, *Experiment in Space*, *Pillars of the Moon*, and *Through the Labyrinth*. In 1984 she participated in an International Exhibition of Women's Art, held in Bonn, West Germany. That same year Zagreb Television produced an eight-minute film of her three cycle projects, *The Form of the Experience after the Fall of Icarus*, *The Circle of Icarus*, and *The Pillars of the Moon*. Lah has had approximately twenty-five personal exhibits and participated in more than 250 national and international group exhibitions. Since 1965 Lah has been the recipient of several first prizes for her work and has also had the satisfaction of seeing a commissioned work, *Poetry of Space*, accepted for her adopted home, Zagreb, at the Maksimir Park. In the sixth decade of her life, Lah continues to work with incredible exuberance and strength. Life affirming and philosophically challenging, her vision continues to unfold on an intimate as well as a monumental scale, revealing her personal creative joy in the arduous physical process of giving poetic shape to stone.

Betty LaDuke

The Great Chain of Being

THROUGHOUT the years, the sketchbook has served to record visual impressions of the cultural diversity experienced during journeys of exploration around the world. Fascinated by the movement of people, whether at the marketplace, weeding a field of rice, or carrying offerings to a shrine, temple or church (Figs. 3,4,5,8,9,11), I reach beyond the sketched façade when my paintings and prints are produced later, at my home studio in Ashland, Oregon (Fig. 1). I attempt to surprise myself by the forms and colors that emerge as I recreate the essence of a rite of passage or a survival activity, or I try to capture those needs we all share, such as love, compassion, and a sense of self-worth required to live with dignity. Boundaries disappear and forms of people, animals, birds, and vegetation flow together becoming a series of mythical and universal beings.

Gloria Orenstein refers to my work as the "Great Chain of Being," and my images of women as "the great bodies of humble women, seen as epiphanies of the Great Goddess around the globe,"

Her poetic visions of the interconnectedness of animal, plant, and human life are also metaphors for the interconnectedness of human cultures—Latin America, Africa, European, Asian, and so forth. In her work we, too, each flow through the other, and are composed of spiritual matter inspired by other cultures. LaDuke's vision counters that of colonization, for instead of proposing a mechanistic model of conquest and conflict, she proposes an organic model of flow and spiritual sustenance.[1]

The following paintings accompanied with brief verbal clues, reveal my personal interpretations of select experiences in Borneo, India, Mexico, the United States, and Yugoslavia.

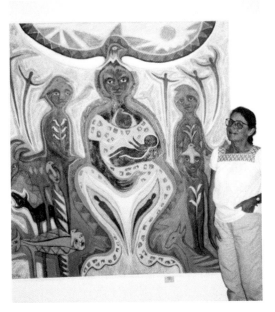

Fig. 1 Betty LaDuke, 1990, with *Africa Madona*, acrylic, 68 by 72 inches.

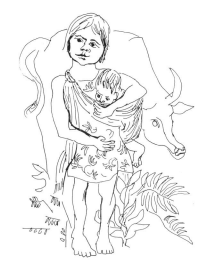

Fig. 3 *Tuk Tuk,* Samosir Island, Sumatra, pen drawing, 11 by 14 inches, 1974.

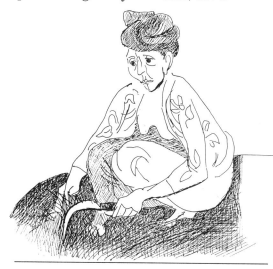

Fig. 4 Ubud, Bali, pen drawing, 11 by 14 inches, 1974.

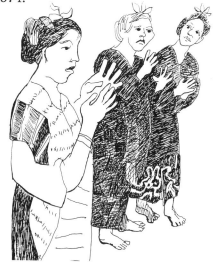

Fig. 5 *Coming of Age Dance,* Sumatra, pen drawing, 11 by 14 inches, 1974.

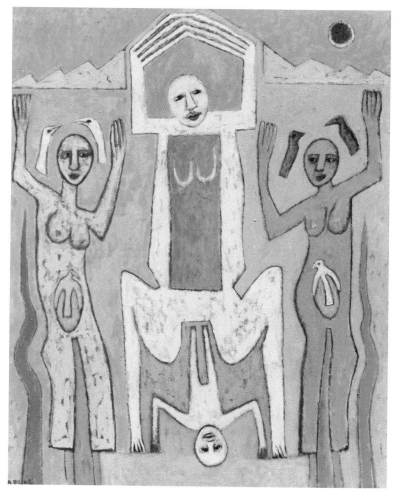

Fig. 2 *Borneo: Rite of Passage,* Betty LaDuke, acrylic, 54 by 68 inches, 1980.

Borneo: Rite of Passage (Fig. 2) was inspired by the Iban *pua* or sacred ceremonial weaving. Featured is a woman giving birth, accompanied by two attendants. Body shapes are simplified and elongated, conforming to the vertical rhythm of the *pua* fibers.

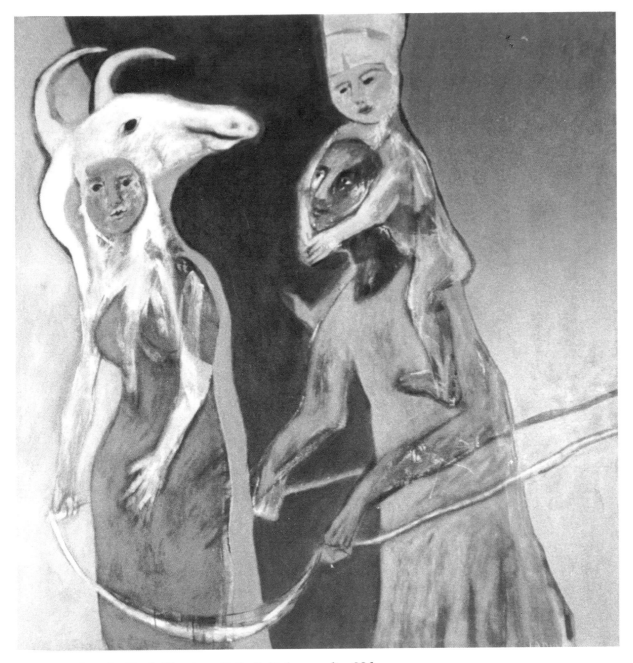

Fig. 6 *India: The Hindu Marriage*, Betty LaDuke, acrylic, 68 by 72 inches, 1972.

India: The Hindu Marriage (Fig. 6) projects the future expectations of both the bride and groom. Fertility is symbolized by the cow's features imposed upon the bride, while the groom already carries his future son upon his shoulders. A white strand of yarn in the groom's hands also encircles the bride, symbolizing his power over her. This image occurred to me after I attended a Hindu wedding and observed the couple's untangling of a knotted cord, as wedding celebrants watched. I was told this ritual reveals the couple's future relationship and patience with each other in solving problems.

Fig. 8 *Mexico, Easter*, pen drawing, 11 by 14 inches, 1978, Betty LaDuke.

Fig. 7 *Mexico, Easter Celebration*, Betty LaDuke, acrylic, 54 by 68 inches, 1978.

Mexico, Easter Celebration (Fig. 7) explores the multiplicity of relationships symbolized by the Virgin and Christ. In addition to Easter's representing Christ's resurrection and the regeneration of the soil, it also evoked images of passion and people's capacity for good and evil.

Fig. 9 *Mexico*, pen drawing, 11 by 14 inches, 1978, Betty LaDuke.

Fig. 10 *Play Free*, Betty LaDuke, acrylic on masonite, 36 by 48 inches, 1968.

Play Free (Fig. 10), a child with her arms upraised, symbolizes the Civil Rights struggle of the 1960s in the United States. Issues such as voter registration, school integration, equality and justice for all dominated national politics as people took to the streets to voice their demand for change.

Fig. 11 *Nicaragua,* pen drawing, 11 by 14 inches, 1982, Betty LaDuke.

Endnote

1 Gloria Feman Orenstein, *The Reflowing of the Goddess*, New York: Pergamon Press, 1980, p. 86.

Fig. 12 *Behind Walls Birds Sing*, Betty LaDuke, acrylic, 54 by 68 inches, 1986.

Behind Walls Birds Sing (Fig. 12) is based on the experience of seeing the dark, narrow streets and stone buildings that formed the Jewish ghetto in Dubrovnic, Yugoslavia. Although the enclosing gates no longer exist (the Jewish community disappeared into Hitler's concentration camps or a lucky few managed to escape to Israel), I tried to imagine the restricted lives behind these ancient walls as well as the people's yearning for freedom.